THE FIRST TRE ᴜᴜᴍS

The Getty Research Institute
Texts & Documents

THE FIRST TREATISE ON MUSEUMS

SAMUEL QUICCHEBERG'S *INSCRIPTIONES, 1565*

SAMUEL QUICCHEBERG

Translation by Mark A. Meadow and Bruce Robertson
Edited by Mark A. Meadow with Bruce Robertson

THE GETTY RESEARCH INSTITUTE PUBLICATIONS PROGRAM
Thomas W. Gaehtgens, *Director, Getty Research Institute*
Gail Feigenbaum, *Associate Director*

© 2013 J. Paul Getty Trust
Published by the Getty Research Institute, Los Angeles
Getty Publications
1200 Getty Center Drive, Suite 500
Los Angeles, California 90049-1682
www.getty.edu/publications

Laura Santiago, *Manuscript Editor*
John Hicks, *Production Editor*
Catherine Lorenz, *Designer and Typesetter*
Suzanne Watson, *Production Coordinator*
Stuart Smith, *Series Designer*

Printed in China
Type composed in Minion and Trade Gothic

17 16 15 14 13 5 4 3 2 1

Library of Congress Cataloging-in-Publication Data

Quicchelberg, Samuel, 1529-1567.
 [Inscriptiones. English]
 The first treatise on museums : Samuel Quiccheberg's Inscriptiones, 1565 / Samuel Quiccheberg ; translation
by Mark A. Meadow and Bruce Robertson ; edited by Mark A. Meadow with Bruce Robertson.
 pages cm. -- (Texts & documents / Getty Research Institute)
 Includes bibliographical references and index.
 ISBN 978-1-60606-149-7
 1. Museum techniques--Early works to 1800. 2. Museums--Philosophy. 3. Collectors and collecting--History.
4. Cabinets of curiosities--Early works to 1800. I. Meadow, Mark A, translator, editor of compilation. II.
Robertson, Bruce, 1955- translator, editor of compilation. III. Title. IV. Series: Texts & documents.
 AM49.Q5313 2013
 069'.4--dc23
 2013016182

Front cover: Display cabinet with assemblage, see pl. 18
Back cover: Hans Mielich (German, 1516–73), Portrait of Samuel A. Quiccheberg, detail of pl. 1

This volume translates Samuel Quiccheberg, *Inscriptiones; vel, tituli theatri amplissimi* . . . (Munich: Ex Officina
Adami Berg typographi, 1565).

English-language translation copyright: The Regents of the University of California, Mark A. Meadow, and Bruce
Robertson. © 2002. All rights reserved. Used by permission.

Funding for translation provided in part by the University of California Humanities Research Institute and a grant
from the J. Paul Getty Trust.

CONTENTS

BRUCE ROBERTSON

PREFACE
Wonderful Museums and Quiccheberg's *Inscriptiones*

In 1565, just as the Duke of Bavaria, Albrecht V, began building the first dedicated museum structure north of the Alps, his librarian Samuel Quiccheberg published the first museological treatise. Quiccheberg imagined, however, not just a single building but an entire complex devoted to collecting, research, display, and education that involved all the arts, all industry and sciences, and the natural world. This idealized conception of a governmental center for the production of knowledge has a very long subsequent history, as does the heart of Quiccheberg's enterprise, the museum. This basic notion of how object collections, research, and teaching may be gathered together can be seen on the Mall in Washington, D.C.; South Kensington in London; Museum Island in Berlin; Museum Circle in Cleveland, Ohio; and Wilshire Boulevard in Los Angeles (specifically, the juxtaposition of the Los Angeles County Museum of Art with the Page Museum and the La Brea Tar Pits, not to mention the Architecture and Design Museum and the Petersen Automotive Museum across the boulevard). Even the modern research university reflects Quiccheberg's conception.

But what does Quiccheberg's ideal *Wunderkammer* (curiosity cabinet) actually have to say to us about how modern museums are organized and the cultural and epistemological tasks they perform? In 2011, the Smithsonian, one of the world's largest modern museum complexes, opened an exhibition called *The Great American Hall of Wonders* at the Smithsonian American Art Museum, which is housed in the Old Patent Office Building.[1] The exhibition was an attempt to reconceive the history of the Smithsonian's museum enterprise, and nineteenth-century American culture in general, as one imbued with wonder. I suspect this would have come as a shock to the institution's founders as well as to the builders of the Patent Office, and even to the founders of the Smithsonian American Art Museum (or National Gallery, as it was originally called). They all celebrated the rationality of their work, the evenhanded unfolding of ideal and certain taxonomies, straightforward categories, facts and figures, maps, and narratives. For mid-nineteenth-century audiences and institutions, and well into the twentieth century, wonder was an emotion, fit for children and women; it was not a tool for analysis, critical thinking, research, and ideas. How then should we interpret Quiccheberg's wonder-ful museum? Can our interest in his treatise be anything more than historical, when the epistemological foundation

of his museum is seemingly so antithetical to the way the production of knowledge is conducted today?

Kunstkammern (art cabinets) and *Wunderkammern* have proliferated in the last few decades as objects of scholarship, modes of display practice, and actual installations. A spate of scholarly books beginning in the late 1970s—including those by Elizabeth Scheicher in Austria, Adalgisa Lugli in Italy, Oliver Impey and Arthur MacGregor in Great Britain, and Krzysztof Pomian in France—are significant instances of this proliferation.[2] Early Wunderkammern were re-created with the reconstruction and reinstallation of the Danish royal Kunstkammer in 1977 and Schloss Ambras at about the same time, with an ideal Kunst- and Wunderkammer reconstructed (for sale) by the dealers Colnaghi in London in 1981.[3] Starting with Adalgisa Lugli's installation at the Venice Biennale in 1986 (part of the event's overall theme of art and science), which mixed modern art with *naturalia* (natural objects) and *mirabilia* (marvels), museum exhibitions of both contemporary art and historical material followed rapidly.[4] *Age of the Marvelous* (1991), curated by Joy Kenseth, and *Wunderkammern des Abendlandes* (1994), both purely historical exhibitions, were extremely influential. Temporary and permanent collection installations in major museums have also become common, as, for example, in the Walters Art Museum or the National Gallery of Art. With the Museum of Modern Art's installation in 2008 of a permanent collection print exhibition titled *Wunderkammer: A Century of Curiosities,* one realizes that the device has become ubiquitous in contemporary art.

Since the 1980s, many contemporary artists have made Wunderkammern on every scale a normal part of their practice, with figures such as Mark Dion using the Wunderkammer as a model for installations in museums.[5] The notion of artists intervening in historical collections goes back at least to Andy Warhol's exhibition *Raid the Icebox,* staged at the Rhode Island School of Design (RISD) Museum of Art in 1969 and using materials from storage, sometimes still in their storage cabinets.[6]

The tactic of assembling university collections in the manner of a Wunderkammer, as a way of reinvigorating them by startling the visitor with the breadth and variety of the material basis of academic knowledge, is also now commonplace. Ostensibly displaying research objects, these installations habitually gain their force through what have become relatively widespread Wunderkammer strategies for exhibitions: weird or startling juxtapositions, extreme disparities of scale or material, or simple grotesquerie. The examples at the Art, Design and Architecture Museum at the University of California, Santa Barbara, and others I have seen—at the Fowler Museum at the University of California, Los Angeles; the Weisman Art Museum at the University of

Minnesota; and the Martin Gropius-Bau in Berlin—have all been organized by art historians, with one exception: the very interesting exhibition *Ausgepakt: Die Sammlungen der Universität Erlangen-Nürnberg* at the University of Erlangen-Nuremburg.[7]

This route to the Wunderkammer through art and artists reminds us that the root of the interest in the curiosity cabinet as a mode of visual display derives from surrealist installation strategies of the 1930s.[8] The Wunderkammer, as it has reemerged in contemporary consciousness and become part of the practice of artists and museums, has been predicated on notions of the bizarre, the accidental, and the unsystematic, and as antithetical or an antidote to the hyperrational claims of taxonomic systems and systematic organization in general. Contemporary curiosity cabinets are generally presented to overwhelm the modern viewer with an irrational dazzle of objects—trivial, overmanipulated, found, obscure, and anything but explicable.

But Quiccheberg's treatise on the Wunderkammer—the first printed museum treatise—is not about some nostalgic trip to a wonderland of bizarre objects. It is an ambitious attempt to outline why the desire to create curiosity cabinets was becoming so gripping just at this point in European culture. Assembling and displaying physical objects offered sixteenth-century intellectuals a powerful means to access new knowledge, knowledge that lay outside the realm of texts, incorporating practical, empirical, and artisanal knowledge into the realm of the written word. Quiccheberg's inscriptions and classes serve to map out and organize the collectibility of the material world, but they do so for a greater purpose than to taxonomize it. Above all, Quiccheberg sees the goal of his ideal cabinet as practical: the acts of collecting and organizing mobilize objects into their greatest usefulness. Moreover, the interrelatedness of a collection—the juxtaposition of objects, or groupings of objects—enhances the practical value of any single object. An encyclopedic collection allows the user to extract the maximum information from the individual artifact or specimen, but even smaller collections have their usefulness. The heart of Quiccheberg's museum lies in the amassing of stuff. However, as his treatise underscores at every level, this collection is never random or quixotic. For Quiccheberg, wonder and curiosity are part of the armature of rationality, as Mark Meadow's discussion will make clear.

But if we do not see Quiccheberg as contributing to these contemporary art practices that take such pleasure in their antirational impulses, what does this treatise offer of practical value to the modern museum? What can we learn from Quiccheberg's map of the material world? Perhaps the first thing to recognize is the narrowness of contemporary ambitions for knowledge to be acquired from the museum: what do we really learn from museums anymore? The great

age of collecting and organizing collections was the late nineteenth century, when the most extravagant claims for museums were made. Since then there has been the odd paradox of intense multiplication of the number and type of museums matched with their declining ambitions. Art museums are perhaps the narrowest of the lot, organizing the display of their collections almost exclusively chronologically and geographically, a system settled on before the end of the eighteenth century. Universities in particular have found themselves encumbered with collections even as the disciplines within which they were formed seem to have moved on: taxonomy, once dominant in biology, is sidelined; field geology, linguistics, and anthropology are now all subfields within their disciplines. And many universities in the United States have shut down their collections. Even in public science museums, the mere display of objects no longer suffices, as it did in the nineteenth century. Where science museums were once dominated by acres of specimen cases, now these have been relegated to backstage while interactive displays occupy the front of the house. The Victorian ideal of a public that would benefit from the new knowledge embedded in objects has evaporated, and in some ways we have returned to the situation Quiccheberg promoted: the museum is most useful to its users, not its viewers. Indeed, with this belief that collections are to be used, not just viewed, Quiccheberg asserts their fundamental research and scholarly value.

Also relevant is Quiccheberg's insistence on thinking self-consciously about matters of lighting, display, and storage as not just backstage issues that take place out of sight of the viewer. In Quiccheberg's view, these are in the foreground, as he delineates how best to put things out on tables or shelves and how to position them in relationship to the rubrics and titles above them. He concludes, in the last inscription in the last class, with a collection of containers for everything in the preceding inscriptions. What this focus suggests is the way in which display conditions and methods can be used to enhance not merely the viewer's perception but also the acquisition of knowledge. For Quiccheberg, this is a part of his larger strategy of empowering the visitor. And it suggests a powerful avenue of exploration for contemporary museums to follow.

There has been considerable discussion in the last few decades about the role of the omniscient voice of the curator, particularly in art museums but also in anthropology and history museums, and the need to open up the control of knowledge production within the exhibition and allow the visitor in. Quiccheberg urges us to render that physical apparatus, and the curatorial apparatus, more transparent as well.

Within the last two decades it has become common wisdom that constructing tight linear narratives for exhibitions is often self-defeating. Studies have shown over and over again that visitors find their own way through exhibitions,

despite the deployment of every technique available to restrict the passage to the narrative thread ordained by the curator.[9] While visitors will learn much that a curator offers, both the point of entry into the exhibition and what can be taken away from it are determined by the visitor, by what the visitor brings to it. Whether we realize it or not, casual visitors are also active users of collections, just not in the way curators would like them to be.

What Quiccheberg offers instead is not one linear narrative but an open-ended set of associative possibilities. Despite the clear order of his inscriptions—descending from God through the founder's family to the arts and crafts, then to fauna and flora, and finally to the boxes to put it all in—this firm order in the text is simply ordained by the linearity of old-fashioned textuality. We can imagine how Quiccheberg would have appreciated the flexibility of hypertext. He would also, no doubt, have loved to surf the Internet. He would have appreciated the sense of having access to all that is known and knowable at his fingertips.

Above all, Quiccheberg values the universal collection, the collection that relates all of its individual artifacts and specimens to one another. He was already aware of the distinction between Kunstkammer and Wunderkammer (and no doubt *Schatzkammer* [collection of objets d'art] and *Rüstkammer* [collection of armor]), but he treated these as less-than-ideal responses for the financially challenged. More objectionable would be our division into specialized museums in art, anthropology, history, and science, and the removal of workshops and libraries from them. Quiccheberg envisioned a single physical space, or close co-location, that would contain the collection, printing presses, pharmacies, armories, and so on. Even if they were to be separated physically, they were still contained institutionally, all housed under the court. Moreover, all users were well known to the collector and his officials.

This is perhaps the biggest difference between Quiccheberg's conception and any present applicability: the social context. Quiccheberg never envisaged a public museum in the sense we understand by the term *public,* even if his ideal Wunderkammer was more permeable than is often assumed today. Within the realm of the modern public state, there is little will to devote resources to elite enterprises or to those without self-evident economic rewards. But Quiccheberg understood that, too: his museum is productive, accessible, useful. These are terms we should be able to apply to any museum today as well.

At the heart of Quiccheberg's *Inscriptiones* are his classes: they are his starting point and the rest is explication and digression. As Quiccheberg makes clear, in the end organization matters as much as the material; the act of grouping, ordering, and systematizing is what produces knowledge. One object is silent; two tell a story; and three tell multiple stories and must be approached with a sense of order,

with a theory in mind. But we need to remember emphatically that these are in the service of, as much for Quiccheberg as for us now, the production of not just knowledge but the knowledgeable viewer, not a passive, merely contented viewer.

Notes

1. Perry 2011.
2. Scheicher et al. 1977; Lugli 1983; Impey and MacGregor 1985; and Pomian 1990.
3. Cannon-Brookes 1981.
4. Lugli 1986a.
5. Sheehy 2006.
6. Warhol and Ostrow 1969.
7. Andraschke and Ruisinger 2007.
8. Such as the *Exposition internationale du surréalisme,* Paris, 1938.
9. See, for example, Roberts 1997.

ACKNOWLEDGMENTS

As is fitting for an edition of a treatise that valorizes the production of knowledge from object collections, the starting point for this translation was an exhibition organized in conjunction with a graduate seminar in 1995–96. This exhibition, *Microcosms: Objects of Knowledge,* compared the ways sixteenth-century cabinets and contemporary universities organized and used objects. We are very grateful to Dr. Marla Berns, former director of the University Art Museum (now the Art, Design and Architecture Museum) at the University of California, Santa Barbara, for her invitation to curate this show, in which we first explored Samuel Quiccheberg's *Inscriptiones* as a system for knowledge production.

This translation was initiated under the auspices of a residential research group, *Microcosms,* at the University of California Humanities Research Institute (UCHRI), University of California, Irvine, in the spring of 1997. The research group was funded through a Senior Collaborative Research Grant from the Getty Foundation, with additional support from the Gladys Krieble Delmas Foundation. We are deeply grateful to Patricia O'Brien, former director of UCHRI; David Theo Goldberg, the current director; and Rosemarie Neumann, staff assistant, for their support, as well as the ideas generated in concert with the members of the research group and the participants in the many symposia we held.

Microcosms became a Special Humanities Project of the Office of Research, University of California Office of the President, codirected with Rosemary Joyce at the University of California, Berkeley. The translation has benefited from its genesis within this larger intellectual project, which was made possible by generous support from the Office of Research in the University of California Office of the President (UCOP) and the following institutions within the University of California, Santa Barbara: the College of Letters and Science; the Office of Research; the Interdisciplinary Humanities Center (IHC); and the Academic Senate. In particular, we thank Dante Noto, Office of Research, UCOP; David Marshall, executive dean of the College of Letters and Science; Michael Witherell, vice-chancellor for research; and Simon Williams, former director of the IHC.

Background research for this book was conducted at a variety of institutions whose kind assistance we wish to acknowledge. These include the Bayerisches

Staatsbibliothek and Bayerisches Nationalmuseum in Munich; the Fugger Archive in Dillingen; Leiden University; the Alfried Krupp Wissenschaftskolleg Greifswald; and the University of Greifswald.

Translating Quiccheberg's treatise has been very much an iterative and collaborative process that evolved as we came to understand more deeply Quiccheberg's purposes and context. We are grateful to our expert Latinists: Grant Parker, Russell Newstadt, Han Lamers, and Daniel Dooley. For answers to specific research questions we thank Michael North at the University of Greifswald; Reindert Falkenburg, Marika Keblusek, and Wim van Anrooij at Leiden University; librarians and archivists at the Bayerisches Staatsbibliothek; Alexander Wied at the Kunsthistorisches Museum Vienna; and Alfred Auer, director of Schloss Ambras.

Our research assistants made invaluable contributions to this project in many ways. We are extremely thankful to Katharina Pilaski, Matthias Müller, Mitzi Kirkland-Ives, Amy Buono, Emily Peters, Barbara Kaminska, and Jennifer Gully.

This translation was first funded by the Getty Foundation, and we have received support in both material and immaterial ways from the Getty ever since, particularly from Deborah Marrow and Joan Weinstein, director and deputy director, respectively, of the Getty Foundation. Marcia Reed, chief curator of the Getty Research Institute, responded sympathetically to a request from Mark Meadow, when he was a Getty predoctoral fellow, to acquire the copy of Quiccheberg upon which this book is based. Julia Bloomfield, former head of Getty Research Institute Publications, helped get this book under way. In bringing this project to completion we are grateful for the support and encouragement of Gail Feigenbaum, deputy director, and Melanie Lazar, project management coordinator, at the Getty Research Institute. Laura Santiago, manuscript editor, and John Hicks, production editor, both provided invaluable help in bringing this book to completion. We also thank Catherine Lorenz and Suzanne Watson for expertly attending to the book's design and production.

Many others deserve our gratitude for contributions great and small. These include, in no particular order, Harriet Roth, Dirk Jansen, Lina Bolzoni, Paula Findlen, Tom Crow, Robert Jensen, Serge Guilbaut, Ken Arnold, Rosemary Joyce, Horst Bredekamp, and Christl Karnehm. We beg the forgiveness of anyone we may inadvertently have omitted from these acknowledgements.

—Mark A. Meadow and Bruce Robertson

MARK A. MEADOW

INTRODUCTION

The *Inscriptiones; vel, tituli theatri amplissimi* (Inscriptions; or, Titles of the most ample theater), written by the Flemish physician Samuel Quiccheberg (see pl. 1) and printed in October 1565 by Adam Berg in Munich, is the earliest-known treatise on collecting and museums. Begun in 1563, while Quiccheberg was working with the collections of Duke Albrecht V of Bavaria (see pl. 3), the *Inscriptiones* exists in two forms: a manuscript from 1565, which Samuel's brother Leo took to Italy in search of a Venetian publisher; and the published version, which is translated in this volume. The *Inscriptiones* lays out guidelines for assembling an ideal princely *Kunst-* and *Wunderkammer* (an encyclopedic collection encompassing all aspects of human artifice and of nature). In the course of the book, Quiccheberg presents, among other things: an organizational system for a vast, encyclopedic collection; a quite thorough list of the sorts of objects one might acquire; a set of largely pragmatic explanations for why the expense and effort of building up a collection is worthwhile; an interlinked system of workshops, studios, and exhibition spaces to which the Kunstkammer is related; practical suggestions for how to store and display the myriads of objects recommended for acquisition; and a survey of exemplary contemporaneous collectors. As a historical source, the *Inscriptiones* provides invaluable insight into how and why these vast and (for modern observers) often perplexing early museums came into being.

While art historians, historians of museums, and other scholars have long recognized the importance of Quiccheberg's text, this is the first complete English translation to be published. Much of the text is written in a cryptic, abbreviated style, with promises of more thorough explanations in the next edition. Furthermore, the Berg edition was hastily produced. According to notations in the manuscript Leo Quiccheberg took to Italy, the initial outline of the classes and inscriptions and the section on associated workshops were drafted by October 1563, with the rest of the text (except the dedicatory poems) completed by April 1565.[1] By May, revisions of the manuscript were completed.[2] In the four months leading to publication, the sections were reordered, the text partially rewritten, and the book typeset and printed. The problem of translating the text is exacerbated by the fact that Quiccheberg had to adapt the Latin to account for a new phenomenon, the Kunst- and Wunderkammer itself. The

scholarly apparatus in this edition is intended to make the text clearer for modern readers. In our translation, we have worked to retain the syntax and flavor of Quiccheberg's text while preserving comprehensibility.

As groundbreaking as Quiccheberg's book was in establishing a literature on museums and collecting, it is worth sounding a few notes of caution concerning the conclusions we can draw from it. First, modern scholars have often considered the *Inscriptiones* to be a foundational text for the currently burgeoning field of museum theory.[3] In some ways, though not all, this reputation misconstrues the text. As Quiccheberg makes clear, he was offering not a theoretical disquisition on an established cultural institution but a very practical book to aid princes and others in assembling a new and very practical kind of collection, which he refers to variously as a *theatrum sapientiae* (theater of wisdom), a *conclavium* (a secure space under lock and key), a Kunstkammer, a Wunderkammer, and a *museum*. The *Inscriptiones* is a how-to book, closer in tone to the many "books of secrets" then being published in Germany (which offered instructions on how to compound medicines, how to smelt and forge metals, how to fence, and so forth) than to scholarly tomes on medicine, law, or theology. Put another way, the *Inscriptiones* is technical and concrete, rather than theoretical and abstract, in its aims. Indeed, at the start of his Digressions and Clarifications (henceforth the Digressions), Quiccheberg clearly states that he is unconcerned with the hermetic, astrological, or cosmological premises that underlie such texts as Giulio Camillo's *L'idea del teatro,* a treatise on the memory theater with which the *Inscriptiones* is often associated. Even in his use of the term *theater* itself, the author is careful to explain that he refers to particular architectural forms that facilitate viewing rather than to the metaphorical sense in which the term was frequently used in book titles of the period.[4]

Moreover, this slim octavo volume, sixty-four pages in length, is only a preliminary sketch of Quiccheberg's thoughts about collections, which he intended to elaborate upon at much greater length in a later edition. Quiccheberg's untimely death in 1567, only two years after the *Inscriptiones* was printed, precluded a second version. Repeatedly, Quiccheberg alludes to his plans to expand his discussion of various inscriptions such as heraldry and numismatics. In fact, we should probably understand the book as a form of job application, in which Quiccheberg points out the many useful things he could accomplish through his continued employment as collections manager for Albrecht V.[5]

Was the treatise ever used in the creation or organization of any early modern collections? No Kunstkammer, including that of Albrecht V in Munich, exactly matches Quiccheberg's system of classes and subclasses in its layout. This is hardly surprising, since Quiccheberg makes clear that the system is not to be understood as a literal installation guide for the display rooms. Few copies

of the treatise survive today and the book does not appear to have been very widely distributed. Intended only as a preliminary edition, it is likely that the book had a very limited print run. More fruitful for gauging how informative the *Inscriptiones* might be concerning collecting in Quiccheberg's day are the social networks in which he was embedded, which link him directly or at most only one or two steps removed from almost all of the major players in the development of collections and museums throughout sixteenth-century Europe. For this reason, brief biographical details of the persons named in the treatise are provided in endnotes to the translation. Circumstantial evidence suggests that Quiccheberg's ideas were available to the various princes of the Habsburgs and Wittelsbachs, to innovative merchant collectors like the Fuggers, and to the Medici of Florence, among many others. The Exemplars, the section of the book devoted to naming important collectors and scholars in diverse fields, is extremely valuable for tracing the many strands of Quiccheberg's social and intellectual world.

Despite these caveats, the *Inscriptiones* presents the most extensive and substantive statement in the sixteenth century about collecting in general and the Kunst- and Wunderkammer phenomenon in particular. Indeed, it is the pragmatic and at times mundane tone of Quiccheberg's treatise that offers the most instructive insight about collections of the period. Quiccheberg recognized that the princes and patricians he addressed were not necessarily interested in (or always quite up to) the esoteric concept of universal knowledge advanced by Camillo and were far more likely to embark on creating such collections if they could see both the pleasure and the practical utility in doing so: "We are not dividing up for philosophers, precisely in line with nature itself, all natural objects; rather, we are sorting out for princes, into certain uncomplicated orderings, objects that are mostly pleasant to observe."[6]

The kind of pragmatic collection Quiccheberg envisions in his book was still in its infancy, especially as a princely institution. In several places, the author explicitly states that he has written the book in order to encourage and stimulate noblemen, patricians, and others to take up for the first time this new form of collecting, each according to his or her interests and means.[7]

We can look to some of Quiccheberg's early experiences for the origin of his practical interests: assisting the Nuremberg apothecary Georg Öllinger in the completion of his medicinal herbal and organizing the Fugger family's library and collections, both discussed below. Within the context of the Munich court, however, the pragmatic functions of collections were already part of an ongoing debate between the duke and his advisory council.

As early as 3 July 1557, the Bavarian court Council of State sent Albrecht V a report that tried to rein in his expenditures. In addition to lectures about such

matters as the costs of extravagant clothing and lavish feasts, the council also addressed Albrecht's interest in collecting:

> Furthermore, the council should also caution that His Princely Grace should not imitate the city burghers and merchants in the acquisition of various strange luxuries, as these merchants have unfortunately managed to lead great rulers, electors, and princes to the point that, because of their prodigality and extravagance, they have to finance and support their splendor and luxury.[8]

This is a remarkable admonition in many ways. To begin with, it signals that the collecting of rarities and exotica in Munich was already a well-entrenched practice in the late 1550s, although the Munich Kunstkammer did not come into formal existence until 1565. Further, it adverts to the fact that such collecting involved a sufficiently high level of expenditure to rise to the level of a matter of state. Perhaps most significantly, the council attributes primacy to the merchants in developing this new form of collection, placing the princes in the position of imitators. This is a stark reversal of the usual narrative concerning the origins of early modern encyclopedic collections, which sees them first appearing with princes and then imitated by members of the middle class keen on advancing themselves socially.

The issue that lay at the heart of this stern warning concerned not just the amount of money being spent but also the propriety of using state funds, instead of his personal household accounts, for collecting. Albrecht was not pleased at the personal critique contained in the council's admonition as a whole, and strongly expressed his displeasure in a letter dated 8 July of the same year. Albrecht's response, interestingly enough, is written in the hand of Hans Jakob Fugger, a merchant banker from Augsburg.[9] Hans Jakob Fugger and his family were major collectors in their own right, with a fully developed Wunderkammer some thirty years before that of princes like Albrecht.[10] Hans Jakob was a direct catalyst in transforming the Bavarian collections and those of the Habsburgs into what we now recognize as fully fledged Renaissance Kunst- and Wunderkammern. Thus, for assistance in drafting his rebuttal to the council, Albrecht turned to the one person who perhaps most exemplified the "burghers and merchants" he had been warned not to imitate in the "acquisition of various strange luxuries."

Albrecht and his council continued to bicker about financing for years.[11] What we might see as his final response, at least in regard to collecting, comes from the second section of the *Inscriptiones,* the Recommendation and Advice, in which Quiccheberg spells out why a prince should develop collections on this

scale. One passage is particularly interesting and should be taken as a definitive rebuttal to Albrecht's state council, as it justifies using the state budget to finance the collections:

> Indeed, I also judge that it cannot be expressed by any person's eloquence how much wisdom and utility in administering the state—as much in the civil and military spheres as in the ecclesiastical and cultural—can be gained from the examination and study of the images and objects that we are prescribing.
>
> For there is no discipline under the sun, no field of study, no practice, that might not most properly seek its instruments from these prescribed furnishings.[12]

This, too, is a remarkable statement. Quiccheberg here argues that the Wunderkammer serves not only as a place of amusement for the aristocracy and a political showcase for princely magnificence but also as a practical research center working directly at the service of the state's economy, defense, religion, and culture. Given that Quiccheberg was employed in the personal household of Albrecht V and that the treatise was for all intents and purposes addressed to the duke, it is reasonable to assume that his opinion conformed to Albrecht's.

In exactly the same period that Quiccheberg produced his treatise, Albrecht V formalized the Munich Kunstkammer as an institution within the court in two ways. First, he issued a decree declaring a select group of objects to be inalienable objects, inheritable only under the condition that they never leave the collection.[13] This proclamation coincided with the establishment of Bavaria as a political entity along the lines of a modern nation-state, with an integral territory and a fully hereditary government. These objects, then, were to serve as indexes of Bavarian and Wittelsbach identity rather than as compact forms of potentially disposable wealth, a role also to be played by the collections as a whole. Second, Albrecht ordered the construction of a new Kunstkammer building, the first truly classicizing architecture in Munich and the first purpose-built collections facility in early modern Europe.

Although Quiccheberg drew upon his experience working with the Fugger family collections and with Albrecht V's burgeoning Kunstkammer, he makes quite clear that the theater in its grandest form was unattainable for most collectors.

> For these classes of objects are not so proposed as if to suggest that everyone should bring together all objects but rather that each person might seek out from certain classes whatever he desires, or, from objects, those he

is able to acquire. For sometimes someone of meager fortune will be able, according to the opportunity of the place where he spends his time and by virtue of the course of study he sets before himself, very usefully to accumulate different kinds of seeds, metals, or little animals, or ancient coins, or even an abundance of images; and he does so without great expense, and merely through diligence of inquiry and research.

However, for the very rich and for other noblemen who are particularly enthusiastic in this pursuit and who already covet everything, it has been necessary here to describe everything in full so that at least in the general enumeration there is nothing left to be desired. And hence these matters are placed at the center of our discussion; not because I think that the lifetime of any man, even the most wealthy and diligent, is sufficient for collecting everything that could be broadly gathered into these classes but because I wanted, with this most complete and universal enumeration, to add these things to the considerations of men just as Cicero did with regard to the complete orator. Thus, on the basis of these classes, they might measure the magnitude of their knowledge of all things, and they might be stimulated to imagine and investigate other matters in turn.[14]

Therefore, the point of Quiccheberg's book is partly to provide advice about acquiring those things that lie within the collector's scholarly interests and financial means, however humble. But at the larger scale, for princely collectors such as his patron Duke Albrecht, Quiccheberg provides a framework not only for acquiring and organizing the objects they desire but also for stimulating them toward new areas of research and study. Completeness is not the goal; indeed, it is unattainable. Instead the quest is to stimulate new learning and expand useful knowledge.

The invocation of Cicero in this regard is instructive. As the humanistic paragon of classical eloquence, Marcus Tullius Cicero's pronouncements on what was required of the ideal orator were widely known and respected by Quiccheberg's readers. In *De oratore,* Cicero observes that all areas of human study are appropriate to the rhetorician, since he must be able to speak from knowledge on any topic: "No man can be an orator complete in all points of merit, who has not attained a knowledge of all important subjects and arts. For it is from knowledge that oratory must derive its beauty and fullness, and unless there is such knowledge, well-grasped and comprehended by the speaker, there must be something empty and almost childish in the utterance."[15] True and broad knowledge is necessary to both effectively and honorably discharge the duties of the orator within the public sphere. As we shall see, Quiccheberg equates these rhetorical qualities—the ability to speak knowledgeably and eloquently—with the virtues of a wise ruler. He must be well educated as a prerequisite to properly governing

his territories and must also continually seek to expand his working knowledge as an instrument of statecraft.

Quiccheberg's Life and Intellectual Formation

How did a Flemish physician find himself in a position to advise dukes, princes, and emperors about creating these vast, encyclopedic, and pragmatic collections? Reviewing what little we know of his life provides insights into the origins and range of Quiccheberg's various areas of interest and expertise. Biographical information can be gleaned from the *Inscriptiones* and from his earliest biography, published in *Deutsches Heldenbuch* (1570) by the physician and humanist Heinrich Pantaleon.[16]

Samuel Quiccheberg, the child of the merchant Jacob Quickelberg, was born in Antwerp in 1529.[17] Quiccheberg attended Latin school in Ghent, where he "learned the basics of writing."[18] Apparently on confessional grounds, Quiccheberg's family moved to Nuremberg when he was ten, where he studied the liberal arts and began his research into *naturalia*—plants, metals, and precious stones—in relation to their efficacy as *materia medica* (medicaments).[19] In addition, he read "histories," a term that broadly referred to nonfictional works of scholarship.

In 1547, at age eighteen, Quiccheberg moved to Basel, where he enrolled at the university.[20] Pantaleon connects him with Ulrich Coccius, who was a New Testament theologian with Lutheran leanings, described as the "first evangelical preacher in the Margraviate of Baden."[21] Despite the Lutheran tilt of Coccius (and Pantaleon), and the possibly religious motivations in Jacob Quickelberg's emigration from Antwerp, theological controversy does not seem to have preoccupied Quiccheberg, who displayed no particular affinities for the reformers. In fact, theology plays only a very limited, if symbolically important, role in the collection proposed in the *Inscriptiones*. As Katharina Pilaski has convincingly argued, the Munich Kunstkammer, in the context of which the *Inscriptiones* was produced, was specifically used as an instrument for advancing Catholicism as the Bavarian state religion.[22] Pantaleon also connects Quiccheberg with Hieronymus Wolf, who was in Basel and already well on his way to becoming a renowned humanist, Byzantinist, and library scientist. Starting in 1551, Wolf was the librarian to Hans Jakob Fugger and in 1557 was succeeded by Quiccheberg.

Quiccheberg also met Pantaleon himself in Basel.[23] Pantaleon wrote numerous historical, medical, and philological works but is today best known for his edited book of biographies of famous Germans, to which Quiccheberg contributed. Apparently it was Quiccheberg's "good nature and chaste way of life" (*guten art und züchtigen wandel*) that first brought him to Pantaleon's

attention.[24] There seems to be something to this characterization, since Quiccheberg adopted the motto *Intacta virtus* (intact virtue) and included it on the verso of his portrait medallion.[25]

In 1548, Quiccheberg moved to Freiburg im Breisgau, where he may have completed his medical training, and visited Augsburg, arriving in time for the 1548 *Reichstag.*[26] It was in this period that Quiccheberg came to the attention of the Fuggers, with whom his biography was bound for the remainder of his life.[27] On 1 June 1550, Quiccheberg matriculated at Ingolstadt University simultaneously with Anton Fugger's son Jakob. Anton agreed to pay Quiccheberg's matriculation fees in exchange for serving as Jakob's tutor.[28]

Founded in 1472 by Duke Ludwig IX of Bavaria-Landshut, the university at Ingolstadt remained closely linked to the Bavarian dukes. Under the influence of Duke Wilhelm IV and his chancellor Leonhard von Eck, Ingolstadt became the leading Catholic university in the German-speaking lands. According to the *Heldenbuch,* Quiccheberg excelled in his studies at Ingolstadt: "When he was in Ingolstadt, he read several times for the professors and thereby became known to the learned as the most excellent in Bavaria."[29]

Quiccheberg's earliest publication was a set of medical tables that date from his time at Ingolstadt, the *Tabulae omnibus medicis summopere utiles, atque ad curandi studium, accedentibus imprimis salutares* (Table of all that is of principal use to doctors and to the study of healing and especially enhancing wellness; 1553).[30] A second edition, titled *Tabulae medicae medicis ad medicinam veram accendentibus aliisque studiosis perutiles* (Medical tables for doctors, for enhancing true medicine and other very useful subjects), was published in Munich in 1565, the same year as the *Inscriptiones.*[31] As these titles suggest, the medical "tables" that Quiccheberg created were intended for teaching medicine. The term *tabula* in these titles refers to diagrammatic charts such as those Quiccheberg describes in class 5, inscription 4: "Tables of sacred and secular classifications. Also historical catalogs; and chronologies illustrated on enormous panels, just like certain maps that not infrequently have been broadly spread out. There are also tables in the shape of branches [*tabulae ramosae*] and others that place the division of individual disciplines and their main headings fully before the viewer's eyes" (see pl. 16).[32] These are organizational, systemic, or methodological charts, such as those propagated by Petrus Ramus of the University of Paris. Ramus's tables, including one for medicine, consisted of bifurcating branches moving from general concepts to specific details. Members of the circles in which Quiccheberg traveled were well acquainted with Ramist diagrams: Hieronymus Wolf met Ramus during a visit to Paris; and the philosopher Sebastian Reisacher, whom Quiccheberg singles out for particular praise, championed Ramism at Ingolstadt University.

The focus on ordering systems, method, and education already apparent

in this first publication was to remain a constant in Quiccheberg's research and writing. In 1553, the same year that his medical tables were first published, Quiccheberg returned to Nuremberg, where his father still lived, to aid in completing the medicinal herbal being compiled by the apothecary Georg Öllinger. This large manuscript (19 x 12⅝ in. [48.3 x 32 cm]), titled *Magnarum medicinae partium herbariae et zoographicae, imagines quamplurimae excellentes* (Numerous excellent images of the large part of medicinal botany and zoology), contains 647 watercolor images of both local and exotic plants, many depicted life-size, including three varieties of tomato, a plant only recently imported from Peru (see pl. 4).[33] Öllinger may have tutored Quiccheberg in natural philosophy, especially *materia medica,* during Samuel's first sojourn in Nuremberg, which would explain why Öllinger entrusted the completion of his magnum opus to the still little-known Quiccheberg.

Quiccheberg concluded his studies at Ingolstadt by 1555, and that year he entered into the service of Anton Fugger, the head of the Fugger business. On 1 June he was appointed "for three years to serve Mr. Anton Fugger, to care for his body and attend to him medically."[34] Quiccheberg ended his service to Anton Fugger one year early, on 2 June 1557, when he began working for Hans Jakob Fugger as librarian and collections manager.[35] Quiccheberg put into place an ordering system for the Fugger library based upon an earlier example by Conrad Gesner.[36] The Fuggers' need for such an ordering system was acute, since their libraries had already reached 30,000 volumes in the first half of the century. The section of the *Inscriptiones* devoted to the organization of a library is the only surviving trace of Quiccheberg's book-cataloging system.

The Fuggers were prodigious collectors of a vast range of materials including, among many other things, antiquities, musical and mathematical instruments, coins, rare plants and live exotic animals, clocks, and works of art. Thus, prior to the formal establishment of the Wittelsbach and Habsburg Kunstkammern, Quiccheberg had already participated in the compilation and management of their mercantile predecessors. The first member of the family to collect on a large scale was Raymund Fugger I, the father of Hans Jakob Fugger. In the *Fugger'schen Ehrenbuch* (1542–48), a genealogical manuscript and family chronicle commissioned and in part compiled by Hans Jakob, he describes his father as "very desirous of antiquities and medallions, indeed was a diligent inquirer after all the previously mentioned things of useful knowledge, and a patron of all the good arts as his diligence in his former Kunstkammer can be observed."[37] Raymund's collections included rare books and manuscripts, antique sculpture, coins and medals, paintings, mathematical and horological instruments, and *selzamkhayten* (rarities and *naturalia*). Raymund Fugger's collection of antiquities was preeminent in Germany, surpassing the now much

better-known collections of Konrad Peutinger and Willibald Pirckheimer.[38]

Hans Jakob Fugger inherited his father's library and Kunstkammer. Educated in law and linguistics at Dôle, Bourges, Padua, and Bologna, he remained dedicated to humanist pursuits, supporting a wide range of scholars and substantially increasing the size of the library, which is what made Quiccheberg's ordering system necessary. In 1560, Fugger succeeded his uncle Anton as head of the Fugger business. However, in only three years both he and the family business were bankrupt, partly because of King Philip II's default on massive loans from the Fuggers. Albrecht V secured Fugger's debt and in the process acquired his library, his antiquities, his coin collections, and his services. In 1565, Fugger took over Albrecht's Italian correspondence, which frequently concerned the acquisition of coins, statuary, art, and other collectibles. Later that year, Fugger was selected by Albrecht to represent him at the wedding of his sister-in-law, Johanna of Austria, to Ferdinando I de Medici.[39] Over time Fugger assumed more and more responsibilities within the court, advancing to the office of Bavarian *Kammerpräsident* (chancellor) in 1570.

Hans Jakob Fugger's scholarly interests informed his personal collecting, which emphasized classical and humanist texts, ancient coins and medals, and genealogical history. He developed these interests while studying in Italy and during his period of business training at the Fondaco dei Tedeschi, the German trading residence and business center, in Venice. Both Quiccheberg and Jacopo Strada, the Italian scholar, architect, numismatist, art collector, and art broker, assisted Fugger in expanding his collection.

Genealogical and heraldic research was Hans Jakob Fugger's other scholarly passion. He commissioned Clemens Jäger, an Augsburg shoemaker, guild official, and member of the city council, to manage two major projects. The first of these was the *Fugger'schen Ehrenbuch* mentioned earlier, a history of the Fugger family through the family tree, portraits, coats of arms, and biographical sketches of the family.[40] The chronicle extended from Hans Fugger I, a weaver who immigrated to Augsburg around 1367, to Hans Jakob and his living relatives. The second major project, presumably also researched by Jäger, was a very similar genealogical history of the Habsburg dynasty, the subtext of which was the enduring role the Fuggers played in the fortunes of the Austrian imperial family.[41]

The two primary fields of Hans Jakob Fugger's scholarly endeavors—numismatics and genealogy/heraldry—must have helped shape Samuel Quiccheberg's own interests in these areas. Witnessing the substantial financial support provided by Fugger for Strada's catalogs of Roman imperial coins, and aware of the similar funding from Marcus Laurinus van Watervliet for Hubertus Goltzius's numismatic studies and publications, Quiccheberg surely recognized the lucrative opportunities for employment afforded by such expertise.

Through his connections with Hans Jakob Fugger, Quiccheberg secured a paid position with Duke Albrecht V by 1559, presumably in connection with Albrecht's burgeoning collections. Genealogy and heraldry constituted part of Quiccheberg's portfolio. Pantaleon informs us that Quiccheberg "planned to account for the German nobility, discover the origins of the old families, and represent the heraldic arms. Doing this was made so much easier for him because the prince often led him through the princely collections where Samuel could diligently inquire into all things."[42] In the *Inscriptiones,* Quiccheberg refers to the same genealogical project as completed but still unpublished research by noting that he will "attempt to make known . . . whatever I have diligently discovered in my earlier studies concerning the insignia and arms of noble families."[43]

Over the years, Quiccheberg traveled extensively to visit members of the nobility, collectors, and collections, gathering genealogical and numismatic information and aggressively developing the kind of social network that humanistic scholarship, collection development, and gainful employment required. By his own account, he visited Italy "while still a young man" and there visited the collections of Ulisse Aldrovandi, as noted in the digression on class 3, inscription 1.[44] Quiccheberg attended the Council of Trent in 1563 and later that year made a second journey to Italy to visit collections and act as a broker in the purchase of art and antiquities for Albrecht. It is likely this trip included a visit to Venice, "where learned men examined a copy of our theater."[45]

Quiccheberg acquired a familiarity with collections of all kinds during his "research and residencies at various museums and libraries and our frequent visits to markets and councils"—and did not shy from bragging about it.[46] He proudly and repeatedly intimates in the Exemplars that he has surpassed Hubertus Goltzius's pathbreaking list of coin collectors published in 1563: Goltzius overlooked many numismatic collectors, including those interested in modern coinage and, while the minor nobleman Marcus Laurinus van Watervliet generously funded Goltzius, Quiccheberg enjoyed the patronage of the Bavarian duke. The Munich schoolmaster Gabriel Castner takes up and extends this competitive comparison in his dedicatory elegy included in the set of honorific poems at the end of the book:

If through coins alone such great praise arises,
Which Goltzius the author now possesses by merit,
How much more renown is owed our own Quiccheberg,
Who collects uncountable kinds of things?[47]

At Munich, Quiccheberg collaborated with the artist Hans Mielich in the creation of two opulently illuminated musical manuscripts. Cipriano de Rore, a Flemish composer who lived in Venice and Ferrara for most of his career, wrote the first of these.[48] The motet volume is dated 1559, the year Quiccheberg entered into a formal relationship with Albrecht V's court, and contains twenty-six motets, with eighty-two pages of illuminations by Mielich. Five years later, in 1564, Quiccheberg collaborated with Mielich to create a commentary volume on the manuscript.[49] The introduction to the commentaries includes a list of the artists and craftsmen involved in producing the manuscripts and a glossary of the artistic terminology that Quiccheberg employs in his discussions of individual illuminations. As the musicologist Jessie Ann Owens points out, certain entries in this glossary, such as his discussion of plant-derived ornamentation, closely resemble passages from the *Inscriptiones*.[50] Other sections deal with codicology: the forms of lettering used, a system for identifying where on each page the various illuminations are located, explanations of musical conventions and abbreviations, and a set of indexes. The main body of the commentary discusses the textual sources for the motets, Mielich's iconography, theological and other contextual material relevant to the stories and images, and the ornamentation of each illuminated page.[51] Between 1565 and his death in 1567, Quiccheberg further collaborated with Mielich to create a commentary on a second illuminated manuscript of motets by the Munich court composer Orlando di Lasso.[52]

Perhaps hoping to secure future financial support, Quiccheberg refers repeatedly to plans for publications devoted to genealogy, heraldry, coins and medals, painting, arithmological poetry, and, most importantly, to a substantially expanded edition of the *Inscriptiones*. He even offers to instruct book printers about the most effective use of rubrics and marginal notations to help their readers navigate texts efficiently.

None of these plans came to fruition, however, since Quiccheberg fell seriously ill shortly after the *Inscriptiones* was published. In 1566, the court accounts show a payment to "Samuel Quiccheberg out of mercy,"[53] followed by another outlay in 1567 for "expenses incurred because of the illness of Doctor Quiccheberg."[54] He died in June 1567 and was buried at St. Peter's Church in Munich.

The Contents of the Inscriptiones

Samuel Quiccheberg's *Inscriptiones* might best be described as a miscellany of six thematically related texts of various lengths rather than a collectively unified treatise. The sections in the published book are, in brief:

Inscriptions or Titles[55]

The first section describes a system of five classes of objects, each divided into ten or eleven subclasses called "inscriptions" or "titles." The *tituli* provide a brief yet comprehensive list of collectible objects and a broad conceptual order that facilitates locating individual objects and understanding their relationship to the collection as a whole.

Museums, Workshops, and Storerooms

Using a logistical framework that integrates the Kunstkammer into the operations of the princely court, this section presents a comprehensive apparatus of craft workshops, storage and display areas, study and research facilities, and utilitarian spaces essential to the daily operation of the household, such as the kitchen, chapel, apothecary, and gardens.

Recommendation and Advice

Here, Quiccheberg supplies a rationale for establishing the collection and developing it according to his own model. He also reinforces his bona fides to author the *Inscriptiones* and flatteringly acknowledges his debt to Albrecht V.

Digressions and Clarifications

This section contains elaborations upon various inscriptions. Quiccheberg justifies the seeming duplication by noting that he wished to keep the *tituli* "pithy and circumscribed," allowing the reader to understand the overall structure and sweep of the theater without getting bogged down in details.[56]

The Exemplars

Quiccheberg's penultimate section lists names of already established collectors and scholars, roughly grouped by social rank and family as well as by their particular fields of interest. Quiccheberg uses this enumeration to acknowledge debts he owes to those who have facilitated his research in various areas and to nod in the direction of those who may be of help in the future.

End of the Theater

The final part of the *Inscriptiones* contains a very brief set of biblical texts that pertain to collecting, followed by dedicatory poems by colleagues and acquaintances of the author. While these are occasional pieces, written at the request of Quiccheberg and therefore hardly unbiased, they represent the only direct commentary on the *Inscriptiones* that we have from the period.

The *Inscriptiones* and Their Digressions

The opening section of the *Inscriptiones* comprises a list of five classes of objects, each divided into ten or eleven subclasses that Quiccheberg terms titles or inscriptions. Each inscription, in turn, lists a series of related objects, specimens, or artifacts that might be collected. The section begins without any preamble other than the title page and a brief note to explain the appearance among the *tituli* of the astronomical sign of Mercury, which serves quaintly (referring as it does to the messenger of the gods) to point out which of the inscriptions he elaborates upon in the fourth section of the book, the Digressions. No metaphoric or esoteric meaning is ascribed to the symbol. Why Quiccheberg chose to name these subclasses "inscriptions" or "titles" is explained at the outset of the Digressions: should any collector desire, he or she might distribute signboards in the Kunstkammer to signal the location of specialized collections.

FIRST CLASS Following the theme of the administrative utility of a prince's collections, Quiccheberg's first class primarily concerns itself with the founder of the theater as the administrator of his realm, including his duties as military commander and manager of the state economy. With its focus upon the prince's person, his family, and his territories, class 1 reveals the collection to be a *representatio principis,* or (self-)representation of the prince and founder.[57]

The very first inscription of the theater encompasses the only explicitly religious group of objects: depictions of sacred narratives in paint, sculpture, or other media. While this might seem out of place in a class that glorifies the prince, it is worth remembering that the promotion of state religion is one of the four aspects of administration listed by Quiccheberg. Albrecht was the first Bavarian duke to exercise the principle of *cuius regio, eius religio* (whose state, his religion), which dictated that the confession of each German ruler became the official religion of his realm. Any German prince's declared confession was therefore, especially at this point in history, a defining aspect of his persona. As Katharina Pilaski has demonstrated, the Munich collections were actively used in the promulgation of Catholicism in Bavaria.[58]

By following religious imagery with inscriptions dedicated to the ruler's identity—genealogies, portraits of him and his family, and material pertaining to his territories—Quiccheberg relates the collection to ideas of Aristotelian causality.[59] God, the unmoved mover, creates the world in its entirety, the macrocosm, while the founder of theater creates the world in miniature, the microcosm. Both can be understood, within their own spheres, as final causes; that is, as the respective reasons why the macrocosm and microcosm came into being.[60] Thus, the prince-cum-collector declares a purposeful authorship of the collection; and the collection exists to further the ruler's goals, which are synonymous with those of the state. From this perspective, the artists/authors/creators of the objects within

the collection, and the objects themselves, become means that serve these higher ends. In other words, since the task of administering the state also qualifies as a final cause of the collection, then the collection is an efficient cause (the means by which a purpose is achieved) of the well-run state.

Inscriptions 4, 5, 8, and 9 fall within the modes of neo-Ptolemaic cartography: geography, chorography, and topography. Mathematically produced maps of large territories are geographic. Chorography, the description of regions, also includes maps, as well as city views, models of cities, and textual accounts of local customs, flora, and fauna, and so forth. Topography treats specific places: individual buildings, monuments, and landmarks. In the geographic mode, Albrecht V commissioned a leading cartographer and mathematician, Philipp Apian, to survey the Bavarian Duchy and produce a map of the territory at a 1:45000 scale, which was later used as the basis for a series of publications (see pl. 5). A local woodturner, Jakob Sandtner, produced chorographic wooden models of the Bavarian cities of Munich (fig. 1), Landshut, Ingolstadt, and Burghausen for the Munich Kunstkammer.[61]

The princely activities of warfare and ceremonials form the content of inscriptions 6 and 7. Military matters, the traditional role of the nobility, constitute another of the four administrative duties for which a princely collection was indispensable. Under his discussion of subsidiary museums, storerooms,

Fig. 1.
Jakob Sandtner (German, d. after 1580)
Model of the city of Munich, 1570, partly basswood, 17 × 186 x 200 cm (6¾ × 73¼ × 78¾ in.)
Munich, Bayerisches National-museum, Mod. 1

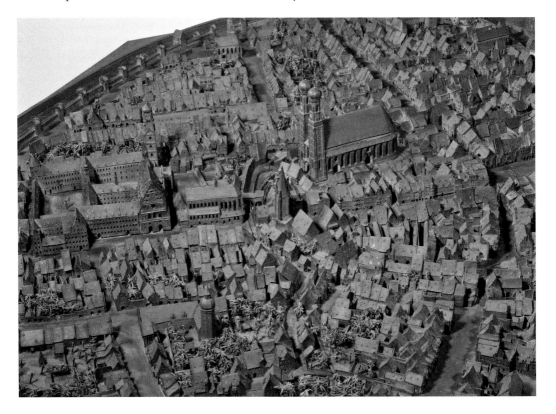

and workshops, Quiccheberg includes two armories: one to house weapons and armor for ceremonial events and another for outfitting soldiers in actual wars.

The final inscription of class 1, miniature models of machines, is less obviously related to the founder of the theater than the others: "Tiny models of machines, such as those for drawing water, or cutting wood into boards, or grinding grain, driving piles, propelling boats, stopping floods, and the like. On the basis of these models of little machines and constructions, other larger ones can be properly built and, subsequently, better ones invented."[62] Although these might at first glance appear to be more suited to class 4, which houses tools and instruments, they directly pertain to the prince's duties in supporting and promoting the state's economy. Through miniature models of machines, the collecting of large-scale technology becomes feasible; in addition, current technologies may be improved and new industries stimulated. Even in the face of unexpected events—whether disasters such as floods or new challenges posed, for example, by the opening of a new mine—these models could be consulted as needed.

SECOND CLASS Class 2 comprises three-dimensional examples of human artifice and artistry. The first inscription covers sculpture, both ancient and modern, in any medium. Inscriptions 2 and 3, respectively, contain art and craft objects produced in metal (excluding coins, medals, and the like) and those made from any other material.

The fourth inscription is a generic catchall for "ingenious objects" that are "primarily tiny and rather elegant." Particularly noteworthy is the equivalence it asserts among objects that are admirable "owing to their rarity or to the distance of space or time from their point of origin." Exotica, within this rubric and the next, are equally as interesting, valuable, and instructive as antiquities. Local, recently made artifacts, so long as they are scarce and unusual, might also be grouped here. However, the function of knowledge production is of paramount importance, as is made clear by Quiccheberg's permission to include larger objects if they "lead us to an understanding of foreign customs and craftsmanship."[63]

Among the most desirable of collectibles in the sixteenth century were exotica from Africa, Asia, and the New World. Many modern scholars have assumed that the owners of Kunst- and Wunderkammern had little to no interest in learning anything about the originating cultures.[64] Quiccheberg, in this inscription and in class 4, inscriptions 9 and 10, is quite emphatic that the opposite was true. Pragmatism is the driving force: "arms of the most diverse and practical employment" should be diligently collected "so as to compare foreign weapons with our own and the old with the new."[65] Queens and princesses collected dolls "so they can examine the foreign garments of distant peoples in fine detail. And sometimes the very customs of peoples present themselves for observation."[66]

Inscription 5 is simply a subset of 4: vessels that are interesting because they are old, foreign, or at least scarce, even if from the founder's territories. The digression on this inscription offers two benefits to collecting vases and other vessels of diverse shapes. The first concerns the promotion of local industry: "to suggest right away to certain people that new ceramics can be produced at a minimal cost."[67] The second advantage is more surprising: antique vessels of widely varying shapes require research to determine their proper names, thus contributing to the philological study of Latin. As Ken Arnold has argued, artifacts from classical antiquity bearing inscriptions—coins, medallions, sculpture, and architectural fragments—were especially prized for the same reason.[68]

The next inscription consists of weights and measures. Again, one might expect these to belong amid the tools and instruments of class 4; the fact that they, like vases, coins, and medals, are frequently cast from metal probably explains their inclusion in class 2. Although Quiccheberg once more divides the objects in this class among ancient and new, foreign and domestic, he explicitly excludes scarcity as a necessary criterion, in favor of the "intelligence, perspicuity, and distinction" that comes from their study.[69] In a period without standardization of mercantile measures, the value of having a wide variety of these close at hand is self-evident.

The same is true of ancient and new coins, the subjects of inscription 7. In addition to their philological value and utility for the conduct of international trade, ancient and modern coins bearing portraits and dates are also useful for genealogical research. In the corresponding digression, Quiccheberg even suggests that the study of modern coins—meaning a more precise knowledge of their metallurgical composition, weight, and monetary value—"would restore Europe to a most peaceful and harmonious condition,"[70] foreshadowing some of the arguments for the euro almost 450 years later. The inclusion of ancient and nonlocal coinage under this rubric again speaks to an equivalence between antiquities and exotica, as we saw in inscriptions 4 and 5 above.

Housed under inscriptions 8 and 9 are coin-like artifacts: medallions. Inscription 9 also encompasses plaquettes: small bas-relief narrative or allegorical images in formats other than a medallion but produced using the same techniques.

Small ornamental objects made by goldsmiths, generally designed as supplemental decorations for larger artifacts, constitute inscription 10. In specifying that these "tiny ornaments" include "leafy, flowery, animal, shell-shaped, whorled"[71] and similar forms, Quiccheberg evokes the miniature casts from nature by the Nuremberg goldsmiths Wenzel and Hans Jamnitzer and Hans Lencker (see pl. 8). Examples of their exquisite work were found in collections across sixteenth-century Europe, including Munich and Ambras. Similar

adjectives appear in the digression on class 5, inscription 3, which describes the subset of ornamental graphics within the print collection. Artisanal products that are, in fact, only components of larger works provide examples for craftsmen developing their art and thereby again pertain to local industry.

Quiccheberg ends this class with a set of objects distinguished technologically from the preceding forms of metalwork: two-dimensional images and ornaments etched and engraved on sheets of metal, rather than three-dimensional or bas-relief objects and images made by molding, casting, or sculpting. These fit within this class, rather than the fifth, where most two-dimensional works are to be found, on the basis of their material—metal—and their production in the same workshops as the objects in the preceding five inscriptions. Quiccheberg does not distinguish between intaglio sheets that are end products in themselves and those from which images on paper were printed.

THIRD CLASS Class 3, "this universal class, by starting directly with animals, clearly comprises natural things and the entirety of natural matter."[72] The sequence of its inscriptions descends from animals to plants, metals, stones, and earths. This sequence roughly corresponds to that of Pliny's *Natural History* and is generally characteristic of many natural history collections and treatises of the period. The digressions on this class are shorter overall (only three of the ten inscriptions receive digressions) and largely defer explanations to the appropriate textual authorities: for example, Leonhard Fuchs for plants, Georg Agricola for metals, and Aldrovandi and Conrad Gesner for animals. Quiccheberg uses the first digression to urge all collectors to acquire natural specimens, if only to assist those assembling professional collections, while the digression on inscription 5 is solely concerned with the appropriate containers in which to store tiny seeds and plant parts.

The first four inscriptions cover all forms of animal life: humans, mammals, birds, reptiles, fish, and insects. The creatures are intermingled within these inscriptions and not sorted hierarchically. Instead, the sequence proceeds from rare and unusual animals, preserved either in whole or in part; to life castings from animals, of the sort produced by Wenzel Jamnitzer in metals or Bernard Palissy in ceramics; to interesting bits and pieces of animals; and lastly to articulated skeletons and bones together with prosthetic human limbs and organs. Inscriptions 1 and 2 are complementary; the first contains actual specimens preserved as best as methods at the time would allow, while the second recapitulates the smaller creatures through artifice, which can render a more lifelike appearance than desiccated and dismembered specimens. To this second inscription can be appended both class 1, inscription 8 ("grand paintings of animals"), and the digression on class 5, inscription 3 (printed images of "works of nature" at the beginning of the print collection's second "region").

Quiccheberg's rationale for restricting paintings of animals to class 1, inscription 8 solely concerns practicalities of display; they require large expanses on walls and therefore are better hung with other large paintings. The implication is that the paintings of animals (and by extension, depictions of nature elsewhere in the collection) could simultaneously serve as supplements to the natural specimens of class 3, which is a good illustration of their multiple functions and values within Quiccheberg's system. An oil painting of an animal, such as those Hans Hoffmann painted for the Habsburg collections (see pl. 13), could stand as an example of the artist's skill; as an end product made of oils, earths, and pigments; and as an informative image of a live creature in its native habitat.

Inscription 4 concerns human remains and human prostheses. Like the life casts in the second inscription, the prostheses have multiple functions: they are products resulting from studying human anatomy; objects of study in themselves, permitting visitors to study individual limbs and other appendages without handling actual dead humans; and functional examples of medical technology.

Plants are the subjects of inscriptions 5 and 6. The first of these is devoted primarily to the means of propagation—for example, seeds, fruit, and rhizomes—and therefore in large part to agriculture. The digression mentions in passing that these plant materials can include examples from around the world and that apothecaries are a good source, but otherwise is interested only in the appropriate containers for such small and numerous specimens. Inscription 6 includes all other plant parts.

The mineral kingdom comprises the remaining five inscriptions, moving from metals to precious gems, to distinctive and medicinal stones, to colors and pigments, and finally to earths, salts, oils, and acids. By including a range from raw ore to fully refined metals in inscription 7, Quiccheberg again places the stress on technology and manufacture. In the Ambras Kunstkammer of Archduke Ferdinand II of Tyrol, artifacts and specimens were ordered primarily by material, including separate cabinets for gold, silver, and iron, with specimens spanning from raw material to the most technically sophisticated works of goldsmiths and locksmiths. The inscriptions for gems, stones, and earths contain statements confirming that these, like the metals, were above all understood as substances from which things can be made, including jewelry, medicines, paintings, and pottery.

FOURTH CLASS The fourth class contains tools and instruments. Mensuration, the art of measurement, is what links music and mathematics, the subjects of the first two inscriptions. Members of the Fugger family were avid collectors of both musical and mathematical instruments and Albrecht V devoted considerable resources to music. Under mathematics, Quiccheberg also mentions

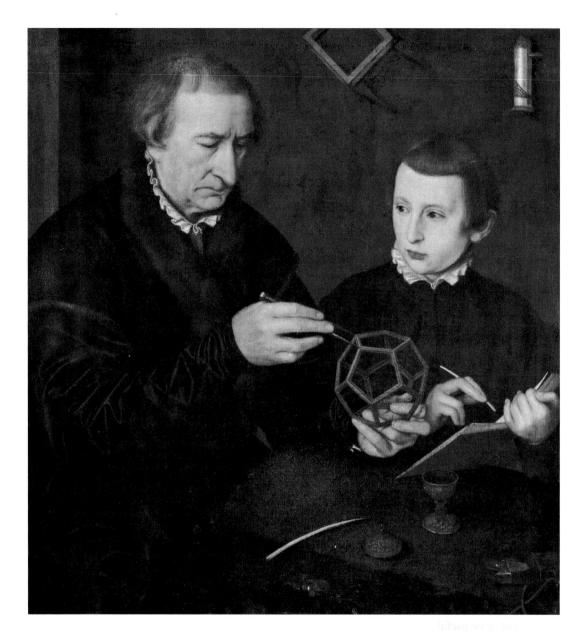

Fig. 2.
**Nicolas Neufchâtel
(Netherlandish, active ca.
1539–73)**
The calligrapher and mathe-
matician Johann Neudorfer
and his son, 1561, oil on
canvas, 90.3 × 85 cm (35½ ×
33½ in.)
Nürnberg, Germanisches
Nationalmuseum, on loan from
the Bavarian State Paintings
Collections, Munich, Inv.P.185

models of the regular or Platonic solids "beautifully constructed of transparent rods."[73] A portrait by Nicolas Neufchâtel of the Nuremberg schoolteacher Johann Neudorfer (fig. 2), who is mentioned in the Exemplars, illustrates what Quiccheberg had in mind; and Neufchâtel's portrait of Wenzel Jamnitzer shows the goldsmith using measuring devices of his own design (see pl. 21). Inscription 3 is devoted to the tools of writing and painting, including printing supplies. In Museums, Workshops, and Storerooms (the section of the book discussing workshops outside the Kunstkammer), music, mathematics, and writing are each provided with their own printing presses. The fourth inscription concerns simple machines—the lever, wheel, pulley, inclined plane, wedge, and screw—and their practical derivatives. By either changing the direction of or enhancing the force applied, these machines epitomize the most basic ways of acting upon nature.

The tools of artisans and surgeons mentioned in the fifth and sixth inscriptions are more specialized devices, for, respectively, manipulating the things of the world in general or acting upon the human body in particular. Equipment for leisure activities, especially of the nobility, makes up inscriptions 7 and 8. Roughly the same distinction between the previous two inscriptions—instruments acting on the external world or corporeally on humans—pertains here: in treating hunting, fishing, fowling, and gardening, the seventh relates to engaging with the outer world, while the eighth "pertains particularly to the agility of the body."[74]

Most of the tools found in this class serve either to study the natural world, namely, the mathematical instruments; to act upon nature, that is, the simple machines of the fourth inscription; or to manipulate natural materials into artistic and artisanal works. The Munich Kunstkammer housed comparatively few tools within the main collection, but in elector August I's Dresden Kunstkammer they constituted approximately 75 percent of the collection.[75]

Among the more intriguing aspects of this class are Quiccheberg's remarks in the Digressions concerning the foreign weapons and clothing of inscriptions 9 and 10. He proposes that these be the subjects of comparative technical and cultural analysis. From the weapons one can learn about new ways of hurling projectiles and draw useful lessons concerning weapons manufacture and use. As already discussed, foreign garments provide information about the customs and social classes of other peoples. Turning to domestic clothing in class 4, inscription 11, Quiccheberg enumerates examples of costumes that are retained either for historical or genealogical reasons (the clothing on the founder's ancestors) or for recording markers of social status (political and ecclesiastical vestments). The final lines of the digression on inscription 10 notes that women of high nobility also collect dolls in domestic clothing in order to preserve examples of older costumes and represent in miniature the court with its ceremonies and customs.

FIFTH CLASS Quiccheberg's final class serves three primary purposes. First, it is the repository for most two dimensional artifacts: paintings, prints, maps, portraits, coats of arms, and tapestries. As the digression on printed images (class 5, inscription 3) makes clear, part of the rationale for this concerns efficient storage. Very large numbers of thin, flat objects are most efficiently kept in flat files and stacks. Indeed, Quiccheberg offers one of the earliest-known descriptions of a print cabinet, even suggesting that the prints be interleaved with blank sheets to protect them.

In the first two inscriptions, Quiccheberg describes paintings and watercolors in explicitly aesthetic terms. These particular images are to come from the hands of the most eminent and distinguished artists. The idea is to compare works of different artists in terms of subject, skill, and appearance, "as if in an honorable competition" so that "it might be observed to what extent one artist seems to have surpassed the other."[76]

Next, we can think of much of the material in this class as codifying and displaying the knowledge derived from the rest of the collection. Inscription 4 is devoted entirely to instructional material (diagrams, tables, charts, classifications, and chronologies), but we can also understand the genealogies in the fifth inscription and the wise sayings of inscription 9 as falling under this rubric.

Last, a few inscriptions recapitulate the collection as a whole. The printed images of inscription 3 pertain to all branches of learning and are organized into three "regions," as Quiccheberg terms them. These are topically quite broad: the first is concerned with religion; the second with all aspects of nature, history, and culture; and the third with geography, chorography, and topography on the one hand and miscellaneous equipment, workshops, and ornaments on the other. Thus the prints display knowledge derived from every facet of the larger theater.

The aphorisms, proverbs, and other wise and witty sayings in inscription 9 rehearse the larger collection very differently. Written, painted, or inscribed on boards, on cabinets and shelves, or directly on the walls themselves, these words of wisdom are to be distributed throughout the theater, commenting on the objects, providing moral guidance, and stimulating conversations among visitors to the collection. They offer additional information by illustrating various letter designs, scripts, and languages.

The final inscription of the entire system, class 5, inscription 10, also recapitulates the entire theater but in a very peculiar manner. It lists the only explicitly three-dimensional objects in the class: the containers and furniture that house and display everything else in the collection. By including all of the tables, boxes, cabinets, chests, and so forth as members of the collection, over and above their function as a conceptually invisible apparatus for protecting and

accessing everything in the collection, Quiccheberg converts them into objects worthy of study and aesthetic contemplation in their own right.

The Inscriptions as a System

Quiccheberg states that the entire set of classes and inscriptions are intended to cover everything and anything that a collector might acquire to map the universe, promote learning in any field, and result in usable, practical knowledge: "Since all those topics are present that universal nature embraces, that all books teach, that all of human life can offer, it is perfectly clear that no discipline can be taught, no work of art examined, no state of life imagined, that does not have its foundations, equipment, means of support, or examples here in the theater."[77] Read sequentially, the system begins with God and the founder of the collection as analogous creators and then proceeds by stages through the world of crafted objects, the world of nature, the tools and instruments by which nature is studied and turned into artifacts, and finally the world of representations (paintings, maps, diagrams) as a form of enacted knowledge produced from the rest of the collection.

The five classes are in fact a linked cycle, the character of which can be interpreted through the exercise of selecting one or another of the classes as a governing principle for the others. We might, for example, take class 3, the full expanse of the knowable natural world, as the foundation from which knowledge and artifice are derived.

Table 1. *Diagram of Samuel Quiccheberg's Classes I*

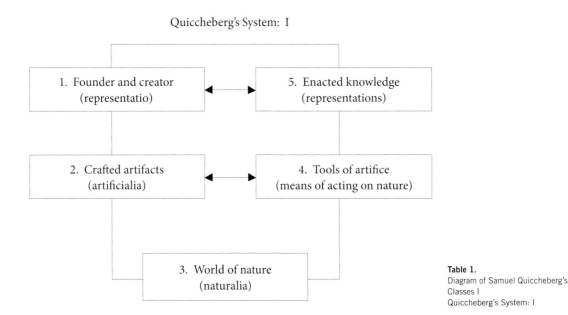

Quiccheberg's System: I

1. Founder and creator (representatio)

5. Enacted knowledge (representations)

2. Crafted artifacts (artificialia)

4. Tools of artifice (means of acting on nature)

3. World of nature (naturalia)

Table 1.
Diagram of Samuel Quiccheberg's Classes I
Quiccheberg's System: I

The next level, classes 2 and 4, presents the process of artifice: the tools and instruments that act upon nature and the material artifacts that result. Artifice is not an end in itself, however. Relating the first and fifth classes to each other reveals that the role of artifice is to serve higher purposes: the service of God, the ruler, and knowledge itself.

Placing class 1 at the head of the cycle helps make apparent a full system of causality, emphasizing God and the founder as final causes. Below them, classes 2 and 5 represent the efficient causes by which God and the founder project their sacred and secular authority: two- and three-dimensional artifacts, images and forms of enacted knowledge. Natural substances and the physical instruments together compose the material causes upon which the efficient causes operate and out of which the goals of the system are achieved.

Table 2. *Diagram of Samuel Quiccheberg's Classes II*

Table 2.
Diagram of Samuel Quiccheberg's
Classes II
Quiccheberg's System: II

Alternatively, we might place in the governing position the fifth class, now representing the end product of the collection: enacted, insightful knowledge. In this arrangement, the prince becomes the generator of wisdom through his judicious use of the appropriate instruments. Finally, the realms of *naturalia* and *artificialia* serve as the bases from which the prince derives his knowledge.

Table 3. *Diagram of Samuel Quiccheberg's Classes III*

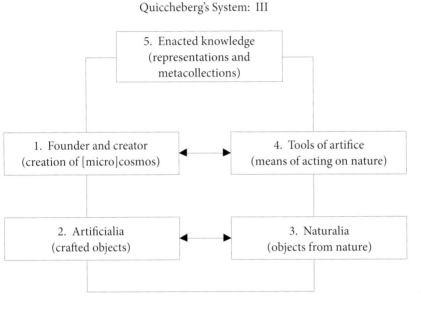

Quiccheberg's System: III

5. Enacted knowledge
(representations and
metacollections)

1. Founder and creator
(creation of [micro]cosmos)

4. Tools of artifice
(means of acting on nature)

2. Artificialia
(crafted objects)

3. Naturalia
(objects from nature)

Table 3.
Diagram of Samuel Quiccheberg's
Classes III
Quiccheberg's System: III

The interrelationships among the classes illustrated by this exercise are of course not mutually exclusive. Each class relates in a meaningful way with every other, a quality essential to Quiccheberg's theater fulfilling the roles he has assigned it. Individually and collectively, the classes and their contents are the processes, the products, and the purposes for which the Kunstkammer exists.

The Museums, Workshops, and Storerooms

In the shortest section of the *Inscriptiones,* Quiccheberg integrates the theater into a complex of research sites (*musea*), workshops (*officina*), and storage facilities (*reconditoria*).

Table 4. *Quiccheberg's System of Kunsthammer and Workshops*

Quiccheberg's System: I

Several of the facilities that Quiccheberg lists were standard parts of a large court: a pharmacy, woodworking and metalworking shops, armories, and a chapel. Others were becoming increasingly common, such as the library, the portrait gallery, and the trophy room. In fact, of all of the working spaces that Quiccheberg names, the newest and most innovative was the Kunstkammer itself. In placing it at the center of the preexisting court apparatus, the author transformed a scattered and disparate range of offices into a coordinated apparatus dedicated not just to the daily operations of the princely household but also to the larger administration of the state and its economy.

Quiccheberg begins with the library and its ordering principles. These are based on the "faculties, disciplines, and languages," and indeed correlate generally to the range of faculties and subjects in universities of the period. The library is organized into ten classes. The first three account for the three higher university faculties: theology, law, and medicine. The remaining seven cover the range of subjects taught in a Faculty of Arts: history, philosophy, literature, poetry, music, and grammar. The "literary" section of the library is a catchall, incorporating books on any subject "that cannot be assigned to the other classifications," such as texts on warfare, agriculture, and architecture.

The vocabulary that describes the physical layout of the library is taken from geography and cartography: regions are the largest units, the walls; each bookcase is a station; while colonies and appendixes describe supplements to the regions, perhaps freestanding cabinets, as required by the volume of books in a given subject area. The visitors thus metaphorically navigate through the library, steering themselves to the subject areas they seek. Visual clarity is important, as is efficiency in returning the books to their proper locations: each book is numbered and every tenth book marked by color. As in modern library classification systems, each book occupies a unique location.

From the library, Quiccheberg proceeds to the printing presses, noting that printed books with mathematical formulas or musical notation, still a relatively new phenomenon, require customized woodblocks. The publisher of the *Inscriptiones,* Adam Berg, was one of the pioneers of music printing in Germany.

The woodworking shop houses tools and machines such as lathes but also finished display pieces in a wide range of materials. The focus is on woodturning, the most technically advanced aspect of woodworking and carpentry, and also, as Quiccheberg notes, a favored hobby of the nobility, including Albrecht V, the Saxon elector August I, and the Holy Roman emperor Ferdinand II. The woodworking shop produced both practical things like furniture and luxury items like those described in class 2, inscription 3. In the context of Quiccheberg's theater, this shop would have manufactured many of the required boxes, caskets, shelves,

Table 4.
Quiccheberg's System of
Kunstkammer and Workshops
Quiccheberg's System: I

and tables. Bookbinding may be included here because the covers of hardbound books of the period were leather-covered wooden boards.

Another very practical office was the court pharmacy. For a court on the scale of Albrecht V's, most medicines would have been made in-house. The kitchen gardens would have supplied much of the plant-based *materia medica;* others could be derived from the holdings of class 3. As Quiccheberg observes, using Duchess Anna of Austria as an example, women typically oversaw the operations of the pharmacy, as well as the gardens and kitchens (see pl. 3). The responsibility of female consorts for managing both the kitchen and the household pharmacy is confirmed by recipe books of the period, such as the *Koch- und Arzneibuch* (Cooking and medicinal recipe book) of Philippine Welser, the morganatic wife of Archduke Ferdinand II of Tyrol at Ambras.[78]

The foundry, like the woodworking shop, produced utilitarian objects—such as the locks, hinges, weapons, and armor that make up inscription 2 in class 2—and artistic works. As class 2, inscription 10, and class 3, inscription 2, indicate, these included the sort of virtuosic life-castings made by Wenzel Jamnitzer in Nuremberg (fig. 3; see pl. 8). The foundry also housed the mint (important in an era in which each territory produced its own coinage) as well as an "alchemical forge" used in refining metals.

Fig. 3.
Wenzel Jamnitzer (German, 1507/08–85)
Silver writing box, ca. 1560–70, silver, 6 × 22.7 × 10.2 cm (2³⁄₈ × 9 × 4¼ in.)
Vienna, Kunsthistorisches Museum, KK 1155

Finally, Quiccheberg lists specialized storage facilities, which can house the materials from any of the inscriptions. He singles out for mention the print collection, a portrait gallery, a map room, tool rooms, a gallery for displaying animal trophies and paintings of animals, a music room, and vaults for tapestries, clothing, and costumes. The fact that these examples come from throughout the classes indicates that for Quiccheberg the inscriptions were not a strict installation plan.

Even the chapel is considered an appendage of the Kunstkammer, a place not just for liturgy and prayer but also for storing liturgical vessels and

vestments. Last but not least are the armories in which utilitarian arms and armor—those used in actual battle—are stored separately from those serving ceremonial purposes.

Most of the spaces named in this section required a specialized staff. Some, such as the scholar librarian, the physician, and the clergy, were learned men. Courts such as Munich also had highly skilled specialists in the arts, including composers and musicians in the chapel, and painters and illuminators associated with the picture galleries and library. Blacksmiths, goldsmiths, carpenters, cabinet makers, armorers, equerries, tailors, seamstresses, printers, gardeners, and cooks were all among the master craftspersons and staff who enabled the court to function. The *Inscriptiones* assigns these specialists, technicians, and artisans new roles as researchers, curators, conservators, and acquisitions managers, effectively constituting a professional museum staff.

The Recommendation and Advice

Following his discussion of display spaces, workshops, and storage facilities as adjuncts to the primary collection, Quiccheberg turns his attention back to the Kunstkammer itself. This is the most eclectic section of the treatise, including an introduction to and a justification of the digressions that follow,[79] a proclamation of the author's larger intellectual and career ambitions, and expressions of gratitude for the support he received from Albrecht V. Along the way, Quiccheberg provides comments on quite a wide range of topics.

In the course of explaining why he will expand upon certain of the inscriptions in the Digressions, Quiccheberg considers the feasibility of actually amassing all the objects he proposes and suggests that many cannot and should not attempt to do so. These elaborations on certain inscriptions are meant to encourage those whose financial means, intellectual interests, or personal ambitions limit them to collecting in only a single area. Diligent research and focused collecting should allow even "someone of meager fortune" to acquire a worthy collection.[80]

For those with the wealth and desire to collect at the largest scale—that is, princes and patricians—Quiccheberg points to his attempt to compile the "most complete and universal enumeration." Though no one person could ever collect everything, the mere enumeration of so many collectible objects has virtue, since it will allow people to "measure the magnitude of their knowledge of all things" and therefore "be stimulated to imagine and investigate" new things.[81]

Here we come to one of the most important insights that Quiccheberg provides us concerning the Kunst- and Wunderkammern of transalpine Europe. Although the phrase is anachronistic, it is not inappropriate to call Quiccheberg's *theatrum sapientiae* a research and development center.

Technological innovation and the fostering of new crafts and industries are of particular interest to him. All forms of research, however, whether applied or pure, can benefit from using such a collection: "For there is no discipline under the sun, no field of study, no practice, that might not most properly seek its instruments from these prescribed furnishings."[82] This universal utility helps account for the stress placed upon workshops, laboratories, and libraries as satellites of the main collection. The Kunstkammer is a display space, so these other facilities provide specialists in each field with a dedicated space housing their working equipment, raw materials, and final products.

Ever mindful of museological practicalities, Quiccheberg returns to the exigencies of storage and display, launching into a Rabelaisian list of kinds of furniture and containers. With these in hand, even the most avid and profligate collector need not hesitate to acquire as much as he wishes. While many of the containers mentioned will hold entire sets of the same sort of object—for example, instrument cases (digression on class 4, inscription 5), seed trays (digression on class 3, inscription 5), and the print cabinet (digression on class 5, inscription 3)—Quiccheberg is very explicit that his classes and inscriptions should not serve as categorical systems that restrict particular kinds of objects to particular places: "There is something else I would advise; namely, that among the inscriptions of the theater and the descriptions of the museums and closets, objects should, in accordance with their nature, be most broadly accessible by being most extensively distributed into these divisions."[83] This raises an important question as to whether Quiccheberg conceived of his classes and inscriptions more as a conceptual ordering than as an installation plan. His discussion of the use of the term *inscription,* at the beginning of the Digressions, does not clarify matters: "We use the term *inscription* . . . in case any king or prince or other patron should . . . have inscribed, in like fashion, collections of individual objects for specific places."[84]

Does he mean literally that some collectors placed written inscriptions on cabinets, cases, or rooms to identify the location of specific classes of objects? Or does he refer to some form of registrarial procedure that catalogs objects by type but does not delimit them by placement? As many inventories from the period indicate, including Johann Baptist Fickler's inventory of the Munich Kunstkammer, some objects were grouped by type, others by material, and still others in more open-ended systems.[85]

From housing myriads of objects, Quiccheberg turns to the acquisitions process. Significantly, he begins this discussion not with princes but with patricians like the Fuggers, who send out "clever men" to different and distant regions to find worthy objects. In actual practice, the Fuggers had offices throughout Europe and beyond, and it was their agents, or "factors," who were

responsible for acquiring both commodities and specialty items. The home office in Augsburg dispatched letters by courier to the Fuggers' factors requesting particular luxury objects for themselves or their clients, including Albrecht V.[86]

Continuing his discussion of acquisitions, Quiccheberg again takes into account the modest collector. Without agents to act on his or her behalf, and without the means to travel for the sake of acquisitions, this collector can fall back on social networks. By giving artifacts to acquaintances according to their interests, the collector can expect to receive equivalent gifts. To make the point about limited resources, Quiccheberg cites artists and artisans who assembled and displayed collections, naming the Augsburg painter Hans Burgkmair and other craftsmen as examples.

Concerning his plans for future publications on collecting, Quiccheberg offers some more specifics about his own research interests and methods. In addition to a greatly expanded version of the *Inscriptiones,* he plans "myriad books" that "will supply a specific enumeration of almost all subjects."[87] These include treatises on genealogies, portrait paintings, and the coats of arms of the nobility. Consistent with statements elsewhere in the *Inscriptiones,* the goal is to "encourage a great many kings, princes, and noblemen to establish theaters of wisdom, or repositories."[88]

To undertake research in these and other areas, Quiccheberg anticipated the need to travel extensively. Just as with scholarly research today, this required funding: "But all these things are in proportion to the modest measure of our ability and study, not beyond it; truly, we can be of service only to the extent allowed by our research and residencies at various museums and libraries and our frequent visits to markets and councils."[89]

Quiccheberg had already availed himself of the Wittelsbach collections at Munich and Landshut. He mentions first the ducal Kunstkammer, followed by the newly expanded library. Other Munich resources noted by Quiccheberg include a new music printing press, the storeroom for musical instruments, the Bavarian mint, and a woodturner's workshop patronized by Albrecht's father, Duke Wilhelm IV. In relation to Duchess Anna, Quiccheberg lists a medicinal laboratory and its associated pharmacy, a collection of documentary portraits of female relatives and young noblewomen who served at court, and a natural history collection and aviary "for which the duchess . . . was celebrated by investigators of natural objects."[90] This aviary is especially noteworthy as a rare mention of a *naturalia* collection under a woman's purview.

The Exemplars

Quiccheberg's penultimate section presents collectors, scholars, and princes as models to be emulated by the founder of the theater. His primary source for the

Exemplars was Hubertus Goltzius's *Vivae omnium fere imperatorum imagines* (The living portraits of almost all the emperors) (1557); thirty-nine of the names mentioned among the Exemplars, roughly one third of the total, are also found in Goltzius. The *Vivae* is concerned exclusively with the numismatics of antiquity, based on Goltzius's travels to inspect coin collections throughout the Low Countries and the Rhine Valley. Quiccheberg grants due scholarly respect for numismatics and for Goltzius's work, but the collection he envisions is vastly larger and more heterogeneous. Coins occupy just one inscription among fifty-two others.

At the start of the Exemplars, Quiccheberg writes that the collectors he has included focus their efforts on four broad areas: antiquities, especially coins; libraries; printed or other sorts of images; and full-blown Kunst- and Wunderkammern, with "objects from the whole world."[91] The names that follow, though, are organized as much by social status as collection type. He begins with the current emperor, Maximilian II, and his family, and then proceeds down the social scale: the seven electors of the empire; Albrecht V; other members of the high nobility and princes of the church; bishops; members of the minor nobility; and finally patricians, scholars, and craftsmen. Many of the names, especially those at the upper end of the social spectrum, constituted Quiccheberg's actual or potential patronage network, as exemplified by the dedication of the Vatican manuscript to Maximilian II. The social breadth of the names provided is significant, however. It indicates that at the onset of the princely Kunstkammer tradition, knowledge-based collections were understood to have emerged from diverse sources. Large-scale, encyclopedic collections first began with urban patricians such as the Fugger family, to be taken up later by the princes, but the efforts of more "modest" and specialized collectors had their place as well. Very little research to date has been done on sixteenth-century collecting among the minor nobility, scholars, and craftspeople, or "those of moderate prosperity."[92]

Collectively, the Exemplars give credence to the testimonial authority of the *Inscriptiones* in its entirety. They demonstrate that Quiccheberg knew nearly everyone in (and a good many people beyond) upper Germany who were connected to the development of Kunstkammern as institutional collections. His firsthand familiarity with the personalities and motivations of a variety of collectors, agents, and artisans certainly informed Quiccheberg's own interests in and understanding of this emergent phenomenon. Indeed, the remarkable diversity of Quiccheberg's informants—High Church clerics and schoolteachers, princes and goldsmiths, merchants and naturalists, librarians and military leaders—provided him with an equally broad range of perspectives on his subject.

Given that Quiccheberg was immersed in the writing and publication of the *Inscriptiones* from before October 1563, that he repeatedly refers to his earlier

travels as research for the treatise, and that both the book and manuscript versions hint strongly about his employability as a collections manager, it is more than reasonable to assume that Quiccheberg discussed with many of these people his own ideas about collecting. Which is all to say that despite Quiccheberg's apparent disappointment at his career—suggested by Gabriel Castner in the final lines of his elegy—he was squarely in the center of the intellectual, financial, and political worlds that engendered the Kunst- and Wunderkammern.

The range of activities that, according to Quiccheberg, should inspire future founders of Kunstkammern offer important insights into his conceptualization and contextualization of these *theatri sapientiae*. The sorts of material things collected—antiquities, ancient and modern coins and medals, sculptures, paintings, printed images, exotica, tools, musical instruments, and *naturalia*—accord well with the classes and inscriptions of his own theater. Within this narrative, though, Quiccheberg seamlessly weaves in practices that for him are equivalent to establishing object museums, even if for us today they would appear to separate or subordinate activities. Their parity derives precisely from the one justification for the Kunstkammer upon which Quiccheberg is most insistent: knowledge production.

Thus, the founding of libraries—the collecting of texts—parallels the collecting of things not in the accumulation itself but in the establishment of research facilities. Not only does Quiccheberg assign this role to the library at the beginning of the section titled Museums, Workshops, and Storerooms, but his ordering system for the library makes clear that it disciplinarily recapitulates and reorders the material collections. This is reinforced by his description of the print collection, also universal in scope, as itself a library. With the idea of supporting research in mind, it is a short step to move beyond collecting texts and objects altogether and consider the founding and sponsoring of entire institutions of learning—universities, seminaries, and gymnasiums—as analogous to founding a collection. All are *musea* in the classical sense.[93]

As Quiccheberg certainly argues for himself, the establishment of any sort of research facility, especially a Kunstkammer, is in itself a form of scholarship. In the same vein, period concepts of research and writing understood them to be forms of collecting: accumulation and compilation.[94] Thus, amassing a coin collection and writing or publishing books about coins equally enhance knowledge about the ancient world. Even history and other literature dealing with immaterial topics—including reference compendia such as proverb books (see class 5, inscription 9), books on genealogy (see class 5, inscription 7), Ramist diagrams (see class 5, inscription 4), military histories (see class 1, inscription 6), and various areas of natural history (see class 3)—can provide useful precedents for the person planning a Kunstkammer. Quiccheberg's own publications of biblical

apothegms, instructional charts for medicine, and a catechism of Christian doctrine are good examples.[95]

It is worth recalling that the collection's founder, as final cause, is its creator, even if he does not physically manufacture the things within it. Similarly, those who sponsor scholarship but do not write it themselves can be understood as sharing authorship. For the nobleman, establishing a Kunst- and Wunderkammer is an act of princely magnificence, an act of generosity that funds craftspeople and scholars. From Quiccheberg's perspective, proposing generous Maecenases as exemplars for the princely collector has an added advantage, given that he was dependent on such patronage.

Collectively, the complex web of relationships that emerges from the Exemplars and the treatise as a whole—families and dynasties, alliances and intermarriages, patronage systems, mercantile and gift exchange networks, scholarly interconnections—constitutes the social matrix that is absolutely necessary for the creation of institutions as vast as the princely Kunst- and Wunderkammern contemporaneous with Quiccheberg.[96] The authors of the paeans dedicated to Quiccheberg, with which the book ends, make up a more immediate social context for the author. These are the people, connected closely enough with him through the Munich court or his time at Ingolstadt University, upon whom he could call for validation even for a preliminary draft of the treatise.

Final Lines and Dedicatory Poems

Two centered and boldfaced lines announce the end of the Exemplars and the treatise as a whole, immediately preceded by what amounts to a second colophon. Nonetheless, there are five additional pages in the *Inscriptiones* that effectively serve as a conclusion to the book. These parting thoughts take the form of a few biblical verses selected by Quiccheberg and a set of dedicatory poems written in honor of the author and his book.

Quiccheberg—never one to overlook an opportunity to encourage great princes in collecting—uses three selections from 1 Kings and 2 Kings to demonstrate that wisdom, honor, peace, and prosperity will result from establishing Kunst- and Wunderkammern. The example of Solomon suggests that contemporary princes might become comparably wise and renowned through assembling a *theatrum sapientiae*. King Hezekiah, by opening his storehouses to the Babylonian king's emissaries, provides a model for using the Kunstkammer as an aspect of state diplomacy.

The capitalized phrase *SYMBOLUM LIBELLI* (symbol of a small book), which might have been inserted by either Quiccheberg or the publisher Adam Berg, is likely an instruction to the printer to add the printer's, or perhaps Quiccheberg's, device at that point. The fact that the device or emblem was not

printed suggests that the Berg edition of the treatise served as a hastily produced draft rather than a proper publication. The paragraph following *SYMBOLUM LIBELLI* provides confirmation: friends, scholars, printers, and poets are invited to send in tributes for the future edition, to be added to the few dedicatory poems and the names of the exemplars he already has. Quiccheberg envisions this as an ongoing project in which more and more eminent people contribute dedications to a series of editions, eventually leading to, as he immodestly phrases it, "the greatest work of historical exemplars of our time."[97] A collection in the making in its own right, the set of dedicatory verses supplements the preceding Exemplars in demonstrating just how interconnected Quiccheberg was within the political, ecclesiastical, and intellectual elite of his day.

Seven dedicatory poems honoring Quiccheberg fill out the short remainder of the treatise, all appropriately written in the elegiac meter (hexameter-pentameter couplets), which carries connotations of nobility and honor.[98] They collectively provide the only known period commentary on the *Inscriptiones*. Written by invitation, they are hardly objective and, brief as they are, contain little detail. Nonetheless, they give some sense of how Quiccheberg's contemporaries may have understood his work.

The Munich court physician Petrus Cortonaeus contributed two distichs in Greek. The first succinctly alludes to the twin functional poles of any collection or archive: to protect its holdings and provide access to them. Cortonaeus's second couplet addresses the notion of the collection as a microcosm, revealing the universe in its totality and all its particularities.

Erasmus Vend was the Munich court archivist and thus a direct counterpart to Quiccheberg. Both curators were clearly aware of where their career interests lay. Vend continues the theme of the microcosm but now in specific reference to Albrecht V's collections. The final line of his poem is especially intriguing, since it echoes an idea attributed to Giulio Camillo. In a 1532 letter from Viglius Zuichemus von Aytta to Erasmus, Camillo is quoted as describing his memory theater as *mentem . . . fenestratum* (a mind with windows), asserting that the visitor can both survey and know the cosmos from within the theater.[99] Vend's poem reverses the direction of the gaze by describing the Bavarian collections as "likenesses of [Albrecht V's] luminous mind."[100] The collections thus constitute a portrait or reflection of the duke's intellect and character.

Where Cortonaeus employs the metaphor of the world as a stage to propose Quiccheberg's collection as a microcosm—"draws open the curtain on the boundless universe"—and Vend speaks of Albrecht's collections as a mirror of the duke's wisdom, Jodocus Castner takes a different tack. The encyclopedic scope of Quiccheberg's vision of the theater allows its visitors to inspect "the globe in its entirety,"[101] doing away with the need for dangerous travel in the real world.

Moving from metaphor to activity, the imperial poet Vitus Jacobaeus selects as his theme the utility of the theater in promoting military preparedness, noting favorably Quiccheberg's recommendation that the nobility follow the example of Count Froben Christoph von Zimmern's passion for tournaments and military training in anticipation of war.

Gabriel Castner, schoolteacher and administrator in Munich, titles his poem as an "elegy," which appears to be a reference to its meter rather than to its tone or subject. Taking up the relationship of Quiccheberg's Exemplars to Hubertus Goltzius's 1557 *Vivae omnium fere imperatorum imagines,* Castner introduces the theme of emulation, a competitive form of imitation in which an author strives to outdo his model. By far the longest poem, the point he makes is quite straightforward. Goltzius, admirable as he was, visited only numismatic collections, "that unvariegated kind," while Quiccheberg takes on the much vaster and more ambitious task of envisioning an encyclopedic collection. Castner understands the 1565 *Inscriptiones* as a draft, and one a long time in coming, by referring to the renown to come "when you publish the book you have long been arranging."[102]

By comparing Quiccheberg with his colleague Aegidius Oertel, the first director of the Bavarian ducal library, Joachim Haberstock follows a variation on Gabriel Castner's emulative theme. Oertel is highly deserving of fame for his tremendous labor in compiling the library. Quiccheberg, however, who sets his sights on collecting and ordering the cosmos in its encyclopedic heterogeneity, assumes a still greater task that will merit yet greater renown. Haberstock confirms Quiccheberg's self-perception as the champion of a new kind of princely collection oriented toward knowledge production, referring to these collections as "new temples to the Muses."[103] Haberstock's closing lines are charmingly hyperbolic: since Quiccheberg's *theatrum amplissimi* reaches the utmost limit of human understanding, only death can result from encountering anything that offers still more knowledge.

Valuing Quiccheberg

Quiccheberg repeatedly stresses the novelty of his *theatrum sapientiae,* a sentiment echoed by Haberstock, specifically because of its content's endless utility. Quiccheberg was quite correct about how innovative both his book and the collection he proposed were. The certain fame that Gabriel Castner predicted for him, however, never came. Quiccheberg died impoverished and dependent on Duke Albrecht's charity before he could take the project any further. Considered purely in terms of the demonstrable impact his treatise had, he died a failure. As noted at the outset of this introduction, we have no explicit documentary evidence to confirm that any collection of the period, including

Albrecht's, was based directly upon Quiccheberg's prescriptions. Other than the set of poems within the book, Heinrich Pantaleon is the only contemporaneous author to write at any length about Quiccheberg. Pantaleon's sole reference to the *Inscriptiones* is the single clause noting that Quiccheberg "presented a short theater in which the entirety of philosophy was contained."[104]

Instead, the *Inscriptiones* is of historical and museological value in providing us with a consummate insider's account of the foundation of the museum as an institution. Though it would be easy to see him as the personification of the dilettante, Quiccheberg was in fact extraordinarily well qualified to report on the myriad scientific and cultural strands that were then being woven into the fabric of the Kunst- and Wunderkammer tradition. He bore witness to (and to a limited degree participated in) the birth of taxonomic botany and other natural sciences; to profound technological innovations; and to the political centralization of German and European states. We can see the enormous, multifaceted museum that Quiccheberg proposed, as well as the actual Wunderkammern that were formed, as one form of response to the explosion of informational bandwidth in the form of texts, images, and objects that he, along with the rest of sixteenth-century educated Europe, experienced.

Quiccheberg worked as a professional librarian and curator for the Augsburg merchant family who was instrumental in establishing the Kunst- and Wunderkammer as a site of knowledge production, as well as for one of the first princes to create such a collection as a state institution. Like many other scholars in the period, he moved fluidly from the world of the university to those of the courts, diplomats, merchants, dealers, and craftsmen. He was by avocation a naturalist, a numismatist, and a genealogist and by vocation a physician. During his brief career, Quiccheberg studied with theologians, physicians, philosophers, linguists, and humanists, and he collaborated with botanists, musicians, artists, printers, and historians. As a result, Quiccheberg was intellectually capable of presenting a clear rationale for the utility of a combined museum of art, nature, technology, ethnology, and history and had the practical experience to construct a definite method for how to do so.

Notes

1. Quiccheberg 1565b, 15r: "Hactemis absoluta haec enumeratio Monachii Anno M.D.LXIII Mense octobri et aliquo modo recognita ibidem Anno M.D.LXV Mense Aprili." Translation by Mark A. Meadow and Bruce Robertson. Unless otherwise indicated, all translations are ours.
2. Quiccheberg 1565b, 40r: "Finis totius theatric Sam. Quicchebergi quomodo absoluit Anno M.D.LXV IIII monas Maji ex nova arte urbis Monachiensis, quae est archipolis Bavariae superioris."

3. See, for example, Quiccheberg 2000; Brakensiek 2008; and Bredekamp 1982.

4. On the use of the term *theater* in book titles, see Blair 1997, 153–79; and Friedrich 2004.

5. The idea of Quiccheberg's treatise making the case for his continued employment was first suggested to me in a conversation with Dirk Jansen. For a general discussion on the unfinished nature of the treatise, see Jansen 1993.

6. This volume, page 78.

7. This is by no means to suggest that substantial, heterogeneous, and even humanistic princely collections did not predate Quiccheberg—the collections of Margaret of Austria are an excellent example—but these were not yet focused upon the kind of pragmatic, technical knowledge that distinguishes Quiccheberg's *theatrum amplissimi,* and the Wunderkammer tradition in general, from its predecessors. For Margaret of Austria's collections, see Eichberger 2002.

8. From the "Denkschrift (B) der über den Staat verordneten Räte vom Sommer 1557," transcribed in Riezler 1895, 126: "Ja S.F.G. sollten es auch der reth erachtens den burgeren und kaufleutten in stetten mit vilerlai frembder köstlichait nit geren nachtun wellen, dieweil sy, die kaufleut, die grossen potentaten, chur- und fursten dahin laider gepracht, das sy inen iren pracht und uberfluß von wegen ires ubelhausens und uberfluß wol bezalen und aushalten muessen." My translation, with the assistance of Katharina Pilaski.

9. Lanzinner 1980, 55n136. Albrecht's reply is transcribed in Busley 1965, 209–35. The text of the letter is transcribed in Busley 1965, 233–35.

10. Meadow 2002, 182–200.

11. Riezler 1895.

12. This volume, page 74.

13. *Gründungsurkunde Herzog Albrechts V. von Bayern,* 19 March 1565, 5/2, nr. 1253, Geheimes Hausarchiv im Hauptstaatsarchiv München. Transcribed in Thoma and Brunner 1970, 7–18.

14. This volume, pages 73–74.

15. Cicero 1942, 17 (1.6).

16. Pantaleon 1570, 506 (erroneously paginated 560). For English translation, see this volume, pages 56–57.

17. Quiccheberg's family name appears in many variants, as was not uncommon at the time, including Quicchelberg, Quickelberg, Quickelberger, Quickelbergius, and Quiquelberg. Much of the older literature on Samuel Quiccheberg uses the version "Quicchelberg." I have chosen to adopt the spelling the author himself used in the treatise under discussion but have left his father's name as spelled in Pantaleon.

18. Pantaleon 1570, 506: "Samuel is zu Antorff von Jacob Quickelberger im 1529 erboren, und härnach zu Gendt aufferzogen, da er auch die fundament der geschrifft erlernet." See this volume, pages 56–57.

19. Pantaleon 1570, 506: "Wie er zehen jar alt worden, kame er gehn Nürenberg, übet sich in freyen kunsten, und fienge an die Kreuter, Metallen, un andere edle gestein mit sampt iren natürlichen wiirckungen ze erkundigen, darzu mancherley Historien zu durch lessen." See this volume, pages 56–57.

20. Wackernagel 1956, 58: "1548–49, 37. Samuel Quickelbergius Antverpensis–6 ß."

21. For Coccius, see Quiccheberg 2000, 4; *Historisch–Biographisches Lexicon der Schweiz* 1921–34, 598; and Wackernagel 1956, 29.

22. Pilaski 2007, esp. 129–93.

23. For Pantaleon, see his comparatively extensive autobiography in Pantaleon 1570, 529–34; Buscher 1946; and Buscher 1947.

24. This volume, page 56.

25. The inscription on the recto of the medallion reads *SAM: QVICCHELBERGVS. BELGA. ÆTAT. SVÆ. XXXIII;* and on the verso *FLORVIT INGOLSTADII MEDICVS BAVARIÆ DVCIS SYMB. INTACTA VIRTVS.* See Hartig 1933a, 671. The motto is also mentioned in another early biography of Quiccheberg; see Sweertius 1628, 683: "Samuel Quickelbergius Antuerpiensis . . . Huic Symbolum: INTACTA VIRTVS." The complete medal is described in Broeckx 1862; and Kluyskens 1859, 332–34.

26. This volume, page 56. According to the *Biographie nationale* (1905, vol. 18, col. 499), Quiccheberg "compléta ensuite son instruction médicale à Fribourg."

27. This volume, page 56. See also Roth's note in Quiccheberg 2000, 5: "Durch den Handelsherrn und Reichsgrafen Anton Fugger (1493–1560) bekam Quiccheberg finanzielle Unterstützung. *Samuel Quinkelbergiensis* folgt *Anton Fugger,* dem summe von 48 Florin gezahlt wird: *Jacobus Fuggerus generosi domini Antonii Fuggeri domini Kirchperg et Weissenhorn filius impuber, 2 fl. 30.*" Roth here cites Pölnitz 1937, 662.

28. This volume, page 56. For the matriculation record, see Pölnitz 1937, 662: "Iunii 1. Iacobus Fuggerus generosi domini Antonii Fuggeri domini in Kirchperg et Weissenhorn filius impuber. 2 fl. 30. 1. Samuel Quinckelberginus Antverpiensis 48 ß." See also the biography of Quiccheberg in *NDB* 1953–2010, 21:44: "und wechselte 1550 nach Ingolstadt, wo er zugleich als Präzeptor Jakob Fuggers (1542–98) fungierte."

29. This volume, page 56.

30. Mentioned in Sweertius 1628, 671; and Andreas 1643, 806.

31. Mentioned in Kobolt 1795, 532; Quiccheberg 2000, 10n77; and Falguières 1992, 175n22.

32. This volume, page 69.

33. Öllinger and Quiccheberg 1553, 541, 543, 154. See Lutze and Retzlaff 1949; and McCue 1952, 289–348.

34. Fugger Archive, 1, 2, 1, cited in Lieb 1958, 472: "drei Jahre lang Herrn Anthonien Fugger zu dienen, auf Dero Leib zu warten und zu arzneien." According to Roth, the Fugger archivist Franz Karg reported these records lost (Roth, in Quiccheberg 2000, 6).

35. *NDB* 1953–2010, 21:44: "die er zwei Jahre später wieder aufgab, da ihm von Johann Jakob Fugger (1516–75) die Betreuung seiner Bibliothek und seiner weiteren Sammlungen übertragen wurde."

36. See Lehmann 1956, 57.

37. Cited in Kellenbenz 1980, 76–88; and Rohmann 2004a, 183: "[Raymund Fugger war] der Antiquiteten und Medeyen sehr begierlich, Ja aller vorgemeleter gutwissendeer sachen ein gantz fleissiger erfrager unnd begaber aller guten Künsten, wie dann sein fleis in seiner verlasenen Kunstkamer wohl gespurt,

gesehen, und Jedem sehenden verwunderliche zeugknus von sich gibet."

38. Bursian 1874; Kellenbenz 1980, 78; and Busch 1973, 85. Both Kellenbenz and Busch raise the possibility that some of Fugger's antiquities may have been copies or fakes.

39. Katritzky 1996, 148–49.

40. Fugger [and Jäger] 1545; Rohmann 2004a; Rohmann 2004b; and Maasen 1922, 69–70.

41. Fugger [and Jäger] 1555; Maasen 1922, 59–69.

42. This volume, page 56.

43. This volume, page 75.

44. This volume, pages 81–82.

45. This volume, page 88.

46. This volume, page 76.

47. This volume, page 106.

48. See Owens 1979.

49. Owens 1979, 115–33.

50. Owens 1979, 116–17. Cf. Quiccheberg's commentary on de Rore (Quiccheberg 1564, 4v) to his *Inscriptiones* (this volume, page 66).

51. Though beyond the scope of this edition, Quiccheberg's de Rore and di Lasso commentaries are among the most sustained discussions of individual artworks produced in sixteenth-century transalpine Europe.

52. Lasso 1565 and Quiccheberg 1565a.

53. Hartig 1917, 304: "f. 284r Samueln Quickhelperger aus gnaden 100 fl."

54. Hartig 1917, 305: "f. 351v Unchossten wegen Besinckhnus Doctor Quickhlpergers 16 fl. 2 gr. 10pf."

55. The pairing of the terms *inscriptions* and *titles* is a pleonasm, a very common literary figure in early modern writing that serves to emphasize and clarify a term. Quiccheberg uses the same device in the Recommendation and Advice. In both cases, the two terms are understood as synonyms.

56. In the Vatican manuscript, the Digressions are moved to the end of the text.

57. See Kaufmann 1978, 22–28.

58. Pilaski 2007.

59. Aristotelian causality explains why things are created or change. Aristotle describes four causes: material, formal, efficient, and final. Of importance here are the last two. Final cause is the purpose for which a thing exists, while the efficient cause is the means by which that thing is created. Since the cosmos exists for the sake of God, and the microcosm (the collection) exists for the sake of the ruler, both can be understood as analogous final causes. See Todd 1976.

60. Simultaneously, the deity and the ruler are efficient causes, whose actions result in the cosmos and the microcosm coming into being.

61. Located at the Bayerisches Nationalmuseum, Inv. no. Mod 1–4.

62. This volume, page 63.

63. This volume, page 64.

64. For example, Shelton 1994, 184; and Turpin 2006, 65–66. See also Meadow 2005 for a counterargument.

65. This volume, page 84.

66. This volume, page 84.
67. This volume, page 80.
68. Arnold 1992, 42–86.
69. This volume, page 81.
70. This volume, page 81.
71. This volume, page 65.
72. This volume, page 81.
73. This volume, page 67.
74. This volume, page 68.
75. Menzhausen 1985, 72.
76. This volume, page 69.
77. This volume, page 91.
78. Schloss Ambras, Ms. Inv. Nr. PA 1474.
79. The digressions are discussed above with the inscriptions.
80. This volume, page 74.
81. This volume, page 74.
82. This volume, page 74.
83. This volume, page 75.
84. This volume, page 77.
85. Fickler 1598.
86. Karnehm, Preysing, and Munch 2003; for a few examples, see vol. 1, 196–97, 203, 257, 265, and 505. See also Meadow 2002.
87. This volume, page 75.
88. This volume, page 76.
89. This volume, page 76.
90. This volume, page 77.
91. This volume, page 92.
92. This volume, page 75.
93. Findlen 1989, 59–63.
94. Ong 1976.
95. Quiccheberg 1565a; Quiccheberg 1571a; Quiccheberg 1571b; and Quiccheberg 1591.
96. Meadow 2002.
97. This volume, page 105.
98. My thanks to translation editor Daniel Dooley for the information concerning the elegiac meter. Private communication, 2 August 2010.
99. For Vigilius Zuichemus von Aytta's letter to Erasmus, see Erasmus 1946, 29. The relevant passage is also translated in Yates 1966, 131–32.
100. This volume, page 105.
101. This volume, page 106.
102. This volume, page 106.
103. This volume, page 107.
104. This volume, page 56.

PLATES

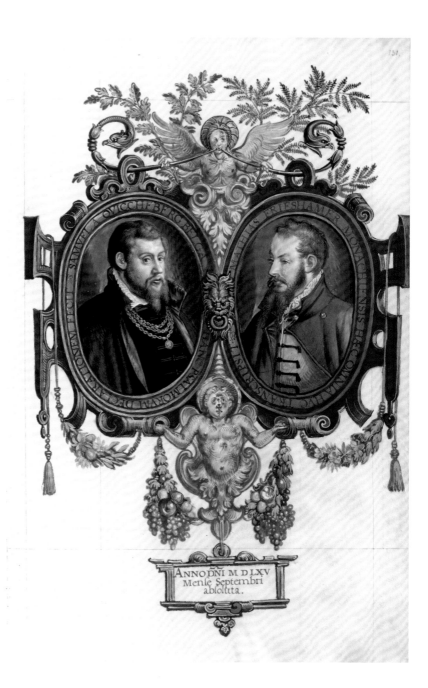

Pl. 1.
Hans Mielich (German, 1516–73)
Portrait of Samuel A. Quiccheberg (at left)
From Samuel Quiccheberg, *Declaratio psalmorum poenitentialium et duorum psalmorum laudate compositionis excellentissimi musici Orlandi de Lassus,* 1565, Mus.ms. AI (Erläuterungsbd), f. 131r
Munich, Bayerische Staatsbibliothek

Pl. 2.
**Albrecht Altdorfer (German,
ca. 1480–1538)**
A Habsburg genealogy
From Joseph Grünpeck, *Historia Frederici III et Maximiliani I,*
1500–15, HS B 9, fol. 6r
Vienna, Haus-, Hof-, und
Staatsarchiv

Pl. 3.
Hans Mielich (German, 1516–73)
Duke Albrecht V of Bavaria and Anna of Austria Playing Chess
From *Kleinodienbuch der Herzogin Anna von Bayern,* 1552, Cod.icon. 429, f. 1v
Munich, Bayerische Staatsbibliothek

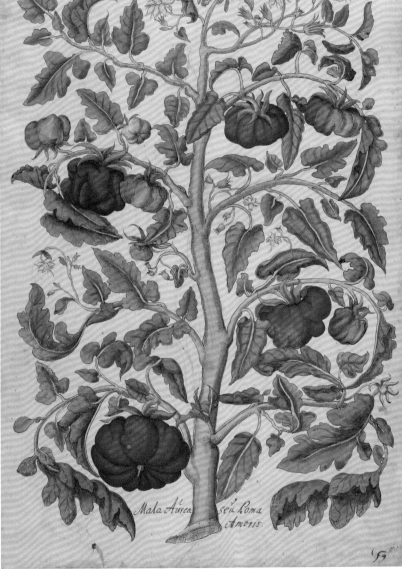

Pl. 4.
Mala Aurea seu Poma Amoris
(Golden apple or apple of love)
From Georg Öllinger and
Samuel Quiccheberg, *Magnarum
medicinae partium herabariae et
zoographicae imagines,* 1563,
Erlangen, Universitätsbibliothek,
Ms. 2362, p. 541

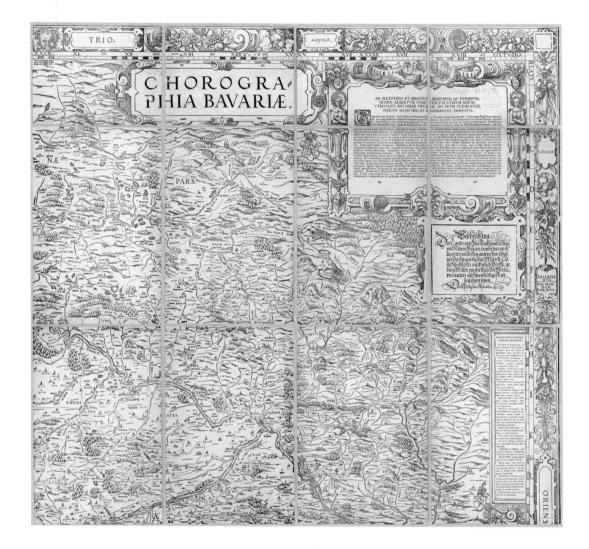

Pl. 5.
Philipp Apian (German,
1531–89)
Chorographia Bavariae (detail),
1568, woodcut on paper,
156 × 159 cm (61³⁄₈ × 63 in.)
Munich, Bayerische Staatsbib-
liothek, Mapp.XI,25 a

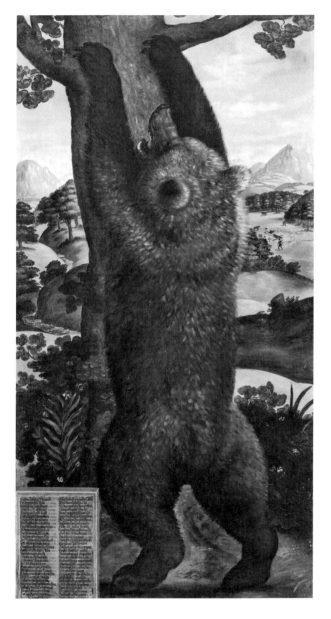

Pl. 6.
**Bear Hunt of Archduke
Ferdinand**
ca. 1550s–1600, oil on can-
vas, 225 × 141 cm (88⅝ ×
55½ in.)
Vienna, Kunsthistorisches
Museum, GG 5741

Pl. 7.
**Clement Kicklinger (German,
1561–1617)**
Ostrich egg goblet, ca. 1570–
75, ostrich egg, coral, silver
plated, partially painted,
H: 56.8 cm (22⅜ in.)
Vienna, Kunsthistorisches
Museum, KK 897

Pl. 8.
Wenzel Jamnitzer (German, 1507/08–85)
Lifecasts of four plants, ca. 1540–50, silver, H (left to right): 5.5, 4.2, 5.8, 6.5 cm (2⅛, 1⅝, 2¼, 2½ in.) Nürnberg, Germanisches Nationalmuseum, HG 11138

Pl. 9.
Attributed to Bernard Palissy (French, 1510?–90)
Oval basin with snakes, lizards, and shellfish, ca. 1550, lead-glazed earthenware, 47.9 × 36.8 cm (18⅞ × 14½ in.) Los Angeles, The J. Paul Getty Museum, 88.DE.63

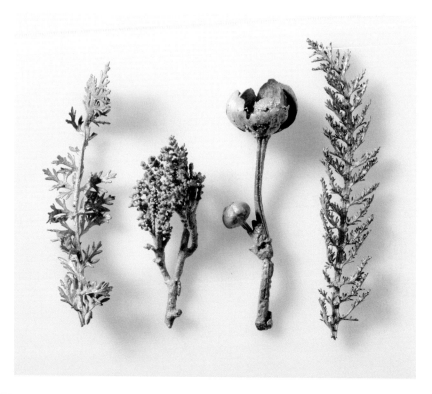

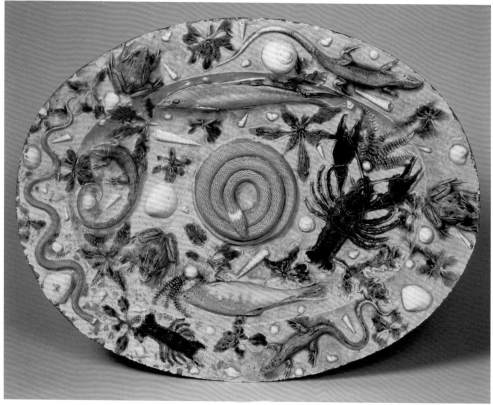

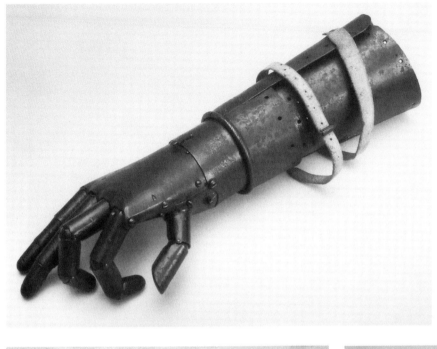

Pl. 10.
**The iron hand of the Knight
Götz von Berlichingen**
ca. 1505–12, iron, 35 ×
12 cm (13¾ × 4¾ in.)
Jagsthausen, Germany, Frei-
herrlich von Berlichingen'sches
Archiv

Pl. 11.
Viola da Gamba Consort
From Michael Praetorius,
*Theatrum instrumentorum seu
sciagraphia . . . und Abcon-
terfeyung Michael Praetorius*
(Wolffenbüttel, 1620), pl. 20
London, The British Library

Pl. 12.
**Christoph Schissler (German,
ca. 1531–1608)**
Armillary sphere, 1569, brass,
bronze, silver, gold-plated,
34 × 19 × 19 cm (13³⁄₈ ×
7½ × 7½ in.)
Munich, Bayerisches National-
museum, L Phys 27

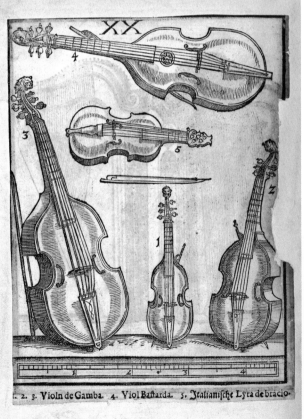

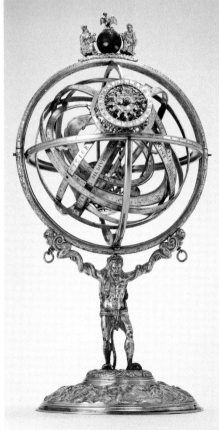

Pl. 13.
**Hans Hoffmann (German,
ca. 1530–91/92)**
A Hare in the Forest, ca. 1585,
oil on panel, Unframed (with
radius of panel, right side):
62.2 × 78.4 cm (24½ ×
30⅞ in.), Unframed (without
radius of panel, right side):
61.9 × 78.4 cm (24⅜ ×
30⅞ in.), Framed: 80.6 ×
96.5 × 9.5 cm (31¾ × 38 ×
3¾ in.)
Los Angeles, The J. Paul Getty
Museum, 2001.12

Pl. 14.
**Japanese armor, Iroiro-Odoshi
Gusoku**
late 1500s–early 1600s, iron,
brass, copper, leather, vinyl,
textile knotting, H: 100 cm
(39⅜ in.), B: 63 cm (24¾ in.),
T: 44 cm (17⅜ in.)
Vienna, Kunsthistorisches
Museum, AM_PA_587

Pl. 15.
Feather headdress
Aztec, ca. 1520, feathers, gold applications, fiber, pipe shavings, leather, color, 175 × 116 cm (68⅞ × 45⅝ in.) Vienna, Museum für Völkerkunde, MVK VO_10402

Pl. 16.
Ramist medical chart
From Jacques Dubois, *Methodus sex librorum Galeni in differentiis et causis morborum & symptomatum . . . per Jacobum Sylvium . . .* (Venetiis: Ex Officina Erasmiana Vincentii Valgrisii, 1554), p. 1 Berkeley, Bancroft Library, University of California, Berkeley, R128.6.D82 M3 1554

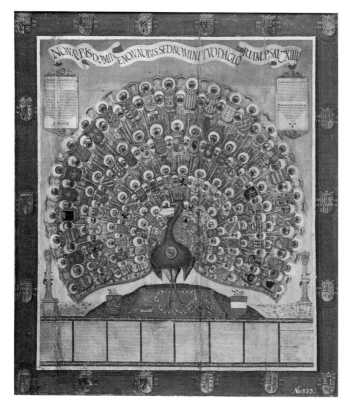

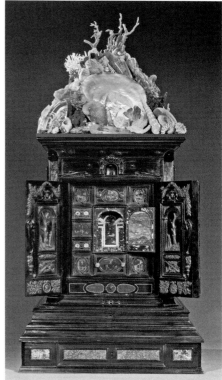

Pl. 17.
Clemens Jäger (German,
ca. 1500–61)
Habsburg peacock, 1550,
watercolor on vellum, 79.8 ×
70 cm (31³/₈ × 27½ in.)
Vienna, Kunsthistorisches
Museum, KK 4975

Pl. 18.
Display cabinet with
assemblage
Display cabinet: German
(Augsburg), ca. 1630,
ebony and other tropical and
European woods, porphyry,
gemstones, marble, pewter,
ivory, bone, tortoiseshell,
enamel, mirror glass, brass,
and painted stone, three wood
carvings by Albert Jansz.
Vinckenbrink (Dutch, ca.
1604–64/65), 73 ×
57.9 × 59.1 cm (28¾ ×
22¹³/₁₆ × 23¼ in.)
Los Angeles, The J. Paul
Getty Museum, 89.DA.28
Assemblage: Sumiya Swoboda-
Nichols (American, b. 1966),
2000, minerals, shells, coral,
pearls, and other natural speci-
mens on a square black Plexi-
glas base, 43.2 × 47.5 ×
48 cm (17 × 18¾ × 18⁷/₈ in.)
Beverly Hills, Edward Swoboda
Collection

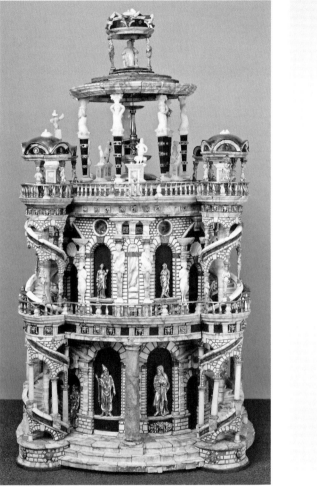

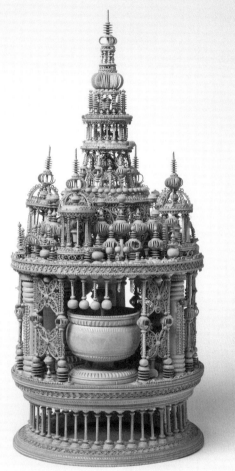

Pl. 19.
Display cabinet
late 1500s, alabaster, marble,
wood, silver, bronze, semi-
precious stone, H: 65 cm
(25⅝ in.), Diam.: 50 cm
(19¾ in.)
Vienna, Kunsthistorisches
Museum, PA 904

Pl. 20.
Writing instrument container
ca. 1550–1600, wood,
H: 44 cm (17⅜ in.),
Diam.: 21 cm (8¼ in.)
Vienna, Kunsthistorisches
Museum, PA 779

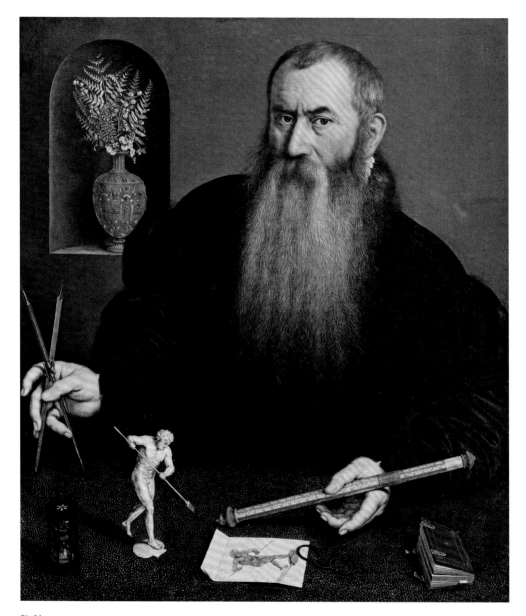

Pl. 21.
Nicolas Neufchâtel
(Netherlandish, active ca.
1539–73)
Portrait of the Goldsmith
Wenzel Jamnitzer, ca. 1562–63,
oil on canvas, 92.5 × 80 cm
(36⅜ × 31½ in.)
Geneva, Musée d'art et
d'histoire, 1825-0023

Pl. 22.
Bernhard Zwitzel (German, 1496–1570), architect
Courtyard of the Old Mint, formerly "Herzoglicher Marstall und Kunst-und Wunderkammer," Munich
Munich, Bayerisches Landesamt fuer Denkmalpflege

BIOGRAPHY OF SAMUEL QUICCHEBERG
Samuel Quickelberg Philosophus

Samuel was born in Antwerp in the year 1529 to Jacob Quickelberger, and later moved to Ghent where he learned the fundamentals of writing. When Samuel was ten years old, he went to Nuremberg to study in the liberal arts. He began to inquire about plants, metals, and other precious stones (together with their natural effects), and he read through various histories. For similar reasons, he came to Bavaria and in the eighteenth year of his life went to the University of Basel and heard about these topics from the general professors Ulrich Coccius and Hieronymus Wolf. Thus Samuel had philosophy revealed to him somewhat exceptionally on a daily basis; it was at Basel that through his good nature and chaste way of life he became known to me. Next, Samuel moved to Freiburg and soon afterward to Augsburg, where Emperor Charles V held a great *Reichstag* in 1548. At this time, the Fuggers showed Samuel their generosity and, in the year 1550, he again moved to Bavaria to further his studies. When he was in Ingolstadt, he read several times for the professors and thereby became known to the learned as the most excellent in Bavaria. His career began when he expanded the Fugger library and gained a great appreciation of the ancient antiquities and sculptures.

When Samuel came to the court of Duke Albrecht, he had planned to account for the German nobility, discover the origins of the old families, and represent the heraldic arms. Doing this was made so much easier for him because the prince often led him through the princely collections where Samuel could diligently inquire into all things. His research continued when he was first in Prague at the time that Maximilian was crowned and afterward in Frankfurt in 1562, when Maximilian was chosen as king of the Romans. Samuel was present when the Council of Trent was assembled, and he desired to make the acquaintance of many lords. In the same manner, in the year 1563 he traveled to Rome and visited almost the entirety of Italy, whereby he gathered together many antiquities. When Samuel again returned home, he compiled the biblical apothegms and strategies, ordered them for printing, and thereto presented a short theater in which the entirety of philosophy was contained. When I came to Munich in 1565 during my return trip, he received me in all friendliness and, in the duke's castle, showed me his studio and many antiquities. Because my

book on excellent Germans also pleased him, he described all the notables of Bavaria and afterward sent them in an orderly manner to Basel. After having experienced so much and having understood many things well enough to describe them, he died in the year 1567 and was honorably buried. Anon.

Note

Translation of "[Anonymous. Samuel Quickelberg Philosophus]," in Pantaleon 1570, 506 [typographical error in original as 560]. Translated by Mark A. Meadow.

PREFACE
Dedicated to Emperor Maximilian II

Whenever something good and useful appears, it is proper to offer it to whoever is most inclined to it and who is certain to be its great protector. I thought this to be the case with this theater (or advice toward the foundation of the theater) that my brother had written.

My brother entrusted me with this, since he planned to travel during this time. Before he left I asked him for these *Inscriptiones,* which were written at length and recently ornamented with several appendixes. He gave them to me, at my discretion, to let Your Majesty's friends privately print several copies or to offer Your Majesty some part thereof.

Thus I thought such to be proper, since my brother's prince, Duke Albrecht of Bavaria, gives Your Majesty the prize in such matters. This is also well known to me through [Jacopo] Strada, who most diligently assists Your Majesty therein.

If only Your Majesty would read and enjoy himself with this book for a short time, it will not leave you annoyed. Because I know of no king, no prince, no potentate who cannot find something that will amuse him and show what, from founding a theater of this sort, might be gained for Your Majesty's prudence[1] from such a *Kunstwunderkammer.*[2]

I am also hopeful that these *Inscriptiones* (with various sponsoring patrons) in which all enumerations should be compiled, should bring Your Majesty into multiple glory and praise, just as the *Iulius Caesar* of Hubertus Goltzius did bring to your father, Emperor Ferdinand.

At Your Majesty's command.

In Padua.

Notes
This letter is from the unpublished Vatican manuscript version of Samuel Quiccheberg's *Inscriptiones* (Quiccheberg 1565b), not the printed text (Quiccheberg 1565c). Translation by Mark A. Meadow.

1. Prudence is one of the primary virtues necessary for a wise ruler: the ability to make proper decisions for the future based on appropriate knowledge.

2. The compound noun *Kunstwunderkammer* is unique to this preface. What it implies is a combined collection of artifice and nature, of exactly the sort that Samuel Quiccheberg proposes in his treatise. See this volume, pages 99–100 for Quiccheberg's discussion of this terminology.

INSCRIPTIONES
VEL TITVLI

THEATRI

AMPLISSIMI, COMPLECTENTIS
rerum vniuerſitatis ſingulas materias et
imagines eximias. ut idem recte quoq; dici poſſit:

Promptuarium artificioſarum miraculoſarumq; rerum, ac omnis
rari theſauri et pretioſæ ſupellectilis, ſtructuræ atq; picturæ.
quæ hic ſimul in theatro conquiri conſuluntur, ut eorum
frequenti inſpectione tractationéq;, ſingularis aliqua
rerum cognitio et prudentia admiranda,
citò, facilè ac tutò comparari
poſsit. autore Samuele à

QVICCHEBERG BELGA.

MONACHII
Ex Officina Adami Berg typographi.
Anno M.D.LXV.
Cum gratia et priuilegio Cæſarco.

INSCRIPTIONES
OR TITLES

OF THE MOST AMPLE

THEATER

That Houses Exemplary Objects and Exceptional Images of the
Entire World, So That One Could Also Rightly Call It a:

Repository of artificial and marvelous things, and of every rare treasure,
precious object, construction, and picture. It is recommended that these
things be brought together here in the theater so that by their frequent
viewing and handling one might quickly, easily, and confidently be able
to acquire a unique knowledge and admirable understanding of things.
Authored by Samuel

QUICCHEBERG FROM THE LOW COUNTRIES

MUNICH

From the workshop of the printer Adam Berg
In the year 1565

By the grace and privilege of the Emperor

☿ This sign of Mercury, to whom the office of interpreter has been assigned, is used to designate those brief inscriptions for which there are explanations or digressions in the second part of the commentary. Why the inscriptions themselves are so abbreviated is indicated partly at the beginning and partly at the end of the digressions. [A1v]

The Theater of Quiccheberg

First Class

INSCRIPTION 1 ☿

Panels of sacred history, both painted and sculpted, or produced by some other craft. These, since they are derived from biblical and other Christian histories, are placed in the first position in the sacred treasury; and so, on account of a certain consummate artifice, are venerated to the highest degree.

INSCRIPTION 2 ☿[1]

The genealogy of the theater's founder (pl. 2), which contains an enumeration, in definite order, of his entire lineage and his more immediate relations by marriage. In support of this primary genealogy there are also additional family trees specific to the more important of these relations and to relations on the distaff side who have been granted a place of honor by the founder.

INSCRIPTION 3

Portraits of the theater's founder (pl. 3), at various ages; and also of his parents, kinsmen, and of his former predecessors in office, however many as were preeminent in his family or earlier governments, at least those whose portraits could be obtained, either in bust length or in full figure. [A2r]

INSCRIPTION 4 ☿

Geographic charts, which are commonly called maps, general and specific, marine and chorographic, and others.[2] Also, most importantly, a chart of the region or territory of the theater's founder himself, one beyond the common lot in that it is more detailed, more sumptuous, and on a larger scale (pl. 5).

INSCRIPTION 5

Depictions of cities in Europe, the [Holy Roman] Empire, Italy, France, Spain, and other lands, both Christian and those cities that are distinguished in regions outside the Christian world. Likewise, the chief cities of the theater's founder, or others more famous than the rest, or finally those cities or even native towns that the lord has wished to honor (see Introduction fig. 1).

INSCRIPTION 6

Military expeditions, wars, sieges, battle formations, naval battles, or other cele-
brated battles: those seen or undertaken both in our own times and in earlier
times. Those, at any rate, that bring glory to our people or that, owing to their
value in relation to certain diverse successes and to the practical knowledge
of things they provide, ought with good reason to be placed before the eyes of
Christians. [A2v]

INSCRIPTION 7

Spectacles, triumphs, festivities, games, and other events of this sort that can in
any way be represented by some sort of image, such as equestrian contests, royal
investitures,³ and other rituals, old and new. Likewise, gladiatorial, naval, and
archery contests and games.

INSCRIPTION 8 ☿

Grand paintings of animals that are more rarely depicted, such as deer, boars,
lions, bears, beavers, and fish (both fresh- and seawater varieties); and any
memorable animals that the founder's native region fosters beyond common
practice, or else those it happens to lack, so that a painting might be prized for
its rarity of subject (pl. 6).

INSCRIPTION 9

Architectural models created by the craftsman's art, for example of houses, for-
tresses, temples, cities, military camps, and fortifications; models made from
sticks, paper, quills, and perhaps decorated with paint (see Introduction fig.
1). Likewise, ships, carriages, staircases, fountains, arches, bridges, and other
constructions executed on a small scale. [A3r]

INSCRIPTION 10

Tiny models of machines, such as those for drawing water, or cutting wood into
boards, or grinding grain, driving piles, propelling boats, stopping floods, and
the like. On the basis of these models of little machines and constructions, other
larger ones can be properly built and, subsequently, better ones invented. [A3v]

Second Class

INSCRIPTION 1

Ancient and modern statues in stone of emperors, kings, eminent men, gods,
divinities, and sometimes animals. Some made out of wood and clay, others out
of marble, bronze, or any other substance. Likewise, fragments of heads, hands,
legs, and torsos.

INSCRIPTION 2 ☿[4]

Handiwork of artisans, made from any sort of metal (see Introduction fig. 3; pls. 8, 10, 12). For example, the work of goldsmiths, braziers, clock makers, swordsmiths, and other outstanding artisans who, through the art of sculpting or founding, produce some artifact from any kind of ingot or sheet of metal.

INSCRIPTION 3 ☿[5]

Artisanal works of every kind, made from wood, stone, gems, glass, woven fabrics, and other materials of the most diverse kinds (pl. 7). Items produced by the art of turners (see pl. 20), plasterers, fine sculptors, glassblowers, embroiderers, weavers, and those who create other artifacts of this sort besides those listed above. [A4r]

INSCRIPTION 4

Ingenious objects worthy of admiration either owing to their rarity or to the distance of space or time from their point of origin (pls. 7, 14, 15). These are primarily tiny and rather elegant, in fact, unless something larger might also on occasion be able to lead us to an understanding of foreign customs and craftsmanship.

INSCRIPTION 5 ☿

Foreign vessels, made of metal, earthenware, sculpted, wooden, and differing widely in shape; some excavated from ancient ruins, some brought from afar or merely less used in the region of the theater's founder. Likewise, some temple and ancient sacrificial vessels. [A4v]

INSCRIPTION 6 ☿

Measures, weights, cubits, feet, and everything related to geodesy, used in various kingdoms and states. In general, those items that are for measuring fluids, dry materials, spaces, fields, mines, fountains, and other things. Separate from the mathematical objects enumerated in a separate place under their own title.

INSCRIPTION 7 ☿[6]

Ancient and contemporary coins, those of ancient Rome as well as other foreign coins, and domestic ones struck by kings and princes of our immediate and more extended ancestral line,[7] preserved because of their history and distinctiveness. They are moreover gold, silver, or bronze and are either forged, cast, carved, or struck.

INSCRIPTION 8

Portraits resembling coins [that is, portrait medallions] made of metal, stone, wood, wax, gypsum, and the like. Depictions of kings, princes, aristocrats, matrons, men distinguished in warfare and preeminent in learning, those famed for their craftsmanship. Also some with their reverse sides displayed, when they happen to be available.

INSCRIPTION 9

Symbolic objects, and those resembling coins, that are carved, cast, forged, struck, and produced by etching.[8] When these are not combined with portraits but are rather the reverse sides of these portraits, as it were, they should be kept under their own specific headings. These objects are made from the same material as the portrait medallions or coins. [B1r]

INSCRIPTION 10

Tiny ornaments made by goldsmiths for small sacred or secular images, for altars, vessels, necklaces, and finery: those that display forms on every side and facet. Among these are decorative forms that are leafy, flowery, animal, shell-shaped, whorled, and so on (pl. 8).

INSCRIPTION 11

Engraved copper artifacts on whose flat surfaces fine images have been cut, or applied through the etcher's art. These comprise and portray histories, effigies, images, emblems, architectural models, and a countless variety of subjects as suits the inclination of the founder of the theater.[9] [B1v]

Third Class

INSCRIPTION 1 ☿

Marvelous and very rare animals, such as unusual birds, insects, fish, shells, and the like, from the land, sea, rivers, mountains, forests, and other places: either parts of these or whole specimens in some manner or by conservation kept free from decay and dried.

INSCRIPTION 2

Animals cast from metal (see Introduction fig. 3), plaster, clay (pl. 9), or any other raw material, all of which appear alive thanks to artistry (for example, lizards, snakes, fish, frogs, crabs, insects, shells, and whatever else there is of this kind) and to which, finally, colors are generally added so that they are thought to be real.

INSCRIPTION 3

Parts of larger animals and even of small ones, should they be memorable. Here are kept horns, beaks, teeth, claws, bones, internal stones, skins, feathers, nails, hides, and whatever of the remaining parts can add some measure of variety. [B2r]

INSCRIPTION 4

Diverse skeletons or connected bones, such as those belonging to men, women, apes, pigs, birds, frogs, and other creatures. Likewise, things artfully made into the shape of human parts—such as human eyes with their own lids as well as ears, noses, and hands—and provided recently to serve [as prostheses for] people who have been mutilated (pl. 10).

INSCRIPTION 5 ☿

Seeds, fruit, vegetables, grain, and roots complementing the seeds [that is, rhizomes and bulbs], and what are said to be materials of this kind. Those at least that are fitting to preserve and pleasant to behold on account of the variety of their nature or the diversity of their names. At any point foreign, marvelous, or fragrant ones receive preference here.

INSCRIPTION 6

Herbs, flowers, small branches, boughs, pieces of bark, wood, roots, and the like. These are dried, genuine, and selected, and arranged in classes. They can also be either cast from metal of some kind (pl. 8), woven from silk [that is, silk flowers], or depicted by some new art. Pieces of all kinds of wood are kept here as well. [B2v]

INSCRIPTION 7

Metals, the metallic products of mines, and in addition the true base metals and mineral ore. Likewise, in the same place, solid veins of the purest metals. Finally, all these substances imitated by artifice; metals that have been annealed and others that have been smelted and separated, some more and some less so.

INSCRIPTION 8 ☿

Gems and precious stones, such as diamonds, sapphires, rubies, and the like. Likewise, among gems: quartz crystals (both raw and polished) and similar shining materials. And perhaps some of these are lightly set in gold so that they can be introduced into wine goblets, earrings, tiaras, or necklaces.

INSCRIPTION 9

More distinctive stones, after those precious stones mentioned above. For example, finer marble, jasper, alabaster, and the like. Similarly, among kinds of marble: porphyry, Dionysos,[10] serpentine stone [ophiticum], etc. These are not at all transparent but are very ornate. There are also medicinal stones in this place that are not transparent, such as hematite, eaglestone [aetite], magnet, tourmaline [theamedes], and so on. [B3r]

INSCRIPTION 10

Colors and pigments, such as those that are spreadable [that is, glazes], friable, mineral, water-based, oil-based, vitreous, and the like, for staining, painting, and coloring metals, gum, wax, sulfur, wood, ivory, woven fabrics, or wool. Here there are special containers for oil paints and others for colors mixed with water and gum.

INSCRIPTION 11

Earthen materials and liquids, both naturally produced and manufactured or purified, or else adhering to various other objects. These include clods, chalk, potter's earth, lumps of earth, and other colored earth. Likewise, vitriols, alums, salts, stones from the earth, and tufa. Finally, deposits from hot springs and caves. [B3v]

Fourth Class

INSCRIPTION 1

Musical instruments, such as flutes, reed pipes, organs, horns, cornets, war trumpets, and the like. Also lutes, lyres, triangular and arched citterns, clavichords, drums, harps, and many other varieties of instrument that can be put into consorts, either broken or of their own kind (pl. 11).[11]

INSCRIPTION 2

Mathematical instruments, such as astrolabes, spheres, cylinders, quadrants, clocks, geometric rods, and other objects to be used in measuring on land and sea, in war and peace (pl. 12). Likewise, the regular solids of various shapes, beautifully constructed of transparent rods (see Introduction fig. 2).[12]

INSCRIPTION 3

Instruments and equipment for writing and painting, such as vellum, paper, panels, writing tablets, reed pens, styluses, print type, printer's inks, compasses, rulers, erasers, and many other things of this kind, arranged in their own cases.

In addition there are also the most suitable portable desks, letter cases, and writing cases.[13] [B4r]

INSCRIPTION 4

Instruments of force, such as those for lifting the heaviest weights and for breaking gates, hinges, irons, etc. Also those that convey by pulling, dragging, or pressing; likewise those designed for adequately climbing anywhere, boating, swimming, and simulating flight.

INSCRIPTION 5 ☿

Instruments for workshops and laboratories[14] used by the more skilled artisans, such as the tools of sculptors, turners, goldsmiths, foundry workers, woodworkers, and indeed of all artisans whom this world supports in our age.

INSCRIPTION 6

Surgical and anatomical instruments and grooming equipment, such as scissors, lancets, augers, bone-saws, syringes, splints, razors, mirrors, combs, sharp needles, and ear probes; and everything that surgery occasions in substantial numbers and that wrestling managers,[15] cosmeticians, barbers, or bath keepers employ. [B4v]

INSCRIPTION 7

Hunting equipment and whatever is necessary for rural life and for gardening, such as those objects that are useful to fowlers or fishermen, or at least those that have a specialized use, such as bird whistles, horns for stags, hooks and tridents for fishermen, etc. But also many other devices for planting, pruning, weeding, and cultivating the earth.

INSCRIPTION 8 ☿[16]

Equipment for games, both for serious and more recreational exercise, as well as what pertains particularly to the agility of the body. Belonging to this kind are chess, discus, javelin, pyramids, dice, hoops, darts, ball games, spears, and balls. Also a morris dancer's satchel that draws simpler people into admiration.

INSCRIPTION 9[17]

Weapons of foreign nations and other very unusual and effective arms, such as scimitars, bows, ballistas, spears, quivers, and slings. And whatever else is so rare that it seems as fit for making a collection admirable as for equipping an arsenal (pl. 14). [C1r]

INSCRIPTION 10 ☿

Foreign garb, such as those belonging to Indians, Arabs, Turks, and the more exotic peoples. Some made from the feathers of parrots (pl. 15), from the weaver's loom, or from some marvelous textile or diversely sewn leather.[18] In addition, miniature garments of foreign peoples, like the garments of dolls, for the purpose of distinguishing the dress of young women, widows, wives, and the like.

INSCRIPTION 11

Rarer and durable garments, such as those of the ancestors of the founder of each theater. Here there might be an emperor's military cloak, a duke's mantle, or priestly garb of some kind. Also other adornments, such as necklaces, hats, girdles, pouches, crests of helmets, and other objects preserved because of some gratifying memory. [C1v]

Fifth Class

INSCRIPTION 1 ☿

Oil paintings by all the most eminent artists. So that in these demonstrations of artistic skill it might be observed to what extent one artist seems to have surpassed the other in subject matter, proportion, gesture, optical effects, variety, and ornaments as well as in other respects worthy of note.

INSCRIPTION 2 ☿

Watercolors produced by distinguished painters from everywhere, assembled with the utmost diligence (pl. 2). It would be as though artists from throughout diverse regions, having been called together as if in an honorable competition, had produced by far the finest artworks or books that they could.

INSCRIPTION 3 ☿

Images imprinted from copper, as well as other prints, on large or small sheets of paper, carefully laid out in cases and in their own individual groups as if in their own library. Among these are also entire volumes and booklets of images, produced and bound in various ways. These have also been separated into their own cases. [C2r]

INSCRIPTION 4

Tables of sacred and secular classifications.[19] Also historical catalogs; and chronologies illustrated on enormous panels, just like certain maps that not infrequently have been broadly spread out. There are also tables in the shape of branches and others that place the division of individual disciplines and their main headings fully before the viewer's eyes (pl. 16).

INSCRIPTION 5 ☿

The most complete genealogies from everywhere, of kings, dukes, counts and of distinguished and highborn families, some painted by hand and others printed (pl. 2). Between them come subordinate lines of descent, which are sometimes adduced in the proof of ancestry that first comprises four forebears, then eight, then sixteen, and so on, by further doubling to infinity.[20]

INSCRIPTION 6

Images of eminent and famous men, acquired in large numbers, so that at the very least those emperors, kings, princes, and other men of outstanding merit—whom it pleased the founder of the theater to commemorate or whom he particularly favored over the rest of his associates—are represented. [C2v]

INSCRIPTION 7 ☿

Coats of arms—also painted coats of arms and trophies—of noble families and of those offices related to certain regions and categories of service (as, for example, those of all the imperial dignitaries who held hereditary functions in the empire). Also those arms of certain classes or factions obviously associated with a particular kingdom, duchy, or bishopric (pl. 17).

INSCRIPTION 8

Tapestries and embroidered hangings of intricate artistry, not too broad in shape but easy to handle. Sometimes these might take the place of painted panels. They may be of silk, gold, wool, or whatever finer fabric you might wish. Finally there are also those that are infused with color across the warp of golden threads[21] or embroidered by needle.

INSCRIPTION 9 ☿

Aphorisms and gnomae inscribed for particular areas of the theater, and especially religious or moralizing ones, or else those that are perfectly appropriate to groups of any sort of object. Some of these are inscribed directly on the walls, some on boards that have been attached to them, some in gold letters, and some in multicolored letters. [C3r]

INSCRIPTION 10[22] ☿

Containers that are easily available everywhere, for storing objects and revealing them so that they might be displayed; such as caskets, chests, letter cases, cabinets (pl. 18), woven baskets, wicker baskets, platforms that have steps, trays and chests. Against the walls are perhaps covered chests, and, throughout

certain areas of the theater, tables. Also caskets resembling arches, turrets, and pyramids (pl. 19). [C3v]

―――――

Museums, Workshops, and Storerooms, Such as Are Meant for Furnishing Wisdom and Pleasing Arts, Which Are Sometimes Constructed Separately in Palaces and Sometimes Joined Together

A LIBRARY that is best equipped with books of every kind and divided in the following manner according to their classes (which are determined according to faculties, disciplines, and languages) so that the books may be arranged in a systematic way:

1. Theological
2. Juridical
3. Medical
4. Historical
5. Philosophical, under which are also the dialectical and magical
6. Mathematical, under which are also the astrological, arithmetic, and geometric
7. Literary, under which are writers on common subjects[23] as well as writers of every variety, including those on other subjects that cannot be assigned to the other classifications, such as writers on military matters, architecture, agriculture, and the like
8. Poetry, sacred and profane
9. Musical
10. Grammatical, under which are also dictionaries and commentators on prose authors and poets (the remaining individual commentators are assigned to their own classifications)

As regards languages, the books are in Hebrew and Greek, under which is also Greco-Latin; German, under which is also Dutch; then Italian, French, Spanish, etc., as many as one might wish to collect.

Further, the library is divided into its own sections (in addition to the lecterns), which have most suitably been called by the following names: for example, Regions, which comprise continuous walls; Stations, which consist of separate shelves; and Colonies and Appendixes, which are joined to Regions, as occasion demands, like additions of a sort. Then volumes are numbered and every tenth one is marked with a particular color so that groups of ten can be distinguished and seen from afar.

A PRINT WORKSHOP AND EQUIPMENT, in which there are types of all kinds ready for printing any possible language, art, and discipline. When there are also musical or mathematical notations present, and various symbols for the above-mentioned arts, then there are woodblocks for producing the majority of the most suitable book ornaments. [C4r]

A WORKSHOP OF TURNER'S EQUIPMENT AND TURNING AND JOINING TOOLS such as those considered among most princes and patricians to belong to the domain of the more congenial arts. Sometimes these tools find their places in the most glorious palaces.

Here, moreover, are diverse works made on the lathe from wood (pl. 20), metal, ivory, alabaster, horn, bone, and perhaps still other materials, readily revealing their inner forms to their makers so that, beyond their ornamentation and elegance (which are here present to the highest degree), a not trifling delight is experienced. And so to these it is also appropriate to add those things that bear upon the binding of books.[24]

A PHARMACY OR APOTHECARY. The wives of kings and princes are admirably pleased by the setting up of this kind of dispensary, thanks to the innate zeal of that sex for aiding the sick and poor. Moreover, in the making of medicines, preserving of many things, and distilling of liquids and oils, the excitement of the mind can never be sated, so long as it can see that new practical expertise flows immediately from facts long known.

THE FOUNDRY WORKSHOP AND MINT, together with the metalsmith's and alchemist's forge itself, suitable for smelting all kinds of metal and for melting, refining, preparing, molding, and so forth whatever kind of material you like. Here it will perhaps be more pleasing to some to be engaged in more elegant pursuits, such as producing little plaster molds of herbs, insects,[25] and reptiles, etc., modeled from real, living things and cast in silver, gold, or tin (see Introduction fig. 3; pl. 8).

SEPARATE CLOSETS[26] are occasionally devised in accordance with individual classifications of objects or even on the basis of the above-mentioned inscriptions, as, for example, where only copperplate engravings might be stored;[27] where only portraits painted on panel are examined;[28] and where only those geographic maps that have been opened out might be displayed. Finally, separate closed chambers are maintained in which artisanal equipment and tools of every kind are kept.

You might even find garrets where are hung only depictions of unusual animals (pl. 6), and deer's antlers and other horns of remarkable hardness, as well as other objects of this kind. Whoever is delighted by music, perhaps even moderately, will have appointed a special chamber or museum for musical instruments.

In a similar fashion, the person who has been devoted above all to the spiritual life will have his own chapel consecrated for prayers and sacred images. [C4v] In the case of silver and gold vessels we might also see their own specific vaults separated from the risk of fire and theft. Tapestries, curtains, and garments, serving different purposes, have their own rooms as well. Here, again, storerooms are not lacking solely for those costumes that are kept, sometimes in great quantity, for equipping spectacles and masques.[29]

In the end, there is hardly an inscription here that would not merit its own museum or chamber should someone decide to cultivate any one topic with tireless devotion.

Here one should at least also add the armories that princes, patricians, and the highest nobles have constructed and fitted out with particular industry in their kingdoms, citadels, palaces, and homes. These armories are different from those intended for general munitions; the latter, belonging to the household, are solely for equestrian exercises and sometimes to supply weapons and ornaments for mock battles on either land or sea, whereas the former supply entire armies, defend walls, destroy fleets, and try to shatter ramparts. We shall not speak at length about these objects here, I say, partly because they are of a specific design and can easily be incorporated under the inscription on weaponry[30] and partly because I have long desired that an elaboration in the form of a new and most thorough encomium (upon arsenals and storehouses for war machines, and on naval and ship-like vessels) be imparted to the souls of nobles who do not disapprove of tournaments, with Count Froben Christoph von Zimmern as their leader; and that the entire German nobility be increasingly incited and encouraged to take up arms against the incursions of tyrants.[31] [D1r]

———

Recommendation and Advice, along with Digressions, by Samuel Quiccheberg, Concerning the Universal Theater

Now that it is proposed in the first parts of the advice that all these classes of object be collected together, along with the entire contents of other museums and libraries, I shall submit in passing certain particulars about other alternatives, which will instruct those who are interested in these things.[32] Thus they will assemble these theaters, storerooms, or chambers that contain a variety of objects, each person according to the measure of his resources, as it pleases him. For these classes of objects are not so proposed as if to suggest that everyone should bring together all objects but rather that each person might seek out from certain classes whatever he desires, or, from objects, those he is able

to acquire. For sometimes someone of meager fortune will be able, according to the opportunity of the place where he spends his time and by virtue of the course of study he sets before himself, very usefully to accumulate different kinds of seeds, metals, or little animals, or ancient coins, or even an abundance of images; and he does so without great expense, and merely through diligence of inquiry and research.

However, for the very rich and for other noblemen who are particularly enthusiastic in this pursuit and who already covet everything, it has been necessary here to describe everything in full so that at least in the general enumeration[33] there is nothing left to be desired. And hence these matters are placed at the center of our discussion; not because I think that the lifetime of any man, even the most wealthy and diligent, is sufficient for collecting everything that could be broadly gathered into these classes but because I wanted, with this most complete and universal enumeration, to add these things to the considerations of men just as Cicero did with regard to the complete orator.[34] Thus, on the basis of these classes, they might measure the magnitude of their knowledge of all things, and they might be stimulated to imagine and investigate other matters in turn.

Indeed, I also judge that it cannot be expressed by any person's eloquence how much wisdom and utility in administering the state—as much in the civil and military spheres as in the ecclesiastical and cultural—can be gained from the examination and study of the images and objects that we are prescribing. [D1v]

For there is no discipline under the sun, no field of study, no practice, that might not most properly seek its instruments from these prescribed furnishings. Yet, in fact, it would require divine genius to assemble from all places and to order all these things that, once concisely and comprehensively collected, might be capable of instructing the mind of any reasonably refined person in countless matters. Nonetheless, we shall not refuse to at least give our advice about this elsewhere.

It is inconsequential that there should be no place, whether broad or narrow, for these things to be kept on display; for many can be stored, either wrapped or folded up, in narrow coffers, cabinets, or boxes, since even if they were to be displayed on vast walls and laid out on enormous tables or small, tiered tables they would hardly have enough space. But here I ought to mention that apart from those caskets, woven baskets, built-in cabinets, tables, and tiered stands, still other containers can serve this same function—particularly moveable shelves with grooves (which will be properly named). Likewise, there are little portable containers with subdividers; then caskets with doors and also caskets with doors folding outward;[35] and finally containers in the shape of turrets, which are of superior artistry and immeasurable practical value (pl. 19). Further

mention is made of containers below in the digression on the third class and fifth inscription; the digression on the fourth class and fifth inscription; and the digression on the fifth class and tenth inscription.[36]

In collecting these objects, patricians will need to have clever men to send to various regions in order to seek out marvelous things. And, in contrast, those of moderate prosperity who are deeply interested in repositories of this kind will come to know which objects they can exchange with friends; once these objects have been sent to other places, they might be able to entice others to send back diverse objects in return.

Indeed, Hans Burgkmair, the most celebrated painter of Augsburg, sometimes made use of this expedient.[37] He was able on his own to prompt a great number of patricians to endeavors of this kind. The goldsmiths of Nuremberg do the same thing, as do other craftsmen who now display cabinets that are outstanding in the variety of their contents. There is in general also this disposition among visitors and viewers that when they see many objects being preserved anywhere, they offer gifts of their own accord, and upon setting out for the farthest lands carry off with them particular things that they hope will adorn the collections for which they are intended (with their names perhaps appended to their own gifts). [D2r]

There is something else I would advise; namely, that among the inscriptions of the theater and the descriptions of the museums and closets, objects should, in accordance with their nature, be most broadly accessible by being most extensively distributed into these divisions. There are also many subjects about which it would also be fitting for someone discussing the art of collecting to give full instruction. Indeed, I have expended more than a few years of effort on them and shall devote yet more should the fates so favor me, so that generally I might not seem to have gone to such great lengths in vain. But the brevity of this treatise provides rather little opportunity to expand on these subjects. As a consequence, for the time being, the scholarly books at hand should be consulted—and not in the last place Ioannes Ravisius Textor's *De officina*[38]—until at length my myriad books, which in their due time will be available to the public, will supply a specific enumeration of almost all subjects.

Indeed, if I start with the genealogies placed near the beginning of these inscriptions, I will show a definite pattern for composing them and the paths that it befits everyone to seek to follow. In treating portraits, I will present agreeable observations that I have jotted down concerning painters. I will in other cases attempt to make known certain other things that I have arranged and observed for the benefit of many people. In particular, whatever I have diligently discovered in my earlier studies concerning the insignia and arms of noble families, and which was earlier confirmed, I would deny no nobleman or scholar.

But all these things are in proportion to the modest measure of our ability and study, not beyond it; truly, we can be of service only to the extent allowed by our research and residencies at various museums and libraries and our frequent visits to markets and councils.

Furthermore, for some years now I have profited from a familiarity with and access to the museums of the illustrious Prince Albrecht, Duke of Bavaria, and to the incredible abundance of images long ago brought together at Munich, and prior to that at Landshut. To be sure, I use these as much in all my research as I do through immersion in my attentive perceptions.[39]

For I was collecting many objects like those named in this theater at the very time I lived in Ingolstadt doing research, and I had it in mind in subsequent years to encourage a great many kings, princes, and noblemen to establish theaters of wisdom, or repositories. [D2v] And at the point that I decided to visit the imperial museum (whose coin cabinet I had recently examined in Augsburg), it so happened that at the home of this prince, the Duke of Bavaria, I found all those things that I had long since intended to classify and that are even now lavishly displayed and enhanced in his sumptuous palaces and buildings in Munich, as will be spoken of elsewhere.

At all events, due to this most illustrious Prince Albrecht—in addition to his enormous theater, appointed with these classes of things—there is also in Munich a recently founded collection of books called the ducal library. Moreover, there is a newly constructed printing press, set up for printing very large musical scores with full-size Latin notations. There is also that insignia devised by the mint, clearly visible since it is in its right place. There is a dedicated space set aside especially for musical instruments. There is a most pleasing turner's workshop, allocated to this use by Prince Wilhelm,[40] father of this duke, and, in his honor, enlarged by Albrecht himself for the most skillfully wrought items. All of these things can be comprehended here both collectively and individually.

Among these various establishments, praise is owed as well to Duchess Anna (pl. 3),[41] dearest wife of Prince Albrecht and daughter of the emperor, Duke Ferdinand. By way of increasing alms and assistance in royal fashion, she had a laboratory for ointments and cures and an apothecary constructed so ornately that they have come to be counted among the most glorious buildings of the new citadel. In doing this Duchess Anna imitated Jacobäa, Marquise of Baden,[42] the most illustrious Prince Albrecht's mother, who some time before had a pharmacy of her own installed in the home where—in the company of Scholastica Nothafft,[43] widow of Christoph, Baron of Schwarzenberg[44]—Jacobäa spent her years of widowhood.

With regard to this elder duchess, the following also deserves mention among the descriptions of our theater: namely, that she installed a separate

chamber for paintings of matrons related to her; and additionally of princes to whom she was joined in close family relation; and occasionally of young women of acclaim as well. From this has arisen the memorable custom of producing paintings of all young Bavarian women who are married out or leave, and then keeping those paintings together. [D3r] By the same token, one here reaches the storehouse of knowledge for which the duchess, Lady Anna, was celebrated by investigators of natural objects even before I had seen it, inasmuch as she with divine generosity keeps a great many species of birds in her enormous aviary so that those who are interested can gain knowledge of these things.

Nor indeed in mentioning these things in passing am I digressing in any way from the planning of our theater. For if it were permissible, I would make extensive mention of other topics as well, and I would easily perceive that in some of them there is a sanctity of life, and I would be compelled to commend a good many divine virtues. But as it is, what pertained to these inscriptions— and what I have consistently examined and attended to here as plainly of divine construction—I right away thought should be brought forth solely for the purpose of urging other princes to the same pursuit. I did this because I am giving and devoting myself so fully to still more fruitful travels (for which I am making preparations) for the purpose of furnishing a complete set of inscriptions for the theater, as well as for seeking out patrons for museums of this kind in other kingdoms as well.

Yet wherever we arrive, we shall truly have to say this about the most illustrious prince, Duke Albrecht of Bavaria: that in adorning his native land of Germany by raising all its art and learning and (pertaining to more elevated matters) by supporting the Holy Empire with his policies, no one will ever undertake greater things in spirit or hope, or suppose that the industry, assiduity, wisdom, and authority of this man ought not to be placed before his eyes.

For my part, out of all the attributes that either divine benevolence or nature has bestowed upon me, I have nothing that could in any way be compared with this same prince's kindness and companionship, with which he had welcomed me as a guest six years ago.

Digressions and Clarifications, According to the Order of Inscriptions

We use the term *inscription* in this way in our theater in case any king or prince or other patron should either have inscribed, in like fashion, collections of individual objects for specific places or indeed have resolved to so inscribe them. Whatever plan I have been able to furnish here—chiefly through the inscriptions, which I wished to be of almost a single design—for founding and appointing these things, I have already provided; the digressions will supply the rest.

Also, the term *theater* is not unsuitably, but instead quite properly, [D3v] employed here for a grand building that is in the form of an arc, or oval, or in the shape of an ambulatory (which in basilicas or cloisters are called "circuits" by those who reside in them) and that is constructed with high stories on four sides, in the middle of which a garden or interior courtyard might be left (such as the Bavarian theater of artifacts, for example), so that four enormous halls open out in very broad fashion toward the four directions of the sky (pl. 22). For this reason it would also be possible in some way to apply the term *amphitheater* to it.[45]

Here it is necessary to mention that the museum of Giulio Camillo,[46] on account of its semicircular construction, could also properly be called a theater. However, others have used this term figuratively, as did Christoph Mylaeus,[47] Conrad Lycosthenes,[48] Theodorus Zwinger,[49] Guilelme de La Perriere,[50] and perhaps others as well, when they, nonetheless beautifully, so titled certain books on, for example, the conditions of human life, the science of writing history, and remaining matters of exposition and narrative—though not on the importance of situating a building and the objects displayed or presented within it.

On the First Class

PANELS OF SACRED HISTORIES, ETC.: FOR INSCRIPTION 1

Here I give prominence to those panels that are sacred and most select—whether or not for any given topic there might be one panel or two or more—so that the gods favor the entrance to the theater or collection. Immediately next, I add the founder's genealogy (pl. 2), portrait (pl. 3), and other objects to which some preference is owed here. The remaining genealogies and portraits of certain distinguished and famous men, assembled without distinction, follow later in the fifth class. Moreover, there will be among the genealogies, portraits, and other chance objects (wherever they may finally be placed) something beautiful, so that princes and patricians might send excellent paintings to each other to preserve in a collection of images of this kind.

Furthermore, as regards the entire ordering, I hope that it will be judged sufficiently plausible, because here we are not dividing up for philosophers, precisely in line with nature itself, all natural objects; rather, we are sorting out for princes, into certain uncomplicated orderings, objects that are mostly pleasant to observe. Nor was it even possible to divide individual objects according to the seven planets, as these philosophers might have been able to do in imitation of Vitruvius[51] and Camillo, since here it was necessary to exhibit a more obvious ordering according to the forms of things. [D4r] Nevertheless, I will publish something more philosophically organized in a book on coats of arms in relation to their colors, or perhaps sooner, if there seems to be an opportunity, in

a book on the simple methods that are in established use solely for the printers of Europe. For from these methods, printers know how to compose systematic indexes of books on whatever subject offered, and the most comprehensible and useful ones too.

GENEALOGY OF THE FOUNDER OF THE THEATER: FOR INSCRIPTION 2

In the preceding digression on this genealogy and on the contiguous inscription of the portraits, we have discussed at length why they are given a place of prominence; but we offer further advice elsewhere concerning the same things, as in the digression on class 5, inscription 5. This had to be indicated here so that you would not, perhaps under the preceding guidance of Mercury,[52] inquire about such matters and nonetheless still stray from the path.

GEOGRAPHIC TABLES AND MAPS: FOR INSCRIPTION 3

The heading "geographic tables" is submitted twice in our theater, but in the second instance only under the collection of printed images. There, no great maps are placed—only individual pages, printed from copperplates. And here the occasion to explain the difference between a "theater" and a "collection of images" is most opportunely afforded us. The former is that infinite and immeasurable design of ours for collecting natural objects, furnishings, images, books, and other such things. The latter is, as it were, a certain part of a theater, whether it be a museum, or several chests or cases. These collections contain only those sheets that, having been printed in unbelievable numbers from copperplates, are brought together in a single pile and, after being sorted and spread out, are perhaps stored in cases. However, when it is permitted for certain images to be printed from woodblocks or painted by hand, only make sure that they are not larger than the common or royal sheets. For once sheets of a substantial quantity have been combined into maps (pl. 5), or perhaps set in broad rolls, or spread out on wooden tiles, then they come to be inscribed under the theater as a whole, not under the heading "collection of images."[53] And so it will be easily discerned that the entire collection of images falls solely under one single inscription of the great theater in the following manner: "images printed from copper." [D4v] Nonetheless, one should also bear in mind (if its full extent were to be considered) that it stands out in the theater as a whole no less than if some individual library were to accommodate it.

GREAT PAINTINGS OF ANIMALS, ETC.: FOR INSCRIPTION 8

Some might perhaps wonder why I do not move these to the third class, where I have said dried animals are to be kept. Let them know that in the third class there are only material objects and things that have to be kept in small boxes,

whereas here paintings have to be spread out on walls vertically and horizon-
tally so that they have their own place among the other large images (pl. 6).
For the rest, in the palaces of German princes and in the citadels of noblemen,
many painted objects of this kind are observed in dining rooms and halls.

On the Second Class

ARTIFACTS OF FINE WORKMANSHIP, ETC.: FOR INSCRIPTION 2; AS WELL AS THE
WORKS OF CRAFTSMEN, ETC.: FOR INSCRIPTION 3

Here I wanted to mention that certain little towers of diverse artistry—with
openings, as it were, or arches allowing a clear view, or small doorways, and
with stepped glass shelves—can be found throughout the theater, so that artists
of every kind might engage themselves in devising, from the specific materi-
als in which they work, different objects of this sort to be deployed on fixed
tables or in windows (pls. 18, 19). Thus, my plan has consisted in this: that just
as I offer guidance concerning paintings in the first and second inscriptions of
the fifth class by all painters of excellence who ought to be represented in the
theater, so also turreted cases of this kind made by individual woodworkers
and on occasion embellished by the most ingenious workmanship ought to be
included; and, what is more, that certain other containers of various materials
be placed among the individual wooden containers: for example, those made
by blacksmiths, braziers, silversmiths, workers in tin, and others, likewise the
works of turners, sculptors, stone smiths, embroiderers, glassblowers, minters,
and many others engaged in similar crafts.[54]

Once these containers have been set up on tables, they would serve the func-
tion of small armoires in whose doors and windows, as I would call them, it
would be possible to group together and arrange books, or a lesser quantity of
small vases or tiny statues.

FOREIGN VESSELS, ETC.: FOR INSCRIPTION 5

Here I speak also about ancient vessels, in relation to which one has to be aston-
ished at how many of these fragile vases diligent men were able to collect with-
out afflicting any damage to them. [E1r] The vessels were found in earth not
too compressed by enormous stones, among ancient ruins and in underground
vaults. In the same place, I further add "differing in shape" in order to suggest
right away to certain people that new ceramics can be produced at a minimal
cost, for which it would be proper to find appropriate names; namely, those
used with incredible variety in antiquity. Hence it might also happen that not a
trifling praise accrues to the suitability of the Latin language.

MEASURES AND WEIGHTS, ETC.: FOR INSCRIPTION 6

I leave it to some good man of quick wit to calculate how much intelligence, perspicuity, and distinction bringing these things together into a single coffer can convey, when new things must be combined with old, domestic with foreign.

To be sure, I know that many men—in fact, private citizens, to say nothing of courtiers and governors—have been prepared to go to great lengths in collecting those objects listed in the full inscription, which are not considered to be of great value; but they have at some point thus been admonished by some mortal or other. And the same applies to other inscriptions so that I do not consider it worthwhile to repeat.

OLD AND NEW COINS: FOR INSCRIPTION 7

Behold this inscription, since it applies even to ancient objects, under which our Hubertus Goltzius,[55] whom I am especially eager to emulate, commended so many great men. But at the same time, concerning new coins, I am proposing that a new source of renown be pursued, among their other devotions, by the most noble and distinguished men, whoever they might be; that is to say, in coins struck throughout Europe by kings, princes, bishops, counts, barons, and cities, so that as many families as possible and their individual coats of arms might be honored and legitimate succession established. Then as well, value that has been more closely scrutinized would restore Europe to a most peaceful and harmonious condition (however much it might be absent in this region). And whoever will not wish to labor in all areas will at least provide for the duchies or bishoprics of his own state.

On the Third Class

MARVELOUS ANIMALS: FOR INSCRIPTION 1 [E1v]

This universal class, by starting directly with animals, clearly comprises natural things and the entirety of natural matter. We know that the greatest minds have been thoroughly involved in collecting only these things, both in Germany and elsewhere, with some of the most felicitous ones in Saxony. Indeed, if only those whose collections abound with the varieties of this sort of thing would assist certain others more liberally! For who would not have wished to help Conrad Gesner in collecting animals,[56] or Leonhard Fuchs in depicting the species of plants,[57] or Georg Agricola in describing metals,[58] or others in other pursuits, should some possibility of helping such a collector have occurred? Who, though not likewise a prince, would not desire with the utmost zeal to enrich now and then, with the resources at one's immediate disposal, the endeavors of Maximilian II while emperor, or Albrecht of Bavaria, so as to enhance the refinement of the entire world and to illuminate all disciplines of study?

In this matter, how much more are private individuals (as I have said) able to help each other than they can kings and princes? Let me take yet another example from beyond our fellow Germans: that of the Italian Ulisse Aldrovandi,[59] whose efforts at preserving all such objects, in incredible quantity, must always be commended and were so commended to me in my youth. While still a young man I would visit him and his museum in Bologna. To be sure, everything I saw at that time with my own eyes was far greater than I had heard about beforehand. And I saw that he had omitted absolutely nothing as regards the things of nature, with the result that he might preserve animals, either in some instances their individual parts or else dried and stuffed in their entirety or at least depicted in still lifes (as he tended to do in the case of fish).

But let others, I pray, point out how much pleasure can accrue to the colloquies of princes from the many objects they have acquired from various places, and how much light can be cast upon commentaries on those things that have been investigated.

For many who are involved in studies of this sort do not have the resources for collecting these objects; also, many while traveling abroad for the sake of their studies cannot carry too much around with them, even those things they own. If only, therefore, there were more people for whom it would not be a burden to bring together a good many objects at the same time. Indeed, I myself began at the earliest possible opportunity to allot something of my resources to ancient coins, and did not avoid new coins either, or even objects made of metal and precious stones. Soon I was unwilling to be deterred by their sheer multitude from collecting brilliant sculptures, fine paintings, and particularly parts of animals, seeds, and herbs, aided by the practice of physicians. [E2r] Truly, I would collect anything I could so that I might oblige the majority of the learned in many respects and spur on all scholars to collect these things.

This I am doing, to tell the truth, all the more ardently because I would consider it dishonorable to be surpassed in this regard by goldsmiths, painters, sculptors, and others who are more or less unlearned. And indeed within my first years at Augsburg I was inspired and attracted, in far more areas than I attended to before, by the instruments of Cyprian Schaller, the gold assayer,[60] and Johann Schümberger, the goldsmith.[61]

SEEDS, FRUITS, AND LEGUMES: FOR INSCRIPTION 5

These individually determine separate groups of small boxes. Nonetheless, we have been accustomed to using boxes of the sort that jewelers use, in which for individual stones they have individual slots, in solid wood, where the stones may be inserted. This is done in such a way, however, that individual wooden trays have more slots and that some trays of this kind are closely overlaid upon

others. We Germans call all small carrying boxes *ledlein.* In these, provided the openings are spacious enough, many things can be placed, particularly seeds, legumes, grains, tiny fragments of stones, etc.

As regards fruit, for example, which can be acquired throughout the entire world, even foreign fruits in no small quantity, and also from apothecaries, they could be kept in larger boxes and trays, often combined into groups of four, for which four-part containers are made.

GEMS AND STONES: FOR INSCRIPTION 8

If anyone is unaware at this point how it is that this study is filled with every delight and how a study might abound with such a variety of terms, let him merely consult the writers on these topics, Marbodeus Gallus,[62] Pictorius Villinganus,[63] Conrad Gesner, and others, and let him observe how many and what sorts of terms each is able to draw, for their own work, from Pliny and other ancient authors.

On the Fourth Class

INSTRUMENTS FOR WORKSHOPS: FOR INSCRIPTION 5 [E2v]

Certainly, in this century, many German artisans have reached the point in collecting these objects that they have enclosed in a single portable case (to the extent that one man is able to carry) all the artisanal instruments used by clock makers, blacksmiths, woodworkers, goldsmiths, engravers, sculptors, turners, workers in gold leaf, metalsmiths, cannon makers, and other artisans besides, in no small number. Not just in such a way that particular individuals might find some of the things they require there but so that everyone finds everything they require: only they should know how to use and diversely adapt a few handles and hafts to many instruments, with their customary skill.

Thus are seen complete sets of circular files, varying in size; sets of flat files and of halved files; likewise, complete sets of augers and burins, hammers, and all other necessary instruments. With regard to this class of objects, I have noticed how pleasant it is to visit individual artisans, contemplate their remarkable work, and now and then investigate German terms that must be either compared with Latin ones or adapted to Latin.

That a good many cases are usually fitted out in this manner, stuffed with instruments of every kind, is attested by the fact that every year several are transported from our lands all the way to Spain, which I know Anton Maiting, with marvelous zeal, has undertaken for Spanish princes and counts.[64]

Moreover, I have also shown how, by being arranged in cases and chests and by having been beautifully organized in any such case or chest with the aid of either outward opening double doors or folding panels, all instruments

can in a short space of time be adapted for use on any wall or table; and how equally they can be immediately and conveniently placed back into this case so that they do not rub against each either or become blunt. Yet this is to suggest nothing other than that double doors or cases of the kind used by surgeons for carrying German lancets are employed: these surgeons have small cases resembling little books held together by rough silk and separated by hooked strips, through which individual instruments that are slightly separated from one another can hold fast and remain in place.

WEAPONS OF FOREIGN PEOPLES: FOR INSCRIPTION 9[65]

Here I am referring as well to arms of the most diverse and practical employment so as to compare foreign weapons with our own (pl. 14) and the old with the new. [E3r] Here will also be those weapons preserved in commemoration of ancient duels and of the battles of our ancestors, since indeed nothing of this kind, though outdated now, should be ignored even by the nobility of our own period. In fact, in dealing with all such objects one ought to procure them as promptly and skillfully as possible. Thus nothing can be presented among courtiers, where many reside together, that is so old or so new that there are not some present who might have at least handled and used some instrument of this kind. Indeed, among these very objects there will be none so rare and so unfamiliar that knowledge of it would be useless.

Moreover, the art of javelin throwing ought never to be overlooked. You will find out something about this from our collection, but nothing altogether new; and you will learn that some have devised and introduced a way of hurling arrows from ballistas as well as balls from bombards, for particular purposes of their own.

FOREIGN CLOTHING: FOR INSCRIPTION 10

Here I also remind the reader of miniature figures like dolls, such as those that queens and princesses are in the habit of sending to one another so they can examine the foreign garments of distant peoples in fine detail. And sometimes the very customs of peoples present themselves for observation. These dolls indicate the habit of dress in the home and outdoors in winter and summer, in temples and at parties; what is worn at weddings and during times of mourning; and particularly what the noblest people wear.

It happens that the domestic clothing customary among the daughters of princes is also preserved in enduring memory by such miniature figures. Indeed, figures of this kind in the hundreds, with both minimal and elaborate silver ornamentation, are kept by Maria Anna and Maximiliana Maria,[66] the daughters of Her Ladyship Anna, Duchess of Bavaria, and Albrecht her

dearest husband; and in still greater numbers by Jacobäa and Salome,[67] the granddaughters of the elder duchess Jacobäa from her daughter Mechilde, Marchioness of Baden,[68] who are distinguished by so great an array of domestic duties and undertakings that anyone examining their individual rooms would seem to have at hand a complete picture of all the chambers, ceremonies, and courtly customs of a palace. But it will also be possible for some to take pleasure in these things by preserving even pieces of foreign cloths. [E3v]

On the Fifth Class

OIL PAINTINGS AND WATERCOLORS: FOR INSCRIPTIONS 1 AND 2

Here we should not omit to inform our finest patrons to what degree Wilhelm, Duke of Bavaria, wisest father of Duke Albrecht and a leader most loving of peace, has expressed his fondness for honoring eminent paintings. For he saw to it that individual works by the most outstanding painters in Germany, in which their genius is marvelously evoked, were painted, with a certain honorable competitiveness, for his larger garden in Munich, and he also sent a number of specific pictures to particular individuals. In fact, to this day foreign visitors contemplate and admire these with the greatest reverence, as they do the city of Munich with the greatest longing, having traveled there owing to the loveliness of the city.

And thus the same fondness for the most outstanding works of art also developed in his sons and grandchildren. But let me not omit mention of these grandchildren at this juncture; that is to say, the dukes Wilhelm,[69] Ferdinand,[70] and Ernst,[71] as in all other matters that it behooves princes most observant of royal virtue and most inspired by genius to follow.

So also I ought to greatly admire and praise the benevolent patrons of both scholarship and the most accomplished paintings of this age. The surest example of this pattern of patronage is the fact that Duke Wilhelm himself, already an extraordinary hero with regard to the preeminence of his virtues and the stature of his body, drew elaborate battles and historical illustrations with his own hand and in a most deft style, even before he had sought instruction from teachers, and engraved them on copperplates.

Because Wilhelm's brothers actively imitate him in all the most genteel pursuits and in the most lofty endeavors of the mind—particularly Ferdinand in geographic pursuits and Ernst in his greater commitment to religious observance—it is proper that all the princes of the empire show the greatest gratitude to Albrecht himself, so eminent a father, and to his eminent sons.

IMAGES STAMPED FROM COPPER: FOR INSCRIPTION 3

Perhaps some scholars will be unaware that it is customary for a library specifically

about these things to be constructed, which it is accepted practice to call a collection of images. They will grasp this fact presently from subsequent titles. [E4r]

Although, as all the most perceptive and wise are accustomed to do, collectors leave unbound those pieces that are printed individually on large pages, in their own groups, but, continually being augmented, are kept spread out in very broad chests under their own distinct titles so that they are stored, separated by their own inscriptions, between unbound sheets in just the same manner as individual books.[72] And so, only those who have no intention of further increasing their collection are content to classify them once and for all according to distinct classes, bind them into books, and store them among the rest.

Therefore, the small bundles and materials of this foundation are constantly increased through the more industrious of its patrons in such a way that it seems possible to acquire knowledge of the greatest number of disciplines from these images alone, for sometimes the simple examination of any picture stands out more in the memory than an extended reading of many pages. And thus scholarship will gradually gain much through these resources, provided that Netherlandish and other artists and engravers continue to enrich our world with their work.

Further, to digress here more freely for the benefit of those who support such things, we have arranged all images thus far into their own regions and headings in the following way.

In the first region there are: (1) biblical histories; (2) New Testament histories; (3) the apostles and evangelists; (4) the saints, male and female; (5) theological discoveries; (6) histories of Christians; (7) miracles; (8) crusades; (9) portraits; (10) genealogies.

In the second region there are: (1) works of nature, such as animals, roots, anatomical parts, etc.; (2) philosophical discoveries; (3) disciplinary charts of mathematics and the arts (pl. 16); (4) musical scores; (5) histories of pagan antiquity; (6) poetry and love affairs of the gods; (7) lighthearted and lewd scenes; (8) spectacles and a good many ancient triumphal ceremonies; (9) contemporary customs: hunting, the art of gesture, festivals, the exercises of gladia-tors and diverse practitioners; (10) images of apparel and deportment; (11) family coats of arms.

In the third region there are: (1) geographic maps; (2) plans of regions (pl. 5); (3) depictions of cities; (4) buildings and architecture; (5) ancient monuments;[73] (6) ancient and modern coins; (7) war machines and ships; (8) workshops; (9) various equipment; (10) small vases, all of them illustrated; (11) small figures for ornamentation, also illustrated in various ways. [E4v]

Thus far I have mentioned the main headings, but many are subdivided into subclasses, which we place in separate cases. For example, I make three or four

sufficiently large divisions among biblical pieces by sorting them into earlier, later, and final biblical scenes and into those scenes that are separately presented in individual books. Accordingly, I divide images relating to the New Testament into scenes of the Nativity and those closest to it in time; ones relating to the Gospels; those relating to the Passion and events following the Passion; and finally, images related to the Acts of the Apostles, and to the Apocalypse. Afterward, there are images of the apostles and evangelists and of the Savior, the Trinity, and the Assumption of Mary.

I likewise divide geographic maps in this manner, and indeed it should not trouble anyone to see some large maps that have been displayed on wooden strips and perhaps hung on walls, or otherwise presented rolled up into very large scrolls, are separated and stored in one place, while others remain under specific inscriptions of the theater. That is to say, I divide these into world maps, sea maps, European maps, or ones devoted to regions of Germany, charts of kingdoms such as Italy, France, Spain, England, and others. Here all islands are classified according to the kingdoms to which they are adjoined.

I also divide ornamental prints into several cases—namely, those ornaments called leafy, those called composite, those designated grotesque, and those designated monstrous; also, others adorned with trophies, with fruit, or with a combination—in the same way as I made divisions among the images owned by the most illustrious Prince Albrecht, Duke of Bavaria, who some time ago, after consulting with Mathias Schalling,[74] collected the largest quantity of all these sorts of objects.

Thus, as regards the depictions of cities, it is easy for a man who collects everything produced everywhere to understand that he will need several cases into which he will know how to sort them perfectly in the same manner as the geographic maps.

THE MOST COMPLETE GENEALOGIES OF ANY SORT: FOR INSCRIPTION 5

Should anyone happen to be in any further doubt as to why genealogies are placed here—given that some of them have already occurred in the first class and others are again named in the complete collection of images, under the third inscription of the fifth class, where there are "images printed from copper"—it should be understood that the rationale is provided from the earlier inscription in the first digression of all, under the heading "panels of sacred histories, etc." [F1r] From this, since in fact genealogies are also placed among the titles of the collection of images struck from copperplates, it should be understood that only those things that are set out unfolded and flat among whole sheets of paper have a place there; while the rest, which are bound, or spread out on wooden boards, or rolled up into long scrolls, are most properly related

to the whole theater. There is a similar rationale for geographic maps, in relation to which things are organized in almost this same manner, but I digress too far. Nonetheless, I have in fact addressed this very matter in the past while I was in various places, including Venice, where learned men examined a copy of our theater written by hand.[75]

COATS OF ARMS OF NOBLE FAMILIES: FOR INSCRIPTION 7

Concerning these, I will advise elsewhere in what manner family coats of arms should be collected with regard to individual domains of the empire, as well as duchies, archbishoprics, and the like. In the meantime, apart from those that are sometimes placed alongside maps and calendars, let me offer as an example the published eagle, printed from copper and beautifully crafted in the Netherlands, containing the coat of arms of members of the empire; and likewise, the coat of arms belonging to the princes of Hannonia and the entire nobility that was printed from copper on a very broad sheet of paper; or again that of the nobles of Würzburg or of eastern Franconia on a less broad sheet.

Again, in larger format, there are the round tables of nobles, formerly in the court of the king of England, which are annotated with coats of arms; of these I have been able to obtain only a very old example from Peter Obernburger, counselor to Prince Albrecht.[76]

The laudable custom of collecting the insignia of friends, together with inscribed symbols, in certain little books has entered into this practice;[77] and indeed I have often augmented my own thousands of coats of arms from books of this kind, as for example one recently from the little book of that most noble man, Heinrich Taufkirchen zu Höhenrain,[78] when he returned from France to his native land of Bavaria. If only I could inspire successfully enough in this pursuit the rest of the nobility, who occasionally languish in idleness!

APHORISMS AND *GNOMAE*: FOR INSCRIPTION 9

I would want German heroes to be a little more liberal in inscribing these everywhere, since it is possible for such sayings to have some dignity in them, beyond their numerous other virtues.[79] [F1v] If, therefore, there are those who do not know how to imitate the diversely useful inscriptions of Roman antiquities—which individually certainly offer, according to their own kind, something well crafted—they might sensibly follow the philosophers and the multitude of religious writers, who to this end have clearly furnished innumerable suggestions concerning the discipline of life. Or they might imitate those in monasteries everywhere who have been in the habit of writing down aphorisms on doorposts, or likewise Bohemian teachers who, urged by the nature of the structure of their schools and chambers, smooth out the brick walls and roofs

with wood strips, and in the gaps and joins between these, once the latter have been strengthened, inscribe aphorisms everywhere with the greatest elegance.

But the theaters or collections that I am presenting to princes will be able to have on their walls on all sides double doors of the proper size so that panels of all kinds can be extended; these doors may be opened,[80] as is the customary setup in the case of altarpieces, so they reveal two or three new facets. Thus, in the interior there will be some class of objects such as statues and oil paintings; in the middle perhaps genealogies and some spectacles; finally, on the outside perhaps there will be maps, cities, animals, and the like, or other simpler pictures of expeditions or vistas, painted on canvas in watercolors. In that way, any viewer, at any time, might wander around and view the outer paintings and then, returning to his starting point, find a new facet, with some attendant meanwhile having shifted the doors of the walls. And so also for the rest of the paintings. Unless it should be considered preferable to draw curtains and veils around these, which I myself would not do, unless the textiles contained something suitable for the theater or something learned. For whether some writing should be inscribed on these curtains I am not now discussing.

However, some people will also perhaps be delighted here by a variety of writing. Since Germans are not unaccustomed to encountering different manners of writing, I would allow that these be displayed with great diversity—in such a way, however, that the same number of texts in Roman letters is alternatingly interspersed with other kinds of letters so that special honor will accrue to the Latin.

CONTAINERS TO BE VIEWED FROM ALL SIDES: FOR INSCRIPTION 10

Here are all those things that ought to protect in some fashion the objects, substances, and images mentioned above. [F2r] First, there are larger containers into which the smaller ones are readily stored, and certain portable chests and small baskets, as they are named in detail under the inscription itself. And thus many could be designed, varying only in form.

Among the smaller containers, jewel boxes must be mentioned in particular; they are described among the digressions under the fifth inscription of the third class, at the point where "seeds, fruits, and vegetables" are explained. Also mentioned are small trays, which seem almost to imitate the trays of beekeepers. Of these trays as many as possible, of varying size, should be kept together near at hand.

Next in this inscription, small cabinets in the form of triumphal arches, turrets, or pyramids are mentioned, and perhaps they will be of such exceptional weight that it will take two porters to carry one of them (pl. 18). Moreover, it would not be amiss to imitate ancient temples, round and otherwise, and

likewise theaters and those very wonders of the world so famed in ancient times, such as can be sketched out by the talents of learned architects, if only they are so capacious and prepared for such a use that some parts of them can be taken out, opened up, and put back again (pl. 19). In this way let cabinets receive all objects that you might rightly assign to them, so that architects can by all means furnish a fair variety of chests.

Regarding the wonders of the world: because they are differently enumerated by different people and ultimately add up to a larger number (since Baptista Mantuanus[81] in some song of his specifically required that the Temple of Jerusalem and the Roman Theater [that is, the Colosseum] be placed among them), we mention whichever of these undoubtedly existed and were actually recognized as being world wonders while at the same time connecting them to the seven planets.

Thus, under Saturn are the Pyramids of Egypt and certain mausoleums; under Jupiter, the Temple of Diana, the Statue of Jupiter, and the Palace of Cyrus; under Mars, the Walls of Babylon; under the Sun, triumphal arches and the Colossus of the Sun;[82] under Venus, the Hanging Gardens of Thebes; under Mercury, the Lighthouse of Pharos and the enormous Roman theaters; and under the Moon, the Baths of Diocletian and others, and huge ports and docks.

I seem to have dwelled at length on the fact that my prince, Albrecht, Duke of Bavaria, has been the foremost to initiate the introduction of new wonders of the world, in addition to his books of sacred images,[83] many thousands of which have been exclusively painted for the prince by the hand of Hans Mielich of Munich.[84] [F2v] Anyone who has the opportunity to see these books will think that the wondrous theater is all the more distinguished on their account alone.

Still, let there be some mention of those very containers, small vessels, and cabinets listed earlier in the Recommendation and Advice and above the third inscription of the second class, where the "handiwork of artisans" is explained. If added to all this are the walls with their opening doors mentioned in the preceding digression, you will easily contain all objects that seem to pertain to the repositories and places of the theater.

And here are the digressions I have added thus far at this particular place, so that inscriptions that I wanted to be pithy and circumscribed by their own limits, as it were, are not joined together with more copious digressions. In this, people who expect from us something concerning the method of writing books will finally have something to imitate. But let them also recognize that this has been done carefully, for I have added here a few words on the outer edges and upper margins to those subjects that are treated on the pages themselves. These vary so that they are used either once or twice within the full extent of the work, as required by the subject matter.

For while the crowning title—that is to say, the inscription located on the topmost area of a page—should not lack the main title of the work as a whole or the author's name (which is useful for the easy assembling of dismembered books), nonetheless, at least the margins of a page should indicate its subject matter, particularly where its contents have not been divided into chapters or when the chapters are so lengthy that the topics searched for are not immediately found by thumbing through the pages. It is fine with me that printers call these marginal titles *concordantiales tituli* in their own jargon; I only ask that these must be distinguished from crowning titles placed in the center. Further, we have not taken all titles to be explained, for there would never be an end to explaining and expatiating on individual ones.

Since all those topics are present that universal nature embraces, that all books teach, that all of human life can offer, it is perfectly clear that no discipline can be taught, no work of art examined, no state of life imagined, that does not have its foundations, equipment, means of support, or examples here in the theater. [F3r]

And thus for the aspiring leader in a theater of the kind I have just planned to set up with an eye for practical matters (granted that he be involved in it for some time)—if he contemplates the names given to all the present objects (determined by the location and the language that is used there) and if he does not prove to be completely ignorant about what classes he should properly choose but is familiar with a certain style of learning, and has examined what things should be considered as similar, different, opposite, or in a further subordinate class—it cannot be but that in the shortest time, without great exertion and dangers or troubles (which would in general have to be faced in the investigation of things), he will acquire unbelievable practical knowledge regarding everything and a manifestly divine wisdom. For while books are the other common equipment of all disciplines, here—through the observation of paintings, the examination of objects, and the display of the world of instruments, assisted by the tables of divisions and reliable synopses—everything becomes clearer and more comprehensible.

However, I cannot here keep silent about arithmologies that, collected in verse,[85] pertain to this enterprise. If these too are adduced, how much value would they contribute here? Indeed, several of these arithmologies by Gerardus Faustus were seen some years ago,[86] and not a small number have thereupon been issued in Antwerp by Hadrianus Junius,[87] along with images, and here at Munich in Greek by Petrus Cortoneus, doctor to the duke and philosopher of that kind.[88] Nonetheless, I have been collecting Latin examples in particular for more than eleven years from poets of all periods; thus, there are not thousands of examples relevant to the situation at hand, but rather several million.

As it is not my intention to elaborate upon all these things at length, I am unwilling to praise the entire institution of the theater further with even more worthy laudatory elogies.

To whichever enterprising prince, patrician, or scholar, once he has made a collection of objects or has at least sufficiently contemplated the whole enterprise of building up a collection, I leave that task to be accomplished. [F3v]

———

Exemplars for the Reader and for Furnishers of Storehouses of Wisdom, and Founders of Libraries Equipped with Diverse Furnishings; Then as Well for All Collectors of Objects from the Entire World, and for Patrons of Antiquities, Whom Hubertus Goltzius Has Named in His Own Iulius Caesar. Samuel Quiccheberg.

Apart from this—that through our inscriptions of man-made objects in the theater I wish especially to persuade all patricians and those of the upper nobility to found similar institutions—it is also clearly my design that in the future it might be possible to provide lists of the names of Maecenases of this same class and of eminent sponsors of the arts throughout the kingdoms of Europe, such as Hubert Goltzius of Bruges, Belgium, provided in relation to the cultivators of antiquity; or Heinrich Pantaleon of Basel, Switzerland, compiled during these same years in relation to illustrious Germans.[89]

Moreover, I thought that I should briefly present here some examples of how this task ought best to be approached, on the basis of which it would be fitting to make a start. For now, I will principally concern myself, where I am able, with cultivators of antiquities themselves, as Goltzius has done: I will give the names of those who come to mind as founders of libraries; and then just those who furnish storehouses of images produced from copperplates or in some other way; then all together the collectors of objects from the whole world, for the remaining tasks connect to these immediately.

And so I shall take as our starting point a most illustrious exemplar, far ahead of all others, our own emperor Maximilian II.[90] He is indeed by the testimony even of many princes someone of every excellence, the greatest guardian of the arts of this world whom Nature provides, a distinguished furnisher of a storehouse filled to the brim with the most beautiful objects—so that Nature herself, who flourishes most in the presence of novel things, seems to have begotten him especially for the purpose of honoring these times. Indeed, this man has thus far always been devoted to the greatest, most useful enterprises and those most to be admired, to the degree that whatever reposeful time he has left over from governing the Christian world, the Holy Empire, and his own

realms, he freely, generously, and without qualification devotes to listening to and promoting those whom he recognizes as discoverers and cultivators of the most numerous and useful arts, or those whom he is able to track down anywhere in the world. [F4r] And thus, as a result of this, so many ancestral treasuries have been restored and increased; so many chests of ancient coins have been enriched; so many books depicting statues, monuments, inscriptions, diverse instruments, and small vessels rescued from ruin have been published; so many of the most refined paintings, produced by the most outstanding painters; and so many marvelous things have been conserved with such care—of which the most illustrious prince, my Lord Albrecht the Duke of Bavaria, has not ceased to be the most diligent patron—that clearly all who look at them ought to be led to highest admiration. Therefore, just as our Goltzius most gloriously counted Albrecht's brother-in-law, Emperor Maximilian, and the Archdukes of Austria, Ferdinand and Charles, the sons of Emperor Ferdinand, among the ranks of those who have ardently emulated the ancients, so I as well am able, in a far more lustrous encomium, to attribute to these men an instinctive capacity for seeking out all the most beautiful things and to attribute to them the founding of repositories for the arts; their repositories, moreover, would be worthy of being inscribed in individual books and commended to posterity.

Beyond those Goltzius named, however, I will also recount others among the most eminent people who cultivate diverse things, at least in Germany, although there are kings, princes, and other outstanding men in various parts of Europe who have merited their own glory and who therefore ought to be celebrated. This would certainly not be difficult within so great an abundance of inscriptions and titles, but it is scarcely possible in so short an epistle as this. It therefore has been necessary to limit the variety of exemplars within the inscriptions in order to avoid presenting exemplars for each individual object altogether.

Indeed, if it were appropriate to move on to the principal electors of the empire (as if to distinguished kings and popes), of which there are seven living at this time whose frequent company it happens to be most agreeable to enjoy, just as it has been by far the most pleasant thing to contemplate their studies, then I would have in their individual research as many exemplars as possible pertaining to our classes, which would by no means have to be passed over for brief citations. I say, that in Daniel Brendel of Hamburg, archbishop of Mainz[91] (whom I am accustomed to call the most sought-after father of the empire) and in Johann von der Leyen from Trier (whom I acknowledge as guardian of the empire,[92] [F4v] a person of the greatest authority and prudence), I would have what I would celebrate most fittingly by virtue of the restoration of academies by each of them and the revival of the culture of letters in each place on their account. Indeed, concerning the men themselves it ought to be said that

they have in this manner founded by far the most renowned theaters of wisdom—but because I have already written and dedicated a certain account to these matters, I think that a lengthy narrative should be avoided at this juncture. However, since in passing I am touching on matters concerning these two, one also ought never to omit, in the case of Friedrich, Count of Wida, elector and archbishop of Cologne[93] (just as Goltzius wrote in the case of his predecessor Count Gebhard von Mansfeld[94]), that a zeal for antiquity has also been attributed to him, and that the same has even been extended to the attentiveness of his venerable family. This is confirmed in Friedrich of Wida's substantial collection of books, where, when the best form of governing his own electorate arises, his other clearly heroic virtues can easily be expanded upon in the most dignified phrases.

Finally (leaving aside for now the elector and king of the Bohemian Empire, also known as Emperor Maximilian II), I have what I witness with my own eyes in the case of Friedrich, elector of the Palatine:[95] museums of antiquities, which were founded with the utmost industry by Ottheinrich von der Pfalz in Heidelberg,[96] are being beautifully refined and improved by this prince; and likewise their artistic buildings visibly shine with regal splendor. I would wish that no one of them at this point not recommend to themselves for contemplation a marvelous abundance of natural objects.

At last, having arrived at the most illustrious princes—Augustus, elector of Saxony,[97] and Joachim, elector of Brandenburg[98]—I will say briefly, which will nonetheless be gratifying to the entire nobility, that in the latter (as regards our titles for the theater) there is present an enthusiasm for the offices and genealogies of the empire that ought to be commended to the highest degree; and in the former a lively industry for collecting the names of the equestrian nobility and the ensigns of these same men, something that must always be properly applauded in our theater. If that which I gather together in the future concerning these matters should not displease these men, the door to adorning our world will have been opened wider.

However, since it is not possible to do justice to all these matters here, it will be necessary to digress a little on them elsewhere. Indeed, here we have not woven together any complete list but merely seek out certain examples—especially from those places in Upper Germany where we have spent a somewhat longer time, [G1r] namely Bavaria, Swabia, and Franconia—provided it be permitted to impart to everlasting memory the names of learned men everywhere, and artists of the world, and those famous in our own age, connected to their leaders or regions, in a mere, albeit very full, list to serve posterity.

So we proceed directly to certain names recorded by Goltzius and, whenever the subject demands it, we will either add new ones or to the earlier ones we will

append in the briefest of terms something of the encyclopedic study that has been worked out chiefly from our theater. Indeed, the enumeration of examples cannot at this point be described as a history of those who are included; it ought only to be called a concise list of the patrons of our theater.

Accordingly, these four princes occur most prominently in Goltzius's list: in Bavaria, at Munich, Albrecht, Count of Rhineland-Pfalz and the duke of both parts of Bavaria, who is in fact the sole sovereign of Bavaria; in Swabia (from those who have their fixed seat of power there, for others too were listed), at Augsburg, Otto Truchsess von Waldburg, cardinal of Augsburg;[99] and, in this same Swabia, at Stuttgart, Christoph, Duke of Würzburg; and in Franconia, at Würzburg, Friedrich von Würzburg, bishop of Würzburg and also Duke of East Franconia.[100] Since in fact I visited all of these men at their homes and diligently observed their literary interests, I thus easily recognized something more in them than Goltzius celebrates.

Indeed, even in Albrecht, Duke of Bavaria, my excellent prince, there is also inborn, amid the most serious duties of civil government, this noble enthusiasm for establishing an undoubtedly surpassing theater of images and objects, both man-made and miraculous, such as must be acknowledged to have never existed in any age, which I again and again commend here.

The ducal theater, in relation to which the greatest renown and virtue (to be cultivated, emulated, and decorated with the utmost zeal) might be attributed, is so highly visible that these princes, scholars, and artists who are unaware of this magnificent undertaking would appear to have not yet discovered any of the scholarly enterprises under way throughout Europe.

How agreeable it would therefore be for those most celebrated writers on antiquities to learn these things from this prince (for Hubert Goltzius in Flanders; Jacopo Strada in Austria;[101] Aeneas Vico in Italy;[102] Medoro in Venice;[103] and finally Johannes Sambucus the Panonnian [Hungarian] in his own country,[104] who, having traversed many lands for the sake of these sorts of objects, [G1v] also recently wished to travel in Belgium), especially because so great a store of the most acclaimed objects might be joined together here, since whatever our world possesses that excels in artifice and learning might be examined with so much enthusiasm and brought together into a single accumulation, as it were.

Next we congratulate both Otto, cardinal of Augsburg, and Friedrich, bishop of Würzburg, because, having founded separate academies (one of which, at Dillingen in Swabia, has already for many years been very well attended, while the other, at Würzburg, seems to show every promise of the same), they are to be counted among the foremost patrons and guardians of letters in our age: because contributions arrive here from all over which ought to be admired;

because of their search for and promotion of the finest and greatest quantity of books; and for faithfully conveying all German propriety.

With regard to Christoph, Duke of Württemberg,[105] quite apart from his studies of antiquities, for which Goltzius has commended him, I am able to remind you that formerly he stood out as a patron of marvelous objects and architecture, beloved by many. But how much effort he put into these things, and how much he spent, I cannot describe in so few pages.

To the examples given by Goltzius, let me add yet other princes to whom he did not turn his attention at that time. In Bavarian circles there exist four bishops who by necessity ought to be mentioned: Johann Jacobus Khuen, archbishop of Salzburg;[106] Urbanus von Trennbach, bishop of Passau;[107] Vitus von Fraunberg, bishop of Regensburg;[108] and Moritz von Sandizell, bishop of Freising.[109] Each of them delights in some chosen enterprise (in fact, in one or more) apart from their responsibilities relating to ecclesiastic duties: for example, in collecting portraits of illustrious men, in fitting out well-stocked libraries, in producing complete catalogs in book form of coins struck by the noblemen and bishops of Germany, and in collecting the coats of arms and weaponry of Germany's nobility. In this last pursuit, particularly devoted to coats of arms, Bishop Urbanus brings the greatest mark of honor to Germany's many princes.

But even here in the region of Bavaria, this kind of collecting also pertains to Eichstätt, about which something can be read in Goltzius's book concerning the bishop of Freising of the family Hutten,[110] [G2r] where in the meantime Martin of Schaumberg,[111] who is even fitting out his own Sparta by building a new school, just recently came to mind since we ought not to omit praising him for glorifying the liberal arts and theaters. Also Ambrosius von Gumppenberg,[112] appointed cathedral canon in Eichstätt, a man most profound in years, who, in addition to the coins that he collected for many years in Rome, has remained conspicuous as a friend and patron of all foreign artists, and has promoted and cultivated many diverse and original undertakings.

In relation to this category of church officials, once his distinguished study of histories has been added, the most ample praise arises for Alexander Fugger, dean of Freising Cathedral,[113] such praise as might be hoped to continually bear the richest fruit for our country.

From here, however, it is fitting to move on as well to other nobles who ought to be celebrated throughout Bavaria. Accordingly, to the accomplishments of Wiguleus Hundt,[114] a knight and scholar in the court of the Duke of Bavaria named in particular by Goltzius, I now add that beyond collecting those ancient coins struck by the families of the nobility, Hundt also traced their lineage with the utmost zeal, assigned to each of these with admirable industry its proper coat of arms, and thoroughly researched many monuments that

honor the Bavarian region. Indeed, in relation to these same studies, we gladly acknowledge here still other outstanding patrons of these enterprises. Thus we express our admiration for Ottheinrich, Baron of Schwarzenberg, popular ruler of Bavaria, for his study of genealogies;[115] Simon Eck, chancellor,[116] for collecting coats of arms amid the rest of his explicitly religious duties and pursuits, and for giving due regard to the monuments of the ancients; Wilhelm Lösch, the decorated knight,[117] prefect at the royal court of the duchess; and the jurist Michael Heumair,[118] for undertaking the same sort of study, in addition to their genealogies, without any personal stake in the matter.

So also Salzburg has in Sebastian Hoeflinger, chancellor of Salzburg, an industrious supporter of its library.[119] Munich in turn has Hieronymus Pronner,[120] who seeks out enormous quantities of books that I can duly recommend, since I was in the habit of making especially liberal use of them when the old Ridler library still needed cultivating.[121] Something similar might be said of Christoph Bruno, who is so enthusiastic about books that he recently set up a printing press, with his own type, in his home.[122]

Sigmund Friedrich Fugger[123] and Vitalis Gmelich,[124] who were once visited and written about[125] by Goltzius in Pisa, are relevant here as well. They now ought to be emphatically and repeatedly commended for their studies of the antiquities and most distinguished objects in Salzburg. [G2v]

Similarly, we should by no means pass over in silence Oswald von Eck,[126] who has been admirably cultivating a collection of coins in the town of Kelheim above Regensburg and expanding the ancestral library of his father Leonhard von Eck,[127] formerly a most celebrated Bavarian counselor.

One should also by all means commend the unusual theater of philosophy (as I now call it) of the jurist Sebastian Reisacher,[128] the philosopher and counselor at Burghausen. His theater emerges as something far better than Giulio Camillo's had been, which can now be viewed only in books and in which it was necessary to cram together texts within elongated boxes. Of course I ought to declare to all of Europe that Reisacher's theater is a new discovery for prime philosophy, as he himself calls it, providing as it does for the certitude of all disciplines and the most perfect methods, opening the gates of wisdom, so to speak, by seeming to offer the greatest utility for scholarship and perspicuity of a clearly divine order. The study of philosophy is also spreading in Bavaria, not only in the case of other men of great genius but also in the case of Johannes Albertus Wimpinaeus of Ingolstadt[129] and Carolus Rauhenberg of Regensburg.[130]

Goltzius would also have known that in this place of Ingolstadt, Philipp Apian (pl. 5)[131] succeeded his father as a most worthy cultivator of every beautiful instrument pertaining to the extension of his own disciplines and as the most worthy promoter of all antiquities; and that Georg and Johannes Fantner[132]

maintain in excellent order, at Landshut, a collection of numerous coins that they assembled first from other places and then from throughout Bavaria. Likewise, thanks to Goltzius, I will not neglect Ludwig Schrenk[133] and Ludwig Müller of Munich,[134] because in the family of each, no small number are devoted to antiquities, images, and very rare objects.

Then as well, eminent historians would know, and no less than princes and even kings themselves have long since acknowledged, that Orlando di Lasso—the veritable father of the music of our age, whom the learned everywhere support and whom musicians imitate and aristocrats commend—lives in Bavaria, because the most renowned libraries and the most sumptuous museums are marvelously filled with and brought to perfection by his works.[135]

If only it were possible here to hasten further to other eminent men throughout Bavaria who ought to be honored. I would in fact draw attention to the richest crop of those who, while found in other places as well, are especially numerous in Ingolstadt. However, since brevity is surely prescribed here [G3r] and thus I am prevented from doing justice to the rest of Goltzius's names assigned to Bavaria, I have put together examples of this kind in another place. To be certain, it grieves me that I am forced to pass over those very professors of Ingolstadt who are by far the most brilliant, while it nonetheless might be possible to console myself, in part because they are much celebrated on their own account and also in part because they have been commended in the elegies of the poet Vitus Jacobaeus.[136] But because this concerns those who established libraries, I ought to mention that Georg Theander[137] assembled the most complete universal library at Ingolstadt; and Martin Eisengrein, the preeminent theologian,[138] Rudolf Clenck,[139] and Leonhard Probstl[140] likewise assembled treasure houses of abstruse volumes, in manner of recollection.

So now let me move on to those whom Goltzius named from Augsburg. There are firstly the two Fugger brothers, Johann [Hans] Jakob[141] and Raimund.[142] If it were not already commended in writing how many collections of ancient coins they acquired and added to those they had inherited from their parents, it would not be acceptable to pass over them without very lengthy descriptions. But let me note some of the more important details about these two as concerns the plan of our theater. Certainly it should be known that of the two it was Johann Jakob who founded the Fugger library, which now has holdings of such a kind indeed that whole commentaries would have to be filled in order to commend and describe them (in fact, I myself once showed how this should be done); and thus if no catalogs of the library should be made available for public use, our age would seem to be cheated of a great resource.

Indeed, Raimund and this same brother, in consultation with Jacopo Strada, acquired so many volumes about ancient statues and books in which countless

coins are separately depicted that if these materials were to be transported, a number of pack mules would have to be weighed down with them. Similar resources are otherwise only preserved and augmented in the royal museums of the emperor Maximilian.

Here it is necessary to add, for the sake of the inscriptions of our theater, that the Fugger cousins Georg[143] and Markus[144] built individual libraries at their homes that could be considered worthy even of princes' palaces. For while Markus was devoted to language and history and Georg more to mathematics and philosophy, I imagine that once other areas of study are added to these with due consideration, the renown of each will live on forever.

And so too there is something of supreme importance to our theater in the case of Lords Christoph[145] and Johann Fugger,[146] who are also cousins and respectively the brothers of the two Fuggers just mentioned [Georg and Markus[147]]: [G3v] both stood out as generous patrons and sponsored many craftsmen in devising new things, with a similar enthusiasm for images and sculptures of genius, for furniture of remarkable workmanship, and for precious vases and other such objects that, having been produced in this flourishing age of ours, posterity will greatly admire, perhaps even more than it will esteem the ancient Romans. And it has befallen Johann in particular to be recognized as having offered himself as the most generous patron of the foremost talents everywhere.

But here I ought also to recount from Goltzius how distinguished a collection of ancient coins Michael Ludwig and Ferdinand von Freiberg[148] set in books of silver sheets, and how they recently took pains to have these inserted within certain rare plates of gemstones.[149] As regards this kind of object, there is truly thought to be nothing more brilliant in all of Swabia than these.

In this regard as well, the same Swabia has Count Froben Christoph von Zimmern, a senior figure of great expertise in history and other important subjects and an admirable collector of coats of arms and weaponry. It also has Wilhelm Werner, likewise Count of Zimmern,[150] a researcher into the marvels of nature in its entirety. His collection is what everywhere in the German vernacular is not at present called a *Kunstkammer,* which is a conclave for works of art, but solely a *Wunderkammer;* that is, a collection of wondrous objects. It is also under this designation that Ulrich, Count of Montfort in Swabia,[151] founded his own collection of the greatest refinement, which is likewise a conclave of natural marvels.

Moreover, since Goltzius ranks Johann Heinrich Herwart[152] first among the patricians of Augsburg as a cultivator of antiquities, with Lukas Rem[153] not far behind him, so it falls to me to say that, as concerns assembling collections of images, they ought to be celebrated as far as the outermost regions of Europe.

In Augsburg you might also consider especially deserving of such renown the Fuggers, who, for the sake of art, occupy themselves with collecting for specific museums everything that has ever existed. Antwerp, Venice, and Rome, trading ports that produce a good many artists and painters engraving images in copper, ought to take pride in patrons of this kind. [G4r]

However, already some time ago our most distinguished Prince Albrecht, Duke of Bavaria, in constructing his own theater with royal appointments, far surpassed Herwart and Rem. He also added biblical illuminations in the several thousands to those most sumptuous music books of his, as said above, painted by the hand of Hans Mielich of Munich (pls. 1, 3), and of such splendor that these books and images, having already been combined, would seem to constitute a storehouse of pictures, as if a library unto themselves.

There is, moreover, the Peutinger Museum in Augsburg, no less packed with coins and minute bronze statuettes than it is lavished with a law library. Indeed, this very year Christoph Peutinger, prefect of the city,[154] expanded the museum with additional buildings.

Now at this point I would truly wish that certain Germans—after having seen the only museum in Lombardy[155] and the storehouses of those objects of Marco Benavides of Mantua, professor at Padua[156]—might have an example to follow in perpetuity. To describe to these Germans his rare holdings, I recently called certain Italians to witness.

However, Peutinger collected new miniature bronze statuettes as well, some even cast with his own hand, and fashioned in some part many other things. Marina Pfister,[157] that most honorable lady, at the same time and on her own initiative, assembled a very extensive collection of technical tools and instruments of turners, carpenters, painters, mathematicians, and musicians—the broad benefits of which have even continued after her death, as long as there have been those eager to imitate her.

In Augsburg, moreover, the names of four remaining figures mentioned by Goltzius are everywhere celebrated with much honor, and so ought not to be omitted by me. These are Christoph Rehlinger,[158] Markus Welser,[159] Bartholomäus May,[160] and Adolph Occo,[161] whose collections I explored individually and with whom I also rightly listed Johann Achilles Ilsung,[162] counselor to the emperor; as well as Paul Vöhlin[163] and Karl Neidhart, patricians of Augsburg (Goltzius did not omit Christoph Neidhart,[164] the latter's brother, among Lyon's patrons of antiquities, since he lived there for a long time); also Wolfgang Ravenspurger[165] and Georg Mielich.[166] Of these, some have not ceased to enrich my collection from their own coins, though these were not as abundant as those of others.

Similarly, yet still more recently, Leonhard von Harrach the Younger,[167] the most distinguished baron in the emperor's court, [G4v] and Leonhard von

Memmingen,[168] the noblest man in the Bavarian court, offered me some objects; and very recently the jurist Johannes Aurpach,[169] at that time counselor to the emperor and subsequently chancellor to the bishop of Regensburg, wanted to have stored among my holdings objects he had brought with him from foreign lands, which were very much to my taste.

Finally, to the other titles of Augsburg I have added the name of the most illustrious man Johann Baptist Haintzel,[170] who marvelously fitted out a collection of books of his own and a library for the city of Augsburg, at which Hieronymus Wolf served as prefect;[171] and the name of this same Wolf who built a most valuable library almost exclusively from works of his own production, which are very useful in our world.

Apart from these, the remainder of those from Augsburg mentioned by Goltzius were mostly foreigners who were present at assemblies either in the emperor's company or otherwise—just as I, whom he added to their ranks, albeit with a more grand title than I would claim, can say that I frequently spent my time there owing to the frequent Diets of the empire. So I wanted to reserve mention of these figures for another time and place, to be celebrated in several written works, when they will be back in their own homes. Indeed, they will without doubt have removed all their property from Augsburg, even as I did, since I wanted to keep part of what I had there during my travels and in Munich, and determined that other things should be given for safekeeping to my brother Leo[172] in Nuremberg or kept with the Schürstab family.[173]

Furthermore, at Nuremberg, whenever I saw with great pleasure what was the Roemerian treasury at the home of Georg Roemer's sons;[174] and the coins of Willibald Imhoff,[175] the greatest of aristocrats; and, finally, those coins of Georg Chanler,[176] knight and learned doctor, I valued these collections so highly that I always judged that they ought to be counted among the most valuable treasures, just as Goltzius also records them.

In this context, Johann Starck,[177] clearly a great man, should not have been passed over, and likewise Hieronymus Prunsterer,[178] Stephan Praun,[179] and Sebald Flechner,[180] because all of these (like those named by Goltzius) have established a repository of images—that is to say, of pictures printed from copper sheets—as though each had procured his own private library. Nevertheless, with regard to this business of collecting images, Hieronymus Baumgartner,[181] a most august and eminent man, and likewise his son, are still praised beyond the rest; this is also true of Nicolaus von Wimpfen[182] and Paul Ketzler.[183] Moreover, I find these figures as well in Goltzius: Sebald Zilinger,[184] Walbert Pfrauner,[185] Eustachius Molber,[186] Fridelin Bandel,[187] and Rutger Bremling.[188] [H1r]

Furthermore, that market town of Nuremberg, as far as it applies to perfecting the different titles of our theater, has such distinguished patrons of every

kind of craft, commerce, and study, and such versatile inventors of new objects and devices necessary for every life, that it would be more fitting to compose specific commentaries on these men (something I shall by no means omit in its proper place) than to continue briefly here—or more accurately, to make an inadequate beginning.

The patrons and inventors are quite apart from those who collect the totality of things in pictures, and material objects as well, among whom the goldsmiths Hans Maslitzer[189] and Wenzel Jamnitzer[190] are well known, as are the two Johann Neudorfers,[191] father and son, both preeminent mathematicians. For if there were space to speak about these craftsmen, one would immediately have to turn to others throughout the cities of the empire and talk at length about Munich's sculptors, clock makers, swordsmiths, and esteemed makers of cannons and other such weaponry, whose works are heralded with the highest acclaim in the most distant foreign lands.

However, the rest of those in Würzburg in Franconia, who were already mentioned by Goltzius, must all be recalled. There, still among the living at this time, one finds: Johann Zobel, hereditary chamberlain of Franconia;[192] Wolfgang Dietrich von Hutten, a deacon;[193] Eberhard von Ehingen, commander of the Teutonic Knights in the province;[194] and the jurist Michael Peuter.[195] These men—especially with Balthasar von Hellu, chancellor of Franconia and Würzburg,[196] added to their ranks—must be mentioned here and commended for cultivating excellence and advancing the cause of historical and literary work to a remarkable degree.

And so, I have here recounted in brief the majority of those mentioned in Goltzius's *Iulius Caesar*, at least to the extent I consider fitting at this time. For I perceive that it would hardly be opportune to proceed to other parts of Upper and Lower Germany unless it should please me to abandon my rafts and entrust myself to the immeasurable waters of the ocean. Still less ought I repeat those whom Goltzius listed most deservingly in Italy. The magnitude of the enterprise alone ought to deter us from even naming these exemplars; indeed, if the ingenious and splendid works commissioned in Rome by the one supreme pontiff, Pius IV,[197] had alone to be recounted, and if from there one should be required to mention cursorily the palaces and the magnificent intellects of dukes—if, I mean, it were necessary to commend the talents of the Duke of Florence, or of Ferrara, Mantua, Urbino, or others in respect to promoting these studies— even the most voluminous commentaries would hardly be able to contain this. Accordingly, I find nothing more prudent than to imitate Goltzius and persist in merely citing bare names and the names of those whom I touch on in passing, to recognize those patrons who have been most generous in supporting these studies. [H1v]

For the whole of France, Spain, and other kingdoms will come to mind, along with their kings, if I were only to dare move beyond the limits of this project. One must therefore wait until great princes, diligent historians, and learned men of whatever kind have examined these inscriptions for my theater so that they might in every way leave me more certain as to what they would like to teach me and with which recorded names they would like to assist me. For it is my intention, provided that not all of the most noble men will have disapproved of the present work, to also demonstrate to this same audience certain things having to do with other notable matters and to publish certain material related to writing the history of our time. However, in everything I have written I reserve the right *in perpetuum* to insert the names of the most famous men who have written the individual works of this sort that happen to be mentioned, and I will never omit those writing before me on this same subject. Rather, as someone interested in cultivating histories of our own times, I will of course everywhere supply reliable catalogs. But in the meantime, let those whom Goltzius, who out of his individual affection for them all, instated in lasting memory, which so felicitously occurred under the patronage of master Marcus Laurinus van Watervliet,[198] prove themselves not ungrateful. So for instance I, Samuel, now pledge to do on my own behalf and on behalf of my cousin Peeter Quiccheberg,[199] who was named by Goltzius in Antwerp. But let none of them ever tire of refining this book more and more, once they have begun to love that study of antiquities. And as long as I, by virtue of my system of many titles, encourage them, I ask that they not prove themselves deaf to my advice that they pursue things yet more fruitful. Yet at the same time let all the most learned men concede to me this my second request: that they all not be reluctant to diligently record the names of those who have in various ways designed museums, theaters, or collections of this kind and are still developing them.

From the new castle of the city of Munich, the capital of Upper Bavaria. In the year of our Lord 1565, in the month of October.

End of the Theater as a Whole, and of the Exemplars Presently at Hand, of Samuel Quiccheberg

[H2r]

Most suitably for the conclusion of the whole matter, one ought to recall the example of Solomon's consummate wisdom, even about the abundance of things:

> And God also gave to Solomon wisdom and prudence in great quantity, as well as a breadth of understanding as measureless as the sand on the seashore. And the wisdom of Solomon surpassed that of all peoples of the

East and of Egypt. And he was wiser than all men, wiser than Ethan the Ezrahite and than Heman, Chalcol, and Darda, the sons of Mahol; and his name was known among all surrounding peoples. Solomon told three thousand parables, and his songs numbered five thousand.[200] He discussed trees, from the cedar in Lebanon all the way down to the hyssop that grows from the wall; and he discoursed on beasts of burden, creatures that fly, those that crawl, and fish. People came from all nations to hear the wisdom of Solomon and from all the kings of the earth who had heard of his wisdom. (3 Kings 4D)[201]

Through the example of King Hezekiah, one should pray that the owners of these things might have peace of mind.

At that time Merodach-Baladan, son of Baladan and king of the Babylonians, sent a letter and gifts to Hezekiah, for he had heard that Hezekiah had been ill. And Hezekiah showed them his storehouses of spices, gold, silver, various ointments, and oils, as well as his armory[202] and everything that he was able to hold in his treasuries: there was nothing in his house nor in his entire kingdom that Hezekiah did not show them.[203]

But because a certain arrogance was betrayed here, and in the extent of things shown—to the pagans, no less—a certain impudence, the prophet Isaiah foretold ill for the king in the future; and to the many words prompted by the Lord, the king in turn responded as follows: [H2v] "The word of the Lord which you have spoken is good; if only there might be peace and truth in my days." (4 Kings 20D)[204]

Thus may all things redound solely to divine praise and to the benefit of men.

Symbol of a Small Book[205]

The Almighty gave knowledge to men to be honored in his wonders. (Eccles. 38a)[206]

Here I have allocated space for tributes that friends who are devoted to these matters, other learned men, and perhaps even printers and poets might add by writing them under their illustrious names, so that if ever we should have to reprint this little book they would be associated with it. And so from being scholarly (which it is on account of its inscriptions), it will become historical as well, owing to the fact that so many outstanding men, sought from all parts of

the world, will have been celebrated in it until, once these names have been supplemented more liberally, they will together serve as the greatest work of historical exemplars of our time, begun by us. The first draft of this work has still not been seen publicly as of the year 1565; nonetheless, it will eventually be opportune to publish it. In the meantime, those who will wish to help us with names will have an excellent opportunity to convey them to Georg Willer,[207] bookseller of Augsburg and assistant and patron to a great many printers throughout the region. He is already sufficiently well known from book catalogs that he publishes in connection with books distributed at several fairs in Frankfurt and that he disseminates to learned men everywhere. As for the rest, the fact that I just now mentioned—that our little book is partly scholarly and turns out to be partly historical—was presented so that furnishers and donors of libraries might still hear from me as to which classes, or more precisely, to which shelves and indexes I think the entire short commentary should be assigned, once the diversity of its contents has been considered. [H3r]

Petrus Cortonaeus[208] on the Theater of Quiccheberg
As many things as nature and art are able to devise for the sake of mortals,
This theater brings out from innermost sanctuaries, as it were.

Another Distich
The theater draws open the curtain on the boundless universe
In fact, this theater alone perceives clearly the particularities of the universe.

Erasmus Vend[209] on the Theaters of the Most Illustrious Albrecht
Duke of Bavaria
If the world has anything remarkable in its enfolding vastness
The theaters of Bavaria, rivaling nature, possess it.
The monuments of benevolent Prince Albrecht shine forth.
They are likenesses of his luminous mind.

Vitus Jacobaeus, Imperial Poet,[210] in Regard to the Fact That Here Amid
the Peacetime Pursuits, Training in Weaponry Is Also Suggested
What in times of peace, or times of war, must be practiced,
These things Quiccheberg teaches in brief.
Let your nobility undertake what its duties demand from it,
And the learned throng acknowledge your service.

Elegy of Gabriel Castner[211] upon Quiccheberg Collecting Historical Exemplars in Accordance with the Classes of His Theater

Goltzius sought fame at the outermost shores,

While he studiously collected the coins of ancient forebears. [H3v]

In the end, however, his subject, that unvariegated kind,

Was never changed from his original aim.

Oh, what fields does your meditation traverse, Samuel,

Since you stitch together material, almost without end.

Here you arrange sacred images, here coats of arms and maps,

There you place materials and statues.

You provide the sequence of descendants, you provide the instruments

Of the sisters Euterpe the nymph and Terpsichore the goddess.

How could I mention individual things? The matter is infinite to relate,

Which demands both devotion and genius.

If through coins alone such great praise arises,

Which Goltzius the author now possesses by merit,

How much more renown is owed our own Quiccheberg,

Who collects uncountable kinds of things?

Hence when you publish the book you have long been arranging,

Which overflows with historical exemplars,

Then the honor that recently began to run along an easy path

Will come more freely, pouring out in great quantity.

Jodocus Castner[212] on the Theater of Quiccheberg

Once one is captured by the immeasurable charm of art,

What need is there to set full sail upon the shipwrecking surface of the sea,

In order to survey whatever marvels this vast world contains?

What is the delight in eagerly traversing so many lands? [H4r]

A single theater that displays everything in its classes

Can serve as a stand-in for the globe in its entirety: an accomplishment.

Joachim Haberstock[213] of Freising, for Aegidius Oertel[214] and Samuel Quiccheberg

A studious mind, cherished by the Muses, equals the ranks of the gods

And surpasses the home of the sun.

But this divine favor, arriving from heaven,

Is granted only by reason of sleepless labors (a great matter),

Nor, if not devoutly dwelling in these noble sanctuaries of the Muses,

Will he be worthy of so great a gift as this.

Therefore, it is a pious matter to survey sacred libraries;

From this, you truly must believe, renown comes constantly,

And thus accredited to you, Oertel, its first director, the library of Bavaria will give perpetual fame.

But greater by far, to be celebrated by many Muses,

Is that arduous thing, a labor to learned men.

Merely to have built new temples to the Muses,

To be gazed at with their complex arrangement and varied kinds of things,

Which you show forth, Quiccheberg, in your well-constructed theater.

If there can be anything more learned than this, I shall die.

End. [H4v]

Notes

1. Although Quiccheberg provides a digression for this inscription, the Berg edition lacks the Mercury symbol here.

2. Derived from Ptolemy, early modern cartography recognized three modes of mapping: geographic, which was concerned with the world as a whole; chorographic, which treated regions; and topographic, which described particular places.

3. *Celebritas concessorum regalium* may also refer to the festive dispensation of royal favors.

4. Although Quiccheberg provides a combined digression for this and the following inscription, the Berg edition lacks the Mercury symbol here.

5. Although Quiccheberg provides a combined digression for this and the following inscription, the Berg edition lacks the Mercury symbol here.

6. Although Quiccheberg provides a digression for this inscription, the Berg edition lacks the Mercury symbol here.

7. Literally, "by our great-grandfathers and great-great-grandfathers, both kings and princes."

8. By "symbolic objects," Quiccheberg refers to plaquettes: small bas-relief images of stories, allegories, animals, emblems, and devices with an image on one side only. While produced using the same techniques as coins and medallions, these can have various shapes (e.g., rectangular, square, and oval).

9. That is, kinds of decorative metalwork that do not fit into the preceding inscriptions, such as engraved metal boxes, mirror backs, and so on.

10. Possibly *dionysos* marble, a white stone comparable in quality and appearance to Carrara marble.

11. Instrumental ensembles, or consorts, were divided into two classes. A broken consort was composed of different kinds of instruments, in contrast to one made

up of instruments all from the same family, such as a bass, tenor, alto, and treble viol.

12. The regular solids, also known as the Platonic solids, include the tetrahedron, cube, octahedron, dodecahedron, and icosahedron.

13. *Pulpiti* are the pulpit- or lectern-like writing desks such as those depicted in images of *studioli.*

14. The term *laboratories,* as places where things are made, is here understood as a specification of the more generic *workshops.*

15. An *aliptes* is the person responsible for the physical care of wrestlers, especially through the application of unguents.

16. Although Quiccheberg provides a digression for this inscription, the Berg edition lacks the Mercury symbol here.

17. The Berg edition included a Mercury symbol here, although there is no corresponding digression.

18. Quiccheberg possibly refers to patchwork leather garments sewn from hides dyed a variety of colors.

19. Quiccheberg apparently produced such charts in his now-lost publication *Tabulae medicinae* (Medical table; 1565).

20. With the sequence of ancestry by four, eight, sixteen, etc., Quiccheberg refers generationally to grandparents, great-grandparents, and so forth.

21. Quiccheberg refers either to the highest quality of tapestry, interwoven with gold threads or to cloth of gold, one of the most expensive fabrics of the period. *Tela* normally refers to the vertical warp (as in cloth of gold) of golden threads through which the colored silk threads are interwoven. Tapestries more typically have the gold threads in the weft.

22. This inscription is lacking in the Vatican manuscript.

23. *Locorum communium* in this instance refers to the standard topics and themes for books in the period and not necessarily to books about commonplaces.

24. The location of this discussion of bookbinding within the context of a woodworking workshop is problematic. This sentence has probably been transposed from the previous discussion of the printing shop.

25. Literally, *vermis* means "worms," but as in the English *vermin,* here it refers to insects in general.

26. *Conclave* can refer to any storage area, workspace, treasury, or study that is accessible only through a lockable door. The usual English term in the period was *closet.*

27. The literal translation is "images made from copper forms," which conceivably could mean bronze statuettes. Given that all of the other examples he provides in this passage are two-dimensional, we have chosen engravings as the proper meaning.

28. The literal translation is "portraits on hanging tablets," referring to movable panel paintings.

29. *Larvatus* here refers to a large entertainment in costume, disguise, or masks. The equivalent English term in the period was *maske,* later spelled *masque.*

30. See class 4, inscription 9 (this volume, page 68).

31. Count Froben Christoph von Zimmern (1516–66/67) was a historian and is thought to be the author of the *Zimmerische Chronik,* a chronicle of his family's history. He was the nephew of Wilhelm Werner von Zimmern. Wolf 1993, 512–28; Jenny 1959; Pantaleon 1570, 228; and Quiccheberg 2000, 87, 195, 258, 306.

32. The Latin and the context of the treatise suggest that *condicio* (choice) is intended here, rather than *conditio* (preservation), as in the text.

33. *Enumeratione generali* might also mean the enumeration pertaining to Quiccheberg's five classes (that is, *genera*) of objects.

34. Cicero 1942, 1:6.

35. A container constructed like a polyptych altarpiece, with multiple hinged wings that open to a sequence of states. See digressions on class 4, inscription 5 (this volume, page 68), and class 5, inscription 10 (this volume, pages 70–71).

36. Quiccheberg's original text incorrectly references class 5, inscription 9; in the translation, I have amended the reference.

37. This refers to Hans Burgkmair the Elder (1473–1531) or the Younger (b. ca. 1500). Probably Burgkmair the Elder, since Burgkmair the Younger was better known as a graphic artist. Burgkmair the Elder was a famous painter and printmaker in Augsburg. He was the main illustrator for Emperor Maximilian I's *Theuerdank* (1517) and *Weisskunig* (1510–15). Burgkmair the Younger was primarily a printmaker. *NDB* 1953–2010, 3:47; Bosl 1983, 104; and Quiccheberg 2000, 93, 267.

38. Ioannes Ravisius Textor (1480–1524), a gifted linguist and humanist, was a professor at the College of Navarre in Paris and in 1520 was appointed rector of the University of Paris. He compiled two monumental commonplace compendia, the *Nivernensis Officina partim historicis partim poeticis referta disciplinis* (1520) and the *Ioannis Ravisii Textoris epitheta* (1524). Chaudon 1810–12, 17:194; Ong 1976, 91–126; Jöcher 1726–33, 2:812; and Quiccheberg 2000, 95, 267.

39. It is possible that Quiccheberg here makes a comparison between learning through images and through direct sensory perception of objects.

40. Duke Wilhelm IV of Bavaria (1493–1550; r. 1508–50).

41. Anna of Austria, Duchess of Bavaria (1528–90), married Albrecht V in 1546. She was the daughter of the Holy Roman emperor Ferdinand I of Austria (1503–64) and Anna of Bohemia and Hungary (1503–47). Through her sister Johanna of Austria, Anna was sister-in-law to Ferdinando I de Medici. Quiccheberg 2000, 83, 101, 135, 256, 269. For a general discussion of the history of women in relation to the pharmacy, see Schelenz 1975.

42. Jacobäa, Marquise of Baden (1507–80), was the mother of Duke Albrecht V and wife of Duke Wilhelm IV of Bavaria Quiccheberg 2000, 83, 101, 135, 256.

43. Scholastica Nothafft (1509–89) was married to Christoph von Schwarzenberg. She was employed as *Oberhofmeisterin* (chamberlain to the duchess) at the Bavarian court. Schwarzenberg 1963, 78; and Quiccheberg 2000, 83, 101.

44. Baron Christoph von Schwarzenberg I (1488–1538) was intermittently employed in the emerging Bavarian bureaucracy. His son with Scholastica Nothafft, Ottheinrich, played a large role in Albrecht V's government. Schwarzenberg 1963, 77; Bosl 1983, 710; Lanzinner 1980, 402; and Quiccheberg 2000, 83, 101, 256.

45. This is an explicit reference to the architecture of the ducal Kunstkammer in Munich, under construction at the same time Quiccheberg published this book. Built above the stables, the building was in the form of a quadrilateral, three stories tall, with an open courtyard in the center. The Kunstkammer occupied the uppermost floor, with four long, narrow galleries lit by windows on both sides.

46. Giulio Delminio Camillo (ca. 1480–1544) studied philosophy and jurisprudence at the University of Padua and counted Erasmus, Pietro Aretino, Pietro Bembo, the architect Sebastiano Serlio, and the painter Titian among his acquaintances. In 1530, he entered the employment of King Francis I in Paris, for whom he drafted his *L'idea del theatro,* or *Theatro della Sapientia.* Based on the premises of the classical art of memory, Camillo's theater was intended to house the cumulative wisdom of the cosmos. Despite building a wooden model of the theater, funding from Francis came to an end and Camillo returned to Italy in 1537. Yates 1966, 129–172; Jöcher 1726–33, 1:536–37; and Quiccheberg 2000, 107, 111.

47. Christoph Mylaeus (d. 1570) was a Swiss humanist and the author of *De scribenda universitatis rerum historia libri quinque* (1551), a presentation of *universitatis rerum* (universal knowledge) ordered under the five topics of *natura* (nature), *prudentia* (prudence), *principatus* (governance), *sapientia* (wisdom), and *literatura* (literature, writing). Mylaeus also published the *Theatrum universitatis rerum* (1557), a chart summarizing his treatise. Kelley 1999, 342–65; and Quiccheberg 2000, 109.

48. Conrad Lycosthenes (1518–61) was an Alsatian humanist, trained in philosophy at Heidelberg, who taught at the university in Basel from 1542 until his death. He began the *Theatrum vitae humanae* (1565), which was completed by his stepson Theodorus Zwinger. Pantaleon 1570, 406–7; *ADB* 1967–71, 19:727–28; Jöcher 1726–33, 1:1621; and Quiccheberg 2000, 109.

49. Theodorus Zwinger (1533–88) studied medicine at Padua before returning to teach at the University of Basel in his native Switzerland. He was the son, by a prior marriage, of Lycosthenes's wife, Chretienne Herbster; she, in turn, was the sister of Johannes Oporinus, the publisher of both Mylaeus's *Theatrum universitatis rerum* and the *Theatrum vitae humanae,* which Zwinger completed

upon the death of Lycosthenes. *ADB* 1967–71, 45:543–44; Jöcher 1726–33, 2:2019; and Quiccheberg 2000, 109.

50. Guilelme de La Perriere (ca. 1503–ca. 1565) was a French vernacular poet and scholar from Toulouse who recorded that city's chronicles and published the earliest French emblem book, *Le theatre des bons engins, auquel sont contenus cent emblems moraulx* (1539). Jöcher 1726–33, 2:569; and Quiccheberg 2000, 109.

51. Marcus Vitruvius Pollio (ca. 80–70 BCE–after 15 BCE) was a Roman architect and engineer. He was the author of *De architectura* (ca. 15 BCE), the only major architectural treatise to survive from classical antiquity and the primary reference work for the Renaissance revival of the classical orders. Quiccheberg 2000, 111.

52. This refers to the astronomical sign of Mercury marking those inscriptions that Quiccheberg also discusses in the Digressions.

53. Practicalities of scale determine the display method and the storage location. Single-sheet images up to a certain size can be kept in a print cabinet; multisheet maps or images, once conjoined and mounted, would be too large and so must be distributed elsewhere in the collection according to subject.

54. Quiccheberg here equates the acquisition of exquisitely crafted artifacts, made by a variety of distinguished craftsmen, to the collecting of paintings by a wide range of preeminent artists so that "it might be observed to what extent one artist seems to have surpassed the other." This volume, page 69.

55. Hubertus Goltzius (1526–83) was a founder of the field of numismatics. At the behest of Marcus Laurinus, he visited innumerable coin collections throughout Europe and cataloged hundreds of them. This resulted in several published texts on numismatics that are famous for the high quality of their engravings. *C. Iulius Caesar sive Historiae imperatorum caesarumque Romanorum ex antiquis numismatibus restitutae liber primus* (1563) provided Quiccheberg with many of the names he includes in his section on exemplary collectors. *ADB* 1967–71, 9:362–63; Jöcher 1726–33, 1:1115; Reinhardstöttner 1890, 46; and Quiccheberg 2000, 121.

56. Conrad Gesner (1516–65) was a Swiss humanist and bibliographer who specialized in natural philosophy. He studied at the universities of Bourges, Paris, Montpellier, and Basel, where he received his doctorate in medicine in 1541. He authored the *Bibliotheca universalis, sive catalogus omnium scriptorum locupletissimus, in tribus linguis, Latina, Graeca, & Hebraica* (154–55), which attempted to list all works written in Latin, Greek, and Hebrew up to the date of its publication. This was followed by the *Pandectarum sive partitionum universalium* (1548), which organized the contents of the *Bibliotheca universalis* thematically. Gesner is best known for his publications in natural philosophy, especially the *Historia animalium* (1551–87) and the *Catalogus plantarum Latinae, Graecae, Germaniae & Gallice* (1542). Serrai, Menato, and Cochetti 1990;

Pantaleon 1570, 456–57; *ADB* 1967–71, 9:107–20; *NDB* 1953–2010, 6:342–45; Jöcher 1726–33, 1:1084–85; and Quiccheberg 2000, 123.

57. Leonhard Fuchs (1501–66) was a humanist and botanist who taught at Ingolstadt and Tübingen. Between 1524 and 1526 he practiced medicine in Munich. He is known for his botanical work *De historia stirpium* (1542), which lists plants alphabetically and explains their medicinal properties. The flowering plant fuchsia is named after him. *ADB* 1967–71, 8:169–70; *NDB* 1953–2010, 5:681; Reinhardstöttner 1890, 55, 90; Bosl 1983, 230; Jöcher 1726–33, 1:1022; and Quiccheberg 2000, 123.

58. After studying philosophy and medicine at German and Italian universities, Georg Agricola (1490/94–1555) worked as a doctor in mining towns, where he became interested in geology and mineralogy. He gave up his profession and visited other mining areas, advising proprietors and workers on technological and mechanical matters. His prolific output on the topic, especially his *De re metallica* (1556), shaped the science of mining. Pantaleon 1570, 182; *ADB* 1967–71, 1:143–45; *NDB* 1953–2010, 1:98–100; Jöcher 1726–33, 1:60; Bietenholz and Deutscher 1986, 1:13–14; and Quiccheberg 2000, 123.

59. Born to an aristocratic family in Bologna, Ulisse Aldrovandi (1522–1605) studied law, philosophy, and medicine at the universities of Padua and Bologna, where he taught after receiving his degree in 1553. He was appointed professor of philosophy in 1559 and professor of natural philosophy in 1569. One of the most renowned naturalists in Europe, Aldrovandi published prodigiously, including his taxonomic work on fish, *De Piscibus libri 5 et de Cetis libro vnvs.* (1613), one of a series of treatises on metals, plants, insects, fish, reptiles, and birds. He founded the botanical gardens in Bologna in 1568. Aldrovandi assembled one of the most comprehensive collections of *naturalia* in Europe. Olmi 1978; Jöcher 1726–33, 1:98–99; and Quiccheberg 2000, 123.

60. Cyprian Schaller (n.d.) is mentioned in the Augsburg goldsmith ordinance of 1529. He married Sibilla Müller, of the Müller mercantile family in Augsburg. Christoph Weiditz produced a portrait medallion of Schaller in 1527 with the inscription *Ziprianus Schaller considera celestia cetera sunt caduca M.D.XXVII* (Cyprian Schaller, consider the rest of what is transitory in the heavens). Seling 1980, 41; and Quiccheberg 2000, 125, 238, 267.

61. Johann Schümberger (n.d.) was a goldsmith in Augsburg. No further information is available. Quiccheberg 2000, 125.

62. A theologian, Marbodeus Gallus (1035–1123) taught in his hometown of Angers and in 1096 became bishop of Rennes. In the early 1100s, he wrote the *Liber lapidum* (Book of stones), a treatise in hexameters on precious and semiprecious stones and their medical properties. See Marbodeus Gallus [1539]; and Quiccheberg 2000, 127.

63. Georgius Pictorius Villinganus (ca. 1500–69), from the village of Villingen, was physician to Archduke Ferdinand II's court at Ensisheim. He wrote books on bloodletting, balneotherapy, medicinal herbs, and gynecology, as well as works on magic. He contributed verses to the *Liber lapidum* of Marbodeus of Rennes, including a poem on the millstone. Adams 1938, 154–55; Pantaleon 1570, 194–95; Jöcher 1726–33, 2:640; and Quiccheberg 2000, 127, 240, 280.

64. Anton Maiting (ca. 1524–91) was an Augsburg patrician, a Fugger agent in Spain, an agent for the Bavarian dukes, and an employee of Philip II of Spain. In 1564, Maiting brokered the sale of precious objects, including jewels and a crystal jug, between Spain and Augsburg. Reinhard and Häberlein 1996, 532–34; and Quiccheberg 2000, 129, 131, 281.

65. The original text reads "For Inscription 8," but the material discussed belongs to Inscription 9.

66. The daughter of Albrecht V and Anna of Austria, Maria Anna (1551–1606) married her maternal uncle, Charles II of Austria, in 1571. She was the mother of Emperor Ferdinand II. Maximiliana Maria (1552–1614) was an unmarried daughter of Albrecht V and Anna of Austria. Quiccheberg 2000, 135.

67. Jacobäa (1558–97) and Salome (1563–1600) were the daughters of Margrave Philibert of Baden-Baden and Mathilde of Bavaria and the nieces of Albrecht V. Quiccheberg 2000, 135.

68. Mechilde (1532–65) was the daughter of Duke Wilhelm IV of Bavaria and the sister of Duke Albrecht V. Quiccheberg 2000, 135.

69. Wilhelm V (1548–1626; duke from 1579 to 1597) was the eldest son and successor of Albrecht V. He continued his father's interest in art and collecting. *ADB* 1967–71, 42:717–723.

70. Second son of Albrecht V, Ferdinand (1550–1608) attended the 1565 wedding of Ferdinando I de Medici to his aunt, Johanna of Austria. He had a distinguished military career. *NDB* 1953–2010, 5:365.

71. Ernst (1554–1612) was the third son of Albrecht V and served as prince-elector-archbishop of Cologne from 1583 to 1612. *ADB* 1967–71, 6:250–52; *NDB* 1953–2010, 4:614.

72. In period bookbinding, shorter books were frequently left unbound until a sufficient number of them could be bound together.

73. The first five subdivisions of the second region of printed images correspond to the Ptolemaic tripartite division of cartography: geography, or representations of the entire world; chorography, regional descriptions; and topography, the representation of particular places, including cities, buildings, and monuments.

74. Mathias Schalling (n.d.), named an *alte Diener* (old servant) in the financial records of the court, served for thirty years in the Bavarian Kunstkammer. Baumann-Oelwein 2000, 31–32; and Quiccheberg 2000, 145.

75. Quiccheberg 1565b. The manuscript is titled *Inscriptiones theatri materiarum, imaginumque universitatis seu tituli, promptuarij artificiosarum miraculosarumque rerum ac omnis rari thesauri, vel preciosae suppelectilis aut picturae, ad singularem aliquam prudentiam comparandam utilis* (Inscriptions or titles of the universal theater of materials and images; a repository of artificial and marvelous things and of every rare treasure, object, and picture: useful for acquiring unique knowledge).

76. Peter Obernburger zum Train (d. 1588) studied law at Ingolstadt and in Bologna and was later employed at court in Munich (1562–67). He served as *Reichshofsekretär* (imperial secretary) for Emperor Maximilian II and later as *Reichshofrat* (imperial counselor) to Rudolph II. Bosl 1983, 556; Lanzinner 1980, 383; and Quiccheberg 2000, 147.

77. That is, *alba amicorum* (books of friends), which were albums in which visitors, friends, and family inscribed their names, usually accompanied by brief dedicatory inscriptions.

78. Heinrich Taufkirchen zu Höhenrain (1539–1600) studied at Ingolstadt, Bourges, and Padua. His family belonged to the lower Bavarian nobility (main seat: Regensburg). From 1565 to 1568, he was employed at court in Munich, and later at Duke Wilhelm of Bavaria's court at Landshut (1577–78). Bosl 1983, 771; Lanzinner 1980, 321; and Quiccheberg 2000, 149.

79. In employing the phrase "German heroes," Quiccheberg refers to the title of Heinrich Pantaleon's *Prosopographiae heroum atque illustrium virorum totius Germaniae . . .* (Pantaleon 1565–66).

80. Reading *aperiantur* for *aperiatur.*

81. The son of a Spanish nobleman at the court of Mantua, Baptista Mantuanus (1447–1516) entered the Carmelite order. He received degrees and taught philosophy and divinity. Later, he became tutor to the Duke of Mantua's children. Mantuanus was a prolific and widely read Latin poet. His *Eclogae* were especially popular among German scholars of the time. Ellinger 1929, 103; Bietenholz and Deutscher 1986, 2:375; and Quiccheberg 2000, 155.

82. The Colossus of Rhodes, a statue depicting Helios.

83. Probably the *Penitential Psalms* of Orlando di Lasso and the motets of Cipriano di Rore, both richly illuminated by Hans Mielich.

84. Hans Mielich (1516–73) was a painter of portraits and miniatures. After studying in Regensburg with Albrecht Altdorfer, Mielich returned to Munich. The Bavarian court and local patrician families commissioned works from him. He was the illuminator of two luxury manuscripts: Orlando di Lasso's choral setting of the *Penitential Psalms* (1565), which contains a portrait miniature of Quiccheberg (see pl. 1), and a collection of motets by Cipriano de Rore. Quiccheberg supervised the production of both manuscripts and wrote commentary volumes on their

illuminations. Löcher 2002; *ADB* 1967–71, 22:440–42; *NDB* 1953–2010, 18:263–265; Bosl 1983, 534; Reinhardstöttner 1890, 84–86; and Quiccheberg 2000, 157.

85. The meter of arithmological poetry is constructed according to Pythagorean or other systems of geometric and musical proportions and ratios.

86. Probably Georg Fabricius (1516–71), who used the Latin pseudonym Gerardus Faustus Confluentinus [of Koblenz]. A philologist, Fabricius studied at Leipzig in 1535. Later, he traveled in Italy collecting antiquities, after which he relocated to Strasbourg, where he was visited by Goltzius. He later served as historiographer to the Saxon court and was crowned poet laureate in 1570 by Maximilian II. Goltzius 1563, sig. bb1r; Pantaleon 1570, 471; *ADB* 1967–71, 6:510–14; *NDB* 1953–2010, 4:734; Jöcher 1726–33, 1:917–18; and Quiccheberg 2000, 160, 163.

87. Hadrianus Junius (1511–75) was a Dutch botanist and scientist and the author of *Batavia* (1588), a history of Holland. Goltzius 1563, sig. aa3v; *ADB* 1967–71, 14:736–37; Jöcher 1726–33, 1:1433; and Quiccheberg 2000, 163.

88. Quiccheberg names Petrus Cortonaeus (act. 1553–98) as a physician to Duke Albrecht V; he also produced an arithmology in Greek. A Petrus Cortonaeus of Udine published a collection of Greek poems: *Varia carmina graeca* (1555). Karl von Reinhardstöttner records that a Peter Carteneus received fifty gulden for the sale of a book to the ducal library. Reinhardstöttner 1890, 56, 84; and Quiccheberg 2000, 163.

89. Heinrich Pantaleon (1522–95) studied at many European universities. In 1539, he was apprenticed to a book printer in Augsburg and in 1556 became a professor of medicine in Basel. He wrote numerous philological and scientific tracts. His *Prosopographiae heroum atque illustrium virorum totius Germaniae* (1565–66) provided biographies of famous Germans. A German edition, *Teutscher Nation Heldenbook* (1560–70), was published in three volumes. Quiccheberg contributed to this reference work, as did Conrad Gesner. Pantaleon included his autobiography at the end of volume 3. Pantaleon 1570, 529–34; *ADB* 1967–71, 25:128–31; Jöcher 1726–33, 2:486–87; and Quiccheberg 2000, 165.

90. Maximilian II (1527–76; Holy Roman emperor 1564–76) was the son of Emperor Ferdinand I (who founded the Habsburg Kunstkammer) and brother of Duchess Anna of Bavaria and Grand Duchess Johanna of Tuscany. In addition to being an avid collector of antiquities, paintings, and sculpture, Maximilian tried his hand as a goldsmith and a practical alchemist, and had a keen interest in botany. Lhotsky 1941–45; and Rudolf 1995.

91. Daniel Brendel von Homburg, elector of Mainz (1523–82), was arch-chancellor of the Holy Roman Empire and became archbishop and prince-elector of Mainz in 1555. A vigorous promoter of the Counter-Reformation, he summoned Jesuits to the seminary, which in time became a major center of theological learning and was later incorporated into the University of Mainz. He commissioned many

works of art and assembled a Kunstkammer. Goltzius 1563, sig. aa4r; Pantaleon 1570, 441–42; *NDB* 1953–2010, 3:507; Bosl 1983, 92; and Quiccheberg 2000, 171, 297.

92. The Leyen family was prominent in Trier and many of its members were high-ranking church officials. Johann von der Leyen VI (ca. 1510–67) became elector of Trier in 1555 and archbishop in 1556. He attended the Imperial Diet in Augsburg in 1559. Highly educated himself, he took great interest in the University of Trier, and in 1560/61 recruited Jesuits as instructors. *ADB* 1967–71, 14:426–27; *NDB* 1953–2010, 3:499, and Quiccheberg 2000, 171.

93. Friedrich IV, Count of Wida (ca. 1518–68), was elector and archbishop of Cologne from 1562 to 1567. His predecessor was Gebhard von Mansfeld I. Pantaleon 1570, 488; *NDB* 1953–2010, 5:512 and 8:636; and Quiccheberg 2000, 171.

94. Gebhard von Mansfeld I (d. 1562) was an arch-chancellor of the Holy Roman Empire and the prince-elector and archbishop of Cologne from 1558 to 1562. Goltzius 1563, sig. aa4r; and Quiccheberg 2000, 171.

95. Friedrich III (1515–67) became elector of the Palatine in 1559. His wife converted him to Lutheranism and in 1561 Friedrich introduced the Calvinist faith to the region. Friedrich commissioned the 1563 "Heidelberger Katechismus," and strongly supported the University of Heidelberg, which rose to be a major center of Calvinist learning during his reign. Pantaleon 1570, 431–32; *ADB* 1967–71, 7:606–12; *NDB* 1953–2010, 5:530–32; and Quiccheberg 2000, 173.

96. When Ottheinrich, elector of the Pfalz (1502–59), became ruler of Pfalz-Neuburg, Ottheinrich embraced the Protestant Reformation. For the purpose of distributing texts on the new religion, he supported the printing and publishing endeavors of Hans Kilian. Ottheinrich collected manuscripts, books, and works of art. His library grew rapidly, partly because he raided monastery collections. After Ottheinrich was appointed Elector Palatine in 1556, he added the so-called *Ottheinrichsbau* to the ensemble at Heidelberg Palace (1556–59), one of the foremost Renaissance structures in Germany. His Biblioteca Palatina laid the foundation for the famous university library in Heidelberg. When the Catholic League seized Heidelberg in 1622, the library was claimed as war reparations by the pope and remains in the Vatican to this day. Gullath and Bayerische Staatsbibliothek 2002; Zeitelhack and Stadt Neuburg an der Donau 2002; Goltzius 1563, sig. bb; *ADB* 1967–71, 24:713–19; *NDB* 1953–2010, 19:655; Bietenholz and Deutscher 1986, 3:43; and Quiccheberg 2000, 173, 296.

97. The second surviving son of Duke Heinrich of Saxony, August I, elector of Saxony (1526–86), ascended to the dukedom upon the death of his brother Maurice in 1553. Although a Lutheran, Augustus pursued a policy of appeasement with the Habsburgs. An avid collector of arms and an active arts patron, he founded the Dresden Kunstkammer. During his lifetime, the Kunstkammer focused heavily on the collection of tools and instruments of the sorts proposed by Quiccheberg

in his fourth class. Pantaleon 1570, 438–40; *NDB* 1953–2010, 1:448–50; and Quiccheberg 2000, 173.

98. Joachim II, elector of Brandenburg (1505–71), founded the Prussian Kunstkammer, which his successors, electors Johann Georg and Joachim Friedrich, vastly expanded. During the Thirty Years' War, the collection was inventoried and packed away for safety but probably destroyed. Hildebrand and Theuerkauff 1981; Pantaleon 1570, 323–24; *ADB* 1967–71, 14:78–86; *NDB* 1953–2010, 10:436–38; and Quiccheberg 2000, 173, 296.

99. Otto Truchsess von Waldburg (1514–73) studied law and humanities in Germany and Italy. At Bologna, he was a fellow student of Hans Jakob Fugger. In 1537, Truchsess entered the services of Pope Paul III and in 1543 was rewarded with the cardinal-bishopric of Augsburg for his success in his diplomatic dealings with the emperor. In 1544, he began incurring large debts by collecting art and antiquities. To house his growing collection, he had a tower (*Heiliger Turm*) built at his residence in Dillingen. Truchsess founded the University of Dillingen (1549) and a seminary, both of which were run by Jesuits. He donated his private library to the university, where it became the foundation for the university library. In 1550, he established the university's printing press. From 1568 until his death, Truchsess acted as intermediary between the pope and Albrecht V as agent in the latter's acquisition of antiquities for the Munich Antiquarium. Overbeeke 1994, 173–79; Goltzius 1563, sig. aa4v; Pantaleon 1570, 297–98; *ADB* 1967–71, 24:634–40; *NDB* 1953–2010, 19:667–69; Bosl 1983, 819; Reinhardstöttner 1890, 46; and Quiccheberg 2000, 175, 297.

100. Friedrich von Würzburg (1507–73) became bishop of Würzburg in 1559. He took an interest in reforming education and founded Würzburg Gymnasium in 1561, which later became a university. He renovated and expanded Schloss Aschach (1571–73). Goltzius 1563, sig. aa4r; Pantaleon 1570, 435–36; *ADB* 1967–71, 8:60–63; *NDB* 1953–2010, 5:598; and Quiccheberg 2000, 177. Curiously, in this passage Quiccheberg designates Würzburg using four alternatives in close succession: Würzburg, Herbipolis, Wirsberg, and Wirtzbergensis.

101. Jacopo Strada (1507–88) was a renowned scholar, architect, numismatist, art collector, and art broker. He was employed by many of the most notable collectors in early modern Germany and Austria, including Hans Jakob Fugger in Augsburg, where he would first have encountered Quiccheberg. Working for Emperor Ferdinand I in Vienna from 1556, Strada managed the imperial Kunstkammer and was the architect for an expansion of the Hofburg to house the collections. He also designed Schloss Neuburg in Vienna for Maximilian II in 1564. In 1566, he entered the service of Albrecht V of Bavaria, for whom he helped develop a collection of antique statuary. Jansen 1982, 57–69; Jansen 1989–90, 308–22; Bosl 1983, 759; Reinhardstöttner 1890, 46, 58; and Quiccheberg 2000, 177.

102. Aeneas Vico (1523–67) was an engraver for Grand Duke Cosimo de Medici; he later worked in Venice. Goltzius 1563, sig. bb1v; and Quiccheberg 2000, 18, 179, 300.

103. A Medoro Nucci from Arezzo (n.d.) was resident in Venice in the mid-sixteenth century. He was acquainted with Pietro Aretino and offered his services as agent to Cosimo I and Francesco I de Medici. Nothing is known of his collecting activities. Quiccheberg 2000, 179.

104. Johannes Pannonicus Sambucus (1531–84), born in Hungary, studied in Paris, Padua, and Ingolstadt, where he was close to Johannes Aurpach and his literary circle. He later became *Hofrat* (counsel) and personal physician to Habsburg emperors Maximilian II and Rudolph II. In Vienna, he wrote histories and also published editions of the classical authors, many of whose works he had acquired for his considerable library collection. In 1581, he offered to sell Duke Wilhelm of Bavaria various ancient coins and medals, twelve marble busts, and a narwhal tusk for 7400 ducats. Visser 2005; Ellinger 1929, 406; Goltzius 1563, sig. bb1v; Jöcher 1726–33, 2:1006; *ADB* 1967–71, 30:307–8; and Quiccheberg 2000, 179.

105. Exiled from his land when he was a minor, Christoph, Duke of Württemberg (1515–68), grew up at the Habsburg court. Later he was reinstated and became a major Protestant leader and legislative reformer. Although the earliest written evidence of a Kunstkammer at the Stuttgart court dates to the rule of Christoph's successor Duke Friedrich I, Christoph also collected, and objects purchased by him appear in later inventories of the Stuttgart Kunstkammer. Fleischhauer 1982; Goltzius 1563, sig. aa4r; Pantaleon 1570, 402–5; *ADB* 1967–71, 4:243–250; *NDB* 1953–2010, 3:248; Bietenholz and Deutscher 1986, 3:464; and Quiccheberg 2000, 177.

106. Johann Jacobus Khuen (ca. 1517–86) became archbishop of Salzburg in 1560. In 1563 he had Burg Hohenwerfen redesigned in an Italian manner and in 1573 had a new palace constructed at the Burg. Pantaleon 1570, 483–84; and Quiccheberg 2000, 181, 298.

107. Urbanus von Trennbach (1525–98) became prince-bishop of Passau in 1561. During his reign, Passau's Gothic cathedral, St. Stephan's, was completed. Urbanus was an important figure of the Counter-Reformation in Bavaria. His court painter was Leonhard Abent. He had a particular interest in coins and undertook the reconstruction of the Salzburg mint. Bosl 1983, 786; and Quiccheberg 2000, 181, 298.

108. A descendant of one of the oldest families of Bavarian nobility, Vitus von Fraunberg (d. 1567) became bishop of Regensburg in 1563. He was the brother-in-law of Wiguleus Hundt. Bosl 1983, 217; Reinhardstöttner 1890, 111; and Quiccheberg 2000, 181, 298.

109. Moritz von Sandizell (1514–67) became bishop of Freising in 1559, but stepped down in 1566 in favor of Duke Albrecht's son Ernst. *NDB* 1953–2010, 18:135; Bosl 1983, 660; and Quiccheberg 2000, 181, 298.

110. Moritz von Hutten (1503–52). A member of the minor nobility, Moritz von
 Hutten became bishop of Eichstätt in 1539. Both Goltzius and Quiccheberg
 erroneously assign him the bishopric of Freising, perhaps confusing him with
 Moritz von Sandizell. Goltzius 1563, sig. Bb; and *NDB* 1953–2010, 10:98.

111. Martin von Schaumberg, bishop of Eichstätt (d. 1590), studied at Ingolstadt and
 Bologna. He was appointed bishop of Eichstätt in 1560 and was an active founder
 of seminaries. As bishop of Eichstätt, he also by definition became chancellor of
 the University of Ingolstadt. Buzás 1972, 35n6; Pantaleon 1570, 489–90; Bosl 1983,
 668; and Quiccheberg 2000, 181, 298.

112. Ambrosius von Gumppenberg (ca. 1501–74) studied at Tübingen and Ingolstadt.
 He relocated to Rome and quickly rose in the church hierarchy, gaining the
 confidence of high-ranking officials and popes. He was sent on diplomatic
 missions to the German princes and bishops and mediated between the parties
 during the Sack of Rome (1527). Friedensburg 1902, 149–85, 263–93; *ADB* 1967–71,
 10:122–23; *NDB* 1953–2010, 7:310; Bosl 1983, 285; and Quiccheberg 2000, 183, 299.

113. Count Alexander Secundus Fugger (1546–1612) was the son of Hans Jakob Fugger
 and held the offices of cathedral provost in Freising and Metz. *NDB* 1953–2010,
 5:720; and Quiccheberg 2000, 183, 299.

114. Wiguleus Hundt (1514–88) was a historian and legal scholar and *Rektor* of the
 University of Ingolstadt. Married to Anastasia Fraunberg, he was brother-in
 law of Ambrosius von Gumppenberg. He served as one of Albrecht V's main
 advisers from 1552 on. His works include a history of the bishopric Salzburg and
 other genealogical histories of Bavarian noble families. Goltzius 1563, sig. Bb1r;
 Pantaleon 1570, 447–48 (by Quiccheberg); *NDB* 1953–2010, 10:64–66; Bosl 1983,
 379; Reinhardstöttner 1890, 62; and Quiccheberg 2000, 183, 300.

115. Baron Ottheinrich I von Schwarzenberg (1535–90) was the only surviving son
 of Baron Christoph I and his second wife, Scholastica Nothafft von Wernberg.
 He was appointed imperial count in 1566. He served in various offices at both
 the Bavarian court and the Habsburg court in Prague and was also known as
 a coin collector. Schwarzenberg 1963, 78; *NDB* 1953–2010, 5:722; Bosl 1983, 710;
 Reinhardstöttner 1890, 86, 105, 110; and Quiccheberg 2000, 183, 296.

116. Simon Thaddäus Eck (1514/15–74) came to Ingolstadt in 1522. After employment
 in the church bureaucracy, he became ducal chancellor in Munich in 1559. He
 represented Albrecht V in negotiations with the nobility on religious matters and
 encouraged Jesuit activities in Bavaria. Eck donated his considerable library to
 the University of Ingolstadt, forming part of the Biblioteca Eckiana. Buzás 1972,
 39; Pantaleon 1570, 376; *ADB* 1967–71, 5:606–07; *NDB* 1953–2010, 4:275; Bosl 1983,
 163; Lanzinner 1980, 328; Reinhardstöttner 1890; and Quiccheberg 2000, 185, 300.

117. Wilhelm Lösch I (1518/20–72) was *Hofrat* to Anna von Bayern. He is one of
 the composers and signers of the 1557 letter urging Albrecht V to spend less

money on his collections and his court. Bosl 1983, 489; Quiccheberg 2000, 185, 300.

118. From a prominent Landshut family, Michael Heumair (n.d.) matriculated at Ingolstadt in 1544. After obtaining his law degree, he was employed as *Hofrat* to Albrecht V from 1559; two years later he became tutor to the duke's children. Lanzinner 1980, 361; and Quiccheberg 2000, 185, 300.

119. Sebastian Hoeflinger (1533–84) studied law at Wittenberg, Padua, and Bologna, where he received his doctorate in 1547. Between 1544 and 1560 he held the position of chancellor to the bishops of Salzburg, including Johann Jacobus Khuen. Quiccheberg 2000, 185, 300.

120. The father of Hieronymus Pronner was a professor at Ingolstadt before he moved to Munich to become Wilhelm IV's personal physician. Pronner himself (d. 1585) matriculated at Ingolstadt in 1536. He was later employed as *Hofrat* at court in Munich and acquired several landed estates. Hans Mielich portrayed Pronner in 1556. Bosl 1983, 604; Boehm, Müller, and Schöner 1998, 322; Lanzinner 1980, 309; Reinhardstöttner 1890, 46; and Quiccheberg 2000, 185, 300.

121. A member of one of Munich's most influential patrician families, Gabriel Ridler (ca. 1500–81) served on the city's external council in 1532 and the internal council from 1537 to 1558. In 1559, Ridler was portrayed by Mielich. Löcher 2002, 82, 229; Lanzinner 1980, 387; and Quiccheberg 2000, 185, 301.

122. Christoph Bruno (before 1504–after 1568) was a famous Bavarian humanist who held the office of city poet in Munich. He matriculated at Ingolstadt in 1514 and taught poetics in Munich until 1544. Together with Simon Eck, Wiguleus Hundt, and others, he was employed as adviser to Albrecht V in religious matters from 1549 to 1568. Bosl 1983, 98–99; Lanzinner 1980, 310; Reinhardstöttner 1890, 64–74; and Quiccheberg 2000, 185, 301.

123. A son of Hans Jakob Fugger, Count Sigmund Friedrich Fugger (1542–1600) became bishop of Regensburg in 1598. He would have been only about sixteen years old when Goltzius visited his coin collection in Pisa. Goltzius 1563, sig. aa3v; and Quiccheberg 2000, 185, 301.

124. Vitalis Gmelich (n.d.) was from the Salzburg area and matriculated at Ingolstadt in 1541. He was in Rome in 1562. Pölnitz 1981; and Quiccheberg 2000, 185, 301.

125. Reading *inscipt* as *insc[r]ipt[ique]*.

126. The son of Leonhard von Eck, Oswald (d. 1573) was tutored by the famous Bavarian historian Aventinus (Johannes Turmair [1477–1534]). He inherited his father's library and avidly collected manuscripts himself. Oswald leaned toward Luther's teachings. He died impoverished, having sold his collections and his father's lands. Goltzius 1563, sig. bb; Bosl 1983, 163; *NDB* 1953–2010, 4:277 (s.v. "Leonhard von Eck"); and Quiccheberg 2000, 185, 301.

127. Leonhard von Eck (1480–1550) first tutored Wilhelm IV and in 1519 was appointed his chancellor. Von Eck's tenure was long, and he shaped Bavarian politics significantly, fighting against Protestantism's advances as well as Habsburg ambitions. In an advantageous marriage, he acquired a considerable library and large property holdings. Oswald von Eck was his son. Pantaleon 1570, 150–51; *ADB* 1967–71, 5:604–06; *NDB* 1953–2010, 4:277–79; Bosl 1983, 163; Jöcher 1726–33, 1:845; Lanzinner 1980, 327–28; Bietenholz and Deutscher 1986, 1:419; and Quiccheberg 2000, 185, 301.

128. Sebastian Reisacher (1531–71) studied liberal arts and philosophy at Ingolstadt, with attention to the methods of the French humanist and educational theorist Peter Ramus (1515–72). He was appointed professor of Greek at Ingolstadt in 1554 and professor of philosophy in 1557, and served as an adviser to Albrecht V and other princes. The "unusual theater of philosophy" mentioned by Quiccheberg has not been identified. Pantaleon 1570, 487 (by Quiccheberg); Boehm, Müller, and Schöner 1998, 335–36; Reinhardstöttner 1890, 89; and Quiccheberg 2000, 187.

129. Johannes Albertus Wimpinaeus (d. after 1570) became professor of poetics at Ingolstadt in 1563 but was later trained in medicine and in 1567 left the university. In 1569, he published a book with Adam Berg in Munich arguing that Paracelsian medicine was compatible with classical medical authorities. He was employed at court as Albrecht V's personal physician. Boehm, Müller, and Schöner 1998, 7–8; and Quiccheberg 2000, 187, 303.

130. No information is available for Carolus Rauhenberg von Regensburg (n.d.). Quiccheberg 2000, 187, 303.

131. Philipp Apian (1531–89) was a geographer and mathematician. As university professor in mathematics at Ingolstadt (1552–59), he followed in the footsteps of his father, Peter Apian (Bennewitz or Bienewitz), an astronomer and book printer knighted by Emperor Charles V. Philipp was commissioned by Albrecht V to survey the Bavarian lands and draw up a detailed map on the scale of 1:45000, which was completed in 1563. The original plates were exhibited in the palace; Apian published a printed version in 1568. A poem by Hieronymus Wolf praising Apian's unsurpassable work was printed on plate 24 of this edition. Apian 1976; Günther 1882; *NDB* 1953–2010, vol. 1; Bosl 1983, 22; Jöcher 1726–33, 1:184; Reinhardstöttner 1890, 117; and Quiccheberg 2000, 187, 303, 316.

132. The jurist Johannes Aurpach referred to Johannes Fantner of Landshut (n.d.) in a poem published in 1577. The coat of arms of a Georg Fantner (n.d.), mayor of Ingolstadt, graced the Ingolstadt town hall upon completion of a new wing in 1571. Reinhardstöttner 1890, 92; and Quiccheberg 2000, 189, 303.

133. A member of one of Munich's oldest and most politically influential patrician families, Ludwig Schrenk (n.d.) matriculated at Ingolstadt in 1555 and received his

degree in law. Goltzius 1563, sig. bb; Reinhardstöttner 1890, 105; and Quiccheberg 2000, 189, 303.

134. Goltzius names Ludwig Müller (n.d.) as a lawyer in Munich. In 1576, Müller reported to the Munich court concerning the estate of Raimund Fugger II, leading to the sale of the Fugger armor collection for 3000 gulden. He also praised Raimund's collection of lutes. Goltzius 1563, sig. bb; and Quiccheberg 2000, 189, 303.

135. Orlando di Lasso (ca. 1530–94) was one of the foremost composers of his day. His works include the *Penitential Psalms,* illuminated by Mielich and commented upon by Quiccheberg. As Albrecht's court composer, di Lasso became an object of debate when the council found that Albrecht was spending far too much money on musical entertainment at court. Busley 1965, 227–28; Pantaleon 1570, 507–8 (by Quiccheberg); *NDB* 1953–2010, 13:676–78; Bosl 1983, 466; Reinhardstöttner 1890; and Quiccheberg 2000, 189.

136. Born in Nuremberg, Vitus Jacobaeus (d. 1568) entered Wittenberg University in 1556. He was crowned poet laureate in 1558 in Vienna, where he probably converted to Catholicism. He became a professor of poetics at Ingolstadt in 1561. Until his death, Jacobaeus published many books of poetry, most of them on topics associated with university life and the history of the university at Ingolstadt. Bosl 1983, 388; Boehm, Müller, and Schöner 1998, 202–3; Reinhardstöttner 1890, 84, 106, 118; and Quiccheberg 2000, 191.

137. Georg Theander (ca. 1508–70) matriculated at Ingolstadt in 1537, where he received several fellowships. In 1544, he became professor of theology at Ingolstadt; between 1549 and 1566, he held the office of university rector six times. Bosl 1983, 773; Boehm, Müller, and Schöner 1998, 433; Reinhardstöttner 1890; and Quiccheberg 2000, 191, 304.

138. From a Protestant family, Martin Eisengrein (1535–78) converted to Catholicism during his tenure at the University of Vienna, where he was professor of rhetoric and philosophy. Eisengrein was vice-chancellor of the University of Ingolstadt from 1568 until his death. During this time, friction between lay and Jesuit faculty ran high, and Eisengrein's main responsibility was to mediate between the two factions. He reorganized and enlarged the university library by encouraging donations from Bishop Johann Egolph von Knöringen of Augsburg, Simon Eck, and Rudolf Clenck. Buzás 1972, 35; *ADB* 1967–71, 5:765; *NDB* 1953–2010, 4:412; Bosl 1983, 170; Boehm, Müller, and Schöner 1998, 94–95; Jöcher 1726–33, 1:857; Reinhardstöttner 1890, 100–101, 106; and Quiccheberg 2000, 191, 304.

139. Born into a Lutheran family, Rudolf Clenck (1528–78) converted to Catholicism around 1552. After studying at many north German universities, he came to Ingolstadt, where Albrecht V provided his financial support. Clenck began teaching theology in the early 1560s and became professor at Ingolstadt in 1570.

After arguments with Jesuits at the university, Clenck left for the new seminary at Eichstätt but returned in 1570 to head Ingolstadt's theological seminary, the Georgianum. *ADB* 1967–71, 4:322–23; Bosl 1983, 116; Boehm, Müller, and Schöner 1998, 71–72; Reinhardstöttner 1890, 106; and Quiccheberg 2000, 191, 304.

140. Leonhard Probstl (n.d.) was a professor at Ingolstadt University who, together with Philipp Apian, who was dimissed by Albrecht V in 1568, during a purge of Protestant sympathizers. Westenrieder 1806, 262–63; Sugenheim 1842, 1:301n47; and Quiccheberg 2000, 191, 304.

141. Hans Jakob Fugger (1516–75), the son of Raymund Fugger I, studied law and linguistics at Dôle, Bourges, Padua, and Bologna. He received practical training in the family business at the Fondaco dei Tedeschi in Venice and in Antwerp. Hans Jakob was the tutor to the children of the future emperor Ferdinand I of Habsburg, then king of Bohemia. While at court, he met and, in 1540, married Ursula von Harrach, a member of the minor nobility and the sister of Leonhard von Harrach IV. In 1560, he replaced his uncle Anton as head of the family business. Following a personal bankruptcy in 1565, Hans Jakob was ousted from the firm and took a position in the court of Albrecht V, eventually becoming *Kammerpräsident*. He expanded his father's collections and, a lifelong bibliophile, Hans Jakob brought the Fugger library to its peak with the assistance of Quiccheberg; the library accompanied him to Munich, where it formed the core of the newly established ducal library. Meadow 2002; Goltzius 1563, sig. aa4v; *NDB* 1953–2010, 5:720; Reinhard and Häberlein 1996, 152–55; Jöcher 1726–33, 1:1024; Reinhardstöttner 1890, 54–55; and Quiccheberg 2000, 191.

142. Raimund Fugger II (1528–69) was an unmarried son of Raymund Fugger I. In a 1576 inventory of his music room, he had 391 musical instruments in his collection, including 140 lutes, some built by famous makers. Reinhard and Häberlein 1996, 157; Quiccheberg 2000, 191, 305; and Tremmel 1993, 66–68.

143. Count Georg Fugger II (1518–69) was a humanist and *Freiherr* of Kirchberg and Weissenhorn. He married Ursula von Liechtenstein, who converted to Catholicism. *NDB* 1953–2010, 5:722; Reinhard and Häberlein 1996, 150; and Quiccheberg 2000, 193.

144. Markus Fugger III (1529–97) was the eldest son of Anton Fugger. He was chamberlain to Archduke Ernst of Austria and simultaneously held other court positions. Following the removal of his cousin Hans Jakob from the family business, he headed the family firm. Markus was interested in church history and collected books and antiquities. He was the author of *Von der Gestüterey* (1584), a book on horse breeding and training. *NDB* 1953–2010, 5:721; Reinhard and Häberlein 1996, 159–64; Jöcher 1726–33, 1:1024; and Quiccheberg 2000, 193, 316.

145. Christoph Fugger I (1520–79) was an unmarried son of Raymund Fugger I. He

was portrayed by Christoph Amberger. Reinhard and Häberlein 1996, 149–50; and Quiccheberg 2000, 193.

146. Count Johann Fugger (1531–98) was the second son of Anton Fugger and Anna Rehlinger; he married Elisabeth Nothafft. As brother of Markus, Hans was second in command of the family firm, and compiled a massive library of correspondence. He succeeded Markus as head of the firm upon Markus's death in 1597. Johann served as imperial adviser to Ferdinand I and Rudolph II. He was a prominent patron of the arts. Karnehm, Preysing, and Munch 2003; *NDB* 1953–2010, 5:721; Reinhard and Häberlein 1996, 151–52; Steuer 1988, 193; and Quiccheberg 2000, 193, 305, 316.

147. That is, Christoph and Georg were the children of Raymund Fugger I, and Johann and Markus were the children of Raymund's brother, Anton Fugger.

148. The Freibergs were members of the Swabian minor nobility, one branch of which possessed the prince-bishopric of Augsburg. Michael Ludwig (d. 1582) and Ferdinand (d. 1583) studied at Tübingen. Upon their father's death, the territory was divided between them, with Michael Ludwig receiving Justingen and Ferdinand Öpfingen. Schilling 1881, 50–70, 121–22; and Quiccheberg 2000, 195, 305.

149. That is, within metal covers set with gemstones.

150. The uncle of Christoph von Zimmern, Count Wilhelm Werner Zimmern (1485–1575) was a confidant of Archduke Ferdinand of Tyrol and instrumental in his acquisition of Ulrich of Montfort's Kunstkammer. He wrote histories of Swabian noble families. Jenny 1959; Goltzius 1563, sig. bb; Pantaleon 1570, 227–28; Bosl 1983, 878; and Quiccheberg 2000, 195, 306.

151. The Montforts were Swabian counts. The family had assembled a Kunstkammer that possibly included the feather headdress often attributed to Motecuzoma (now in Vienna; see pl. 15). The entry about Ulrich IV, Count of Montfort (ca. 1530–74), in Pantaleon mentions his interest in "old antiquities and rare coins." After Ulrich's death, intense competition for his collection erupted between the courts in Munich and Innsbruck and the Fuggers. Fleischhauer 1982, 9–28; Pantaleon 1570, 497–98; and Quiccheberg 2000, 195, 306.

152. The Herwarts were a patrician family from Augsburg. Johann Heinrich Herwart (1520–83) married Johann Baptist Haintzel's sister in 1555. He was a member of the *Herwarthsche Handelsgesellschaft* (Herwart trading company); his mother, Helene Schellenberger, was said to be the richest woman in Augsburg. In 1559, Conrad Gesner saw and painted a watercolor of a red tulip in the garden of Herwart's garden in Augsburg, apparently the first tulip ever to be cultivated outside of Asia. Beck 1984, 133; Goltzius 1563, sig. aa4v; Reinhard and Häberlein 1996, 279–80; *NDB* 1953–2010, 8:720; and Quiccheberg 2000, 195, 307.

153. Son of Lukas Rem II, the author of the *Tagebuch des Lukas Rem,* Lukas Rem III (1522–81) was a member of the Augsburg mercantile patriciate. He married Sibilla

Welser in 1545. Goltzius 1563, sig. aa4v; Reinhard and Häberlein 1996, 687–89; Bosl 1983, 626; and Quiccheberg 2000, 197, 307.

154. Konrad Peutinger (1465–1547) was an eminent lawyer, book collector, and librarian in Augsburg. He revolutionized the art of cataloging books (he went alphabetically by authors' names or by subject matter instead of using lists of short descriptive titles). His was one of the first attempts to organize effectively the explosion of information his age was experiencing. His heirs kept the library together, but after more than a century, it was dispersed.

Christoph Peutinger (1511–76) was the fifth child of Konrad Peutinger and his wife, Margarete Welser. There is no evidence that he was enrolled in a university, but his schooling in the Peutinger household guaranteed a thorough humanist education. In 1534/35 Christoph was employed at the Madrid branch of his uncle Bartholomäus Welser's company, which was then engaged in large-scale trade with the Spanish colonies. Christoph inherited his father's substantial library and accumulated his own book collection encompassing seven hundred volumes. Zäh 2002, 449–71; Künast and Zäh 2004, 33–44; Goltzius 1563, sig. aa4v; Pantaleon 1570, 42; Reinhard and Häberlein 1996, 616–17; Bosl 1983, 582; Jöcher 1726–33, 2:604–5; Bietenholz and Deutscher 1986, 3:74–76; and Quiccheberg 2000, 197, 307.

155. Probably the collection of Paolo Giovio.

156. Marco Benavides of Mantua (1489–1582) was a renowned jurist, humanist, and collector who played a vital role in the cultural world of Padua. He studied law at Padua University and stayed on to teach from 1518 to 1564. He also served as an adviser to two Holy Roman emperors, Charles V and Ferdinand II. Benavides collected ancient and modern sculpture, portraits and portrait books, graphic art, musical instruments, coins and medallions, and *naturalia*. Favaretto 1984; Klinger 1985; Jöcher 1726–33, 1:353; and Quiccheberg 2000, 199.

157. Marina Pfister, née Adler (d. ca. 1561), married the Augsburg patrician Georg Pfister in 1538. Johann Baptist Fickler lists a portrait of Marina Pfister in his inventory of the Munich Kunstkammer (inv. no. 2929). Fickler 1598; and Quiccheberg 2000, 199, 308, 312.

158. Son of the Augsburg patrician Hans Rehlinger and Anna Peringer of Regensburg, Christoph Rehlinger II (1513–75) matriculated at Ingolstadt in 1522 and married Maria Meuting in 1539. Goltzius 1563, sig. aa4v; Reinhard and Häberlein 1996, 654–56; and Quiccheberg 2000, 199, 308.

159. A member of the Augsburg merchant banking family, Markus Welser I (1524–96) matriculated at Ingolstadt in 1535 and Louvain in 1537. He was a partner in the firms Christoph Welser & Gesellschaft (1553–80) and Marx & Matthäus Welser Gesellschaft (1580–95). Goltzius 1563, sig. aa4v; Reinhard and Häberlein 1996, 942–44; Jöcher 1726–33, 2:667; Pölnitz 1981, col. 528; and Quiccheberg 2000, 199, 308.

160. A member of the Augsburg *Gesellschaft der Mehrer* (the social group linking the merchants and the patricians) from 1561 to 1576, Bartholomäus May (1515–76) was married to Sibilla Rembold, through whom he was connected to the Vöhlins and the Welsers. He worked as a salesman for Bartholomäus Welser und Gesellschaft in Madrid (1538–48) and was a collector of Spanish prints. Goltzius 1563, sig. aa4v; Reinhard and Häberlein 1996, 526–27; and Quiccheberg 2000, 199, 308.

161. Adolph Occo III (1524–1606) was an Augsburg humanist, physician, and numismatist. The Occo family owned a large library. In 1564, Occo published his *Enchiridion sive, ut vulgo vocant, dispensatorium compositorum medicamentorum,* a collection of standardized recipes for compounding medicines. Republished in 1574 by Georg Willer as the *Pharmacopoeia Augustana,* the book was extremely influential in a time when the production and dispensation of drugs was not yet regulated. It became the model for future books of that sort. In 1578, Occo dedicated a book on coin collecting to Albrecht. Gensthaler 1973; Goltzius 1563, sig. aa4v; Bosl 1983, 557; Jöcher 1726–33, 2:385; Reinhardstöttner 1890, 115; and Quiccheberg 2000, 199, 308.

162. The Ilsungs were a powerful Augsburg merchant dynasty. Johann Achilles Ilsung (1530–1609) was appointed imperial counselor to Ferdinand I in 1562. He also served as an agent in financial matters for the Habsburgs. Steuer 1988, 211–12; *NDB* 1953–2010, 10:142; Bosl 1983, 382; and Quiccheberg 2000, 199, 309.

163. Paul Vöhlin (1528–79) was the son of Hans Vöhlin III, who joined the Augsburg patriciate in 1538. Vöhlin's family, which originated in Memmingen, cofounded the Welser-Vöhlin Company in 1498. Paul Vöhlin matriculated at Ingolstadt in 1541. Eirich 1971, 119–42, 150–68; Reinhard and Häberlein 1996, 861–62; Pölnitz 1937, col. 567; and Quiccheberg 2000, 199, 309.

164. Karl Neidhart (ca. 1520–76) and Christoph Neidhart (b. ca. 1521) were sons of the Ulm banker Sebastian Neidhart and Helene Herwart. In 1560, Karl married Ursula, the daughter of the eminent Augsburg merchant Melchior Manlich. Karl was an active member of the family business, which was engaged especially in the Levantine trade. Around 1574, the firm went bankrupt and Karl was arrested for embezzlement. A year later, he fled to Lyon, where he died in 1576. Christoph was Karl's younger brother. Reinhard and Häberlein 1996, 572–73; Bosl 1983, 546; and Quiccheberg 2000, 201, 309.

165. A Wolfgang Ravenspurger (n.d.) is mentioned as a debtor of the Herwarts in 1576. Reinhard and Häberlein 1996, 282, 980; and Quiccheberg 2000, 201, 309.

166. Quiccheberg is probably referring to Georg Mielich (ca. 1504–72), the patrician of Augsburg who was married to Maria Herwart. Reinhard and Häberlein 1996, 554–56; and Quiccheberg 2000, 201, 309.

167. *Freiherr* of Rohrau, Leonhard von Harrach IV (1514–90) served as *Obersthofmeister* (grand master of the household) of Emperor Maximilian II. The

Harrachs were prominent members of the Austro-German nobility. Leonhard von Harrach was the brother of Ursula von Harrach, the wife of Hans Jakob Fugger. Pantaleon 1570, 454; *NDB* 1953–2010, 7:697; and Quiccheberg 2000, 201, 309.

168. From 1566, Leonhard von Memmingen (n.d.) occupied the office of *Obersthofmeister* in the court of Albrecht V, the second-highest administrative position at the court. Vehse 1851–60, vol. 23, pt. 4, 84; and Quiccheberg 2000, 201, 309.

169. From a rural background, Johannes Aurpach (1531–82) studied law at Ingolstadt, Padua, Paris, and Orléans. He was a member of the advisory circle at court in Munich from 1563 to 1565; later he became chancellor to the bishop of Regensburg. Aurpach was a prolific poet who wrote in Latin. Kühlmann et al. 1997, 1336; *NDB* 1953–2010, 1:457; Bosl 1983, 33; Ellinger 1929, 210–24; Lanzinner 1980, 293; Reinhardstöttner 1890, 87–96; and Quiccheberg 2000, 201, 309.

170. Johann Baptist Haintzel (1524–81) was a patrician in Augsburg and a patron of Tycho Brahe, the Danish astronomer who built one of his first astronomical instruments at the Haintzels' country estate outside Augsburg. He was the son of Mayor Hans Haintzel and Katharina Welser. Johann Baptist studied in Wittenberg and Basel and in 1556 was elected mayor of Augsburg. He encouraged Hieronymus Wolf to take up residence in Augsburg as rector of St. Anna Gymnasium and as municipal librarian. Thoren 1990, 33; Beck 1984, 72; Reinhard and Häberlein 1996, 223–24; and Quiccheberg 2000, 201, 309.

171. After studies and various employments all over Europe, Hieronymus Wolf (1516–80) moved to Augsburg, where he worked as Hans Jakob Fugger's secretary and librarian (1551–57). Later, Wolf became rector of St. Anna Gymnasium in Augsburg and, from 1557, municipal librarian. As a philologist, he acquired important manuscripts of classical Greek texts and translated them into Latin. In 1578, Wolf was forced to sell his private collection, which now forms a separate part of the Provincial Library Neuburg (Biblioteca Wolfiana). Beck 1984; Schmidbauer 1963, 58–75; Pantaleon 1570, 388–89; Bosl 1983, 858; Jöcher 1726–33, 2:1915; and Quiccheberg 2000, 201.

172. Leo Quiccheberg (1497–1579), Samuel Quiccheberg's brother, resided primarily in Nuremberg and served there as a member of the civic council. Samuel sent the manuscript version of the *Inscriptiones* with Leo to Italy in an unsuccessful attempt to secure a Venetian publisher. Quiccheberg 2000, 203, 288, 310.

173. The Schürstabs were a large family with many members on the Nuremberg civic council. The St. Lorenzkirche in Nuremberg owns a chalice with the Schürstab coat of arms, dated ca. 1525–50. Bosl 1983, 704; and Quiccheberg 2000, 203, 310.

174. A member of a prominent Nuremberg family, Georg Roemer (n.d.) was a *Genannter* (appointed member) of the Nuremberg civic council. Goltzius references the heirs (*haeredes*) of Georg Roemer rather than Georg himself.

Goltzius 1563, sig. aa4v; Quiccheberg 2000, 203, 310; Reinhard and Häberlein 1996, 935; and Bosl 1983, 704.

175. The Imhoffs were one of the wealthiest Nuremberg merchant dynasties. Willibald Imhoff (1519–80) inherited from his grandfather (the eminent humanist Willibald Pirckheimer) a large collection of paintings, statues, and books to which he added works by Albrecht Dürer, Hans Holbein the Elder, Lucas Cranach the Elder, and Titian. After Imhoff's death, the collection was broken apart and sold to various bidders; Rudolph II purchased most of the Dürer paintings. Imhoff produced a catalog of medallions for Albrecht V. Pohl 1992; Jante 1985; Goltzius 1563, sig. aa4v; *NDB* 1953–2010, 10:150–51; Bosl 1983, 385; and Quiccheberg 2000, 203, 310.

176. Goltzius describes Georg Chanler (n.d.) as a knight of St. Mark's of Venice and a doctor of jurisprudence. A Dr. Georg Kandler was a *Genannter des Größeren Rats* (member of the large council) of Nuremberg from 1558 to 1586. Goltzius 1563, sig. aa4v; Fleischmann and Grieb 2002, 83; and Quiccheberg 2000, 203, 310.

177. Johann Starck (n.d.) was a member of the Small Council in Nuremberg. Fleischmann and Grieb 2002, 77; and Quiccheberg 2000, 203, 310.

178. Hieronymus Prunsterer (n.d.) was recorded as the owner of a house in Nuremberg between 1548 and 1579. Quiccheberg 2000, 203, 310.

179. Stephan Praun II (1513–78) was a wealthy merchant in Nuremberg whose son Paulus II (1548–1616) laid the foundation for the *Praunsche Kunstsammlung* (Praun art collection). Pohl 1992; and Quiccheberg 2000, 203, 310.

180. No information is available for Sebald Flechner (n.d.). Quiccheberg 2000, 205, 311.

181. A member of a Nuremberg patrician family, Hieronymus Baumgartner (1498–1565) matriculated at Wittenberg University, where he studied philosophy, mathematics, law, and linguistics. In 1526, with Philip Melanchthon, he founded the first humanist school in Nuremberg. Baumgartner also played a role in founding the city's first library. He took part in the *Reichstage* in Speyer (1529 and 1544) and Augsburg (1530). *NDB* 1953–2010, 1:664; Bosl 1983, 48–49; Jöcher 1726–33, 1:332; and Quiccheberg 2000, 205, 311.

182. Harriet Roth cites the appearance of Nicolaus von Wimpfen (n.d.) as a witness and legal representative in the judicial records of Nuremberg between 1563 and 1579. Roth, in Quiccheberg 2000, 205, 311; and Fleischmann and Grieb 2002, 89.

183. Harriet Roth cites archival documents in Nuremberg showing that Paul Ketzler (n.d.) owned the rights to the *grossen Zehnts,* the annual tithe on the grain harvest, from the village of Hezelhof. Roth, in Quiccheberg 2000, 205, 311.

184. Sebald Zilinger (n.d.) was named by Goltzius as a theologian and numismatist in Nuremberg. Goltzius 1563, sig. aa4v; and Quiccheberg 2000, 205, 311.

185. Walbert Pfrauner (n.d.) was listed by Goltzius in Nuremberg. No further information is available. Goltzius 1563, sig. aa4v; and Quiccheberg 2000, 205, 311.

186. Eustachius Molber (n.d.) was listed by Goltzius in Nuremberg. No further information is available. Goltzius 1563, sig. aa4v; and Quiccheberg 2000, 205, 311.

187. Fridelin Bandel (n.d.) was listed by Goltzius in Nuremberg. No further information is available. Goltzius 1563, sig. aa4v; and Quiccheberg 2000, 205, 311.

188. Rutger Bremling (n.d.) was listed by Goltzius in Nuremberg. No further information is available. Goltzius 1563, sig. aa4v; and Quiccheberg 2000, 205, 311.

189. Quiccheberg probably refers to the goldsmith Hans Maslitzer (1503–74). Maslitzer was a Nuremberg *Schreibmeister* (calligrapher) and *Rechenmeister* (arithmetic teacher) before changing his profession to goldsmith, medalist, and metal caster. Skilled in metallurgy, Maslitzer preceded Wenzel Jamnitzer in the direct casting of small animals in precious metals. According to Johann Neudorfer, Maslitzer "was . . . the first to make castings of small animals [*Wörmer*]." Tebbe, Timann, and Eser 2007, 268–69; and Quiccheberg 2000, 205, 267, 312.

190. Wenzel Jamnitzer (1507/1508–85) was among the most renowned goldsmiths in Europe; as a result, his work was in great demand. He produced works for the Habsburg emperors Charles V, Ferdinand I, Maximilian II, and Rudolph II. Jamnitzer developed refined metallurgical techniques that enabled him to make highly detailed castings directly from plants, insects, and other small animals, of the sort referred to in class 3, inscriptions 2 and 6 (this volume, pages 65, 66). Bott and Germanisches Nationalmuseum 1985; and Quiccheberg 2000, 205.

191. Johann Neudorfer the Elder (1497–1563) was, like Quiccheberg and his brother, a *Genannter des Größeren Rats* in Nuremberg. Both father and son (Johann Neudorfer the Younger [1543–81]) published textbooks on good penmanship and are considered the founders of standardized German script. Neudorfer the Elder also taught arithmetic and geometry. A 1561 portrait by Nicolas Neufchâtel depicts Neudorfer the Elder explaining an open dodecahedron, which resembles the "regular solids of various shapes, beautifully constructed of transparent rods" in Quiccheberg class 4, inscription 2 (this volume, page 67; see Introduction fig. 2). Fleischmann and Grieb 2002, 70; Bosl 1983, 548; Quiccheberg 2000, 205, 311; and *NDB* 1953–2010, 19:106.

192. Johann Zobel (n.d.) was vicar of the collegiate church Neumünster in Würzburg from 1557 to 1558. Goltzius describes him as the hereditary chamberlain of the bishops of Würzberg. Goltzius 1563, sig. aa4v; and Quiccheberg 2000, 207, 311.

193. *Domdechant* (archdeacon) in Würzburg, Wolfgang Dietrich von Hutten (d. 1575) was the nephew of the famous humanist Ulrich von Hutten (1488–1523). Goltzius 1563, sig. aa4v; *NDB* 1953–2010, 10:99; and Quiccheberg 2000, 181, 207, 311.

194. Eberhard von Ehingen (d. 1549) was a *commendator* (knight and commander) of the Teutonic Order in Heilbronn from 1521 to 1532. Goltzius 1563, sig. aa4v; and Quiccheberg 2000, 207, 311.

195. Michael Peuter the Elder (1522–87) studied at Marburg and Wittenberg, where

he encountered the reformer Melanchthon. Peuter received his doctorate in law from Ferrara in 1554. He was a professor and dean at Greifswald University (1548–58) before becoming counsel to Melchior Zobel, the prince-bishop of Würzburg (and a relative of Johann Zobel). From 1559 to 1560, he was librarian for Ottheinrich, elector of the Pfalz. Goltzius 1563, sig. aa4v; Pantaleon 1570, 511; Bosl 1983, 69–70; and Quiccheberg 2000, 207, 311.

196. Balthasar von Hellu (b. 1526) served as chancellor of the University of Würzburg. Quiccheberg 2000, 207, 312.

197. Pope Pius IV (1499–1565) was elected pope on 25 December 1559 and installed on 6 January 1560. He presided over the third Council of Trent in 1562 and authored the Tridentine Creed in 1564. He was the uncle of Cardinal Carlo Borromeo and unrelated to the Medici of Florence. Quiccheberg 2000, 209.

198. A historian, antiquarian, and devoted numismatist, Marcus Laurinus van Watervliet (1530–81) aspired to write a history of antiquity based on coin inscriptions and epigraphs. For this reason, he sponsored Hubertus Goltzius in his travels and underwrote the publication of Goltzius's volumes on ancient coins, beginning with *C. Iulius Caesar sive Historiae imperatorum caesarumque Romanorum ex antiquis numismatibus restitutae liber primus* (1563), upon which Quiccheberg constructed his list of exemplary collectors. Pantaleon 1570, 485–86; and Quiccheberg 2000, 211.

199. Samuel Quiccheberg's nephew Peeter Quiccheberg (n.d.), along with other members of the Quiccheberg family, still lived in Antwerp in the 1570s and 1580s. Goltzius 1563, sig. aa2v; and Quiccheberg 2000, 211.

200. Quiccheberg has incorrectly transcribed the Latin, writing *quinque millia* for *quinque et mille,* "one thousand and five." Commentaries say that one thousand and five is an equivalent to "a thousand and one" in English, and basically indicates "very many."

201. This biblical passage corresponds to 1 Kings 4:29–34.

202. The Vulgate text reads: "ægrotasset Ezechias. Lætatus est autem in adventu eorum Ezechias, et ostendit" (that Hezekiah had grown ill. And Hezekiah rejoiced at their [the messengers'] arrival, and he showed). Quiccheberg (or his typesetter) has committed a *saut du même au même,* taking his eyes off the text right after the first *Ezechias* and returning them after the second *Ezechias,* thus skipping over the interval.

203. This biblical passage corresponds to 2 Kings 20:12–13.

204. This biblical passage corresponds to 2 Kings 20:19.

205. To what *symbolum libelli* refers is unclear. Possibly this is an instruction for the printer to insert his emblem at this point, which marks the end of Quiccheberg's original text. The Vatican manuscript, however, places the emblem on the title page.

206. This biblical passage corresponds to Ecclesiastes 38:6.

207. Georg Willer (ca. 1514–ca. 1594) was an Augsburg bookseller and printer who specialized in printed music. In 1564, he published the earliest-known catalog of the Frankfurt book fair, continuing to issue it until 1592. Quiccheberg 2000, 219, 315.

208. For Cortonaeus's biographical information, see note 88.

209. From a patrician family, Erasmus Vend (1532–87) matriculated at Ingolstadt in 1549. From 1557 onward he was employed at court, where he soon was put in charge of the official ducal archive. Vend also occupied himself with Bavarian history and wrote poetry. Bosl 1983, 198; Lanzinner 1980, 334; Reinhardstöttner 1890; and Quiccheberg 2000, 221, 251, 315.

210. For Jacobaeus's biographical information, see note 136.

211. From Passau, Gabriel Castner (n.d.) matriculated at Ingolstadt in 1544. He held the position of rector of the cloister school of St. Florian in Munich from 1559 to 1571. In 1560, he filed a legal complaint alleging that the founding of the nearby Jesuit college reduced the number of students enrolling in his school. Pölnitz 1981, 637; Reinhardstöttner 1890; and Quiccheberg 2000, 221, 315.

212. A Jesuit, Jodocus Castner (n.d.) matriculated at Ingolstadt in 1552. He was later in charge of the novices at Benediktbeuern. He published several poems, mostly dedicatory, especially funerary elegies. He was active in Munich from 1563 to 1565. (No known relation to Gabriel Castner.) Pölnitz 1981, 637; Garber 1998, 1073; and Quiccheberg 2000, 221, 315.

213. From Freising, Joachim Haberstock (1533–71) matriculated at Ingolstadt in 1555. He held the post of court poet in Munich. He published volumes of Christian hymns and a funeral ode for Emperor Ferdinand I. Pölnitz 1981, 637; Bosl 1983, 290; Reinhardstöttner 1890, 108–33; and Quiccheberg 2000, 225, 315.

214. From Nuremberg, Aegidius Oertel (ca. 1532–1619) matriculated at Ingolstadt in 1552. He was appointed as the first Bavarian court librarian on 26 February 1561 and held the position until he was dismissed in 1573. Pölnitz 1981, 914; Hartig 1917, 393–409; Reinhardstöttner 1890, 57; and Quiccheberg 2000, 225, 315.

BIBLIOGRAPHY

Achilles-Syndram, Katrin, ed. 1994. *Die Kunstsammlung des Paulus Praun: Die Inventare von 1616 und 1719*. Nuremberg: Selbstverlag des Stadrats zu Nürnberg.

Adams, Frank D. 1938. *The Birth and Development of the Geological Sciences*. Baltimore: William & Wilkins.

ADB [Allgemeine Deutsche Biographie]. 1967–71. Edited by Historische Kommission bei der Bayerischen Akademie der Wissenschaften. 56 vols. Reprint, Berlin: Duncker & Humblot. First published 1875–1912.

Agricola, Georg. 1556. *De re metallica*. Basel: Froben.

Aldrovandi, Ulisse. 1613. *De Piscibus libri 5 et de Cetis libro vnvs*. Bologna: Bellagamban.

Andraschke, Udo, and Marion Ruisinger, eds. 2007. *Ausgepackt: Die Sammlungen der Universität Erlangen-Nürnberg*. Exh. cat. Nuremberg: Tümmels.

Andreas, Valerius. 1643. *Bibliotheca Belgicae de belgis vita scriptisque claris. Praemissa topographica belgii totius seu germaniae inferioris descriptione*. Leuven, Belgium: Jacob Zegers.

Apian, Philipp. 1976. *Bayerische Landtafeln* [1568]. Facsimile reprint of the first Ingolstadt edition. Unterschneidheim, Germany: Uhl.

ARB (Académie royale des sciences, des lettres et des beaux-arts de Belgique). 1905. *Biographie nationale*. Vol. 18. Brussels: Bruylant-Christophe.

Arnold, Ken. 1992. "Cabinets for the Curious: Practicing Science in Early Modern English Museums." PhD diss., Princeton University.

Baumann-Oelwein, Cornelia. 2000. *Der Orlandoblock am Münchner Platzl: Geschichte eines Baudenkmals*. Munich: Oldenbourg.

Bayreuther, Rainer. 2009. *Untersuchungen zur Rationalität der Musik in Mittelalter und Früher Neuzeit: Erster Band: Das platonische Paradigma, Freiburger Beiträge zur Musikwissenschaft*. Freiburg: Rombach.

Beck, Hans-Georg, ed. and trans. 1984. *Der Vater der Deutschen Byzantinistik: Das Leben des Hieronymus Wolf von ihm selbst erzählt*. Munich: Institut für Byzantinistik und neugriechische Philologie der Universität München.

Berliner, Rudolf. 1928. "Zur älteren Geschichte der Allgemeinen Museumslehre in Deutschland." In *Münchner Jahrbuch der bildenden Künst* 5, no. 4: 327–52.

Bietenholz, Peter G., and Thomas B. Deutscher, eds. 1986. *Contemporaries of Erasmus: A Biographical Register of the Renaissance and Reformation*. 3 vols. Toronto: University of Toronto Press.

Blair, Ann. 1997. *The Theater of Nature: Jean Bodin and Renaissance Science*. Princeton, N.J.: Princeton University Press.

Boehm, Laetitia, Winfried Müller, and Christopher Schöner, eds. 1998. *Biographisches Lexikon der Ludwig-Maximilians-Universität München*. Vol. 1, *Ingolstadt-Landshut 1472–1826*. Berlin: Duncker & Humblot.

Bosl, Karl, ed. 1983. *Bosls Bayerische Biographie: 8000 Persönlichkeiten aus 15 Jahrhunderten*. Regensburg: Pustet.

Bott, Gerhard, and Germanisches Nationalmuseum. 1985. *Wenzel Jamnitzer und die Nürnberger Goldschmiedekunst 1500–1700: Goldschmiedearbeiten; Entwürfe, Modell, Medaillen Ornamentstiche, Schmuck, Porträts*. Exh. cat. Munich: Klinkhardt & Biermann.

Brakensiek, Stephan. 2003. *Vom "Theatrum mundi" zum "Cabinet des Estampes": Das Sammeln von Druckgraphik in Deutschland 1565–1821*. Hildesheim, Germany: Olms.

———. 2008. "Samuel Quicchelberg: Gründungsvater oder Einzeltäter? Zur Intention der *Inscriptiones vel Tituli Theatri amplissimi* (1565) und ihrer Rezeption im Sammlungswesen Europas zwischen 1550 und 1820." *Metaphorik.de* 14: 231–52. http://www.metaphorik.de/14/Brakensiek.pdf.

Braungart, Wolfgang. 1989. *Die Kunst der Utopie: Vom Späthumanismus zur frühen Aufklärung*. Stuttgart: Metzler.

Bredekamp, Horst. 1982. "Antikensehnsucht und Maschinenglauben." In Herbert Beck and Peter Cornelis Bol, eds., *Forschungen zur Villa Albani: Antike Kunst und die Epoche der Aufklärung*, 507–59. Berlin: Gebr. Mann.

Broeckx, Corneille. 1862. *Aenteekeningen over Samuel Quickelbergs: Oudheidskundige arts der XVIe eeuw*. Antwerp: Buschmann.

Bursian, Conrad. 1874. "Die Antikensammlung Raimund Fuggers. Nebst einem Excurs über einige andere in der Inschriftensammlung von Apianus und Amantius abgebildete antike Bildwerke." *Sitzungsberichte der philosophisch-philologischen und historischen Classe* 2: 133–60.

Busch, Renate von. 1973. "Studien zu deutschen Antikensammlungen des 16. Jahrhunderts." PhD diss., Eberhard-Karls-Universität, Tübingen.

Buscher, Hans. 1946. *Heinrich Pantaleon und sein Heldenbuch.* Basel: Helbing & Lichtenhahn.

———. 1947. *Der Basler Arzt Heinrich Pantaleon (1522–1595).* Aarau, Switzerland: H. R. Sauerländer.

Busley, Hermann-Joseph. 1965. "Zur Finanz- und Kulturpolitik Albrechts V. von Bayern: Studie zum herzoglichen Ratsgutachten von 1557." In Erwin Iserloh and Konrad Repgen, eds., *Reformata Reformanda: Festgabe für Hubert Jedin zum 17. Juni 1965.* Vol. 2, 209–35. Münster, Germany: Hermann-Joseph Busley.

Buzás, Ladislaus. 1972. *Geschichte der Universitätsbibliothek München.* Wiesbaden: Reichert.

Camillo, Giulio. 1550. *L'idea del theatro.* Florence: Torrentino.

Cannon-Brookes, Peter. 1981. "Objects for a 'Wunderkammer' at Colnaghi's." *The Burlington Magazine* 123, no. 941: 497–501.

Chaudon, Louis Mayeul. 1810–12. *Dictionnaire universel, historique, critique et bibliographique.* Paris: Mame.

Cicero, Marcus Tullius. 1942. *De oratore.* Edited by Harris Rackham. Translated by Edward William Sutton. London: W. Heinemann.

Cortonaeus, Petrus. 1555. *Varia carmina graeca.* Venice: Gryphius.

Daston, Lorraine, and Katharine Park. 1998. *Wonders and the Order of Nature, 1150–1750.* New York: Zone.

Diemer, Dorothea, and Willibald Sauerländer. 2008. *Die Münchner Kunstkammer.* 3 vols. Munich: C. H. Beck.

Dirkse, P. P. 1971. "Het 'Theatrum' van Quiccheberg." PhD diss., Leiden University.

Eichberger, Dagmar. 2002. *Leben mit Kunst, Wirken durch Kunst: Sammelwesen und Hofkunst unter Margarete von Österreich, Regentin der Niederlande.* Turnhout, Belgium: Brepols.

Eirich, Raimund. 1971. *Memmingens Wirtschaft und Patriziat von 1347 bis 1551: Eine wirtschafts- und sozialgeschichtliche Untersuchung über das Memminger Patriziat während der Zunftverfassung.* Weissenhorn, Germany: Kommissionsverlag A. H. Konrad.

Ellinger, Georg. 1929. *Die neulateinische Lyrik Deutschlands in der ersten Hälfte des sechzehnten Jahrhunderts.* Vol. 2 of idem, *Geschichte der neulateinischen Literatur Deutschlands im sechzehnten Jahrhundert.* Berlin: Walter de Gruyter.

Erasmus, Desiderius. 1946. *Opus Epistolarum Des. Erasmi Roterdami.* Edited by P. S. Allen. Vol. 10. Oxford: Clarendon.

Falguières, Patricia. 1992. "Fondation du Théâtre ou méthode de l'exposition universelle: Les *Inscriptions* de Samuel Quicchelberg 1565." *Les Cahiers du Musée National d'Art Moderne* 40: 91–109.

Favaretto, Irene, ed. 1984. *Marco Mantova Benavides: Il suo museo e la cultura padovana del Cinquecento; Atti della giornata di studio.* Padua: Accademia patavina di scienze, lettere ed arti, Comune di Padova, Assessorato ai beni culturali, Università degli studi di Padova.

Fickler, Johann Baptist. 1598. *Inventarium oder Beschreibung aller deren Stuckh und sachen frembder und Inhaimaischer bekanter und unbekanter selzamer und verwunderlicher ding so auff Ir Fürstl. Dthl. Herzogen in Bayern etc. Kunst Camer zu sehen und zu finden ist angefangen den 5. Februarii anno 1598 Geschrieben durch Joan Baptist Ficklern der Rechten Doctorn Fürstl. Dhtl. in Bayern Hofrath zu München.* Cod. ger. mon. 2133 and 2134, Bayerische Staatsbibliothek, Munich.

———. 2004. *Das Inventar der Münchner herzoglichen Kunstkammer von 1598. Editionsband: Transkription der Inventarhandschrift cgm 2133.* Edited by Peter Diemer, Elke Bujok, and Dorothea Diemer. Munich: C. H. Beck.

Findlen, Paula. 1989. "The Museum: Its Classical Etymology and Renaissance Genealogy." *Journal of the History of Collections* 1, no. 1: 59–78.

———. 1994. *Possessing Nature: Museums, Collecting, and Scientific Culture in Early Modern Italy.* Berkeley: University of California Press.

Fleischhauer, Werner. 1982. "Die Kunstkammer des Grafen Ulrich von Montfort zu Tettnang, 1574." *Ulm und Oberschwaben: Zeitschrift für Geschichte und Kunst* 44: 9–28.

Fleischmann, Peter, and Manfred Grieb, eds. 2002. *Das Verzeichnis aller Genannten des Größeren Rats zu Nürnberg von Johann Ferdinand Roth aus dem Jahr 1802 [1802].* Facsimile of the first edition. Neustadt, Germany: Verlag für Kunstreproduktionen.

Friedensburg, Walter. 1902. "Ambrosius von Gumppenberg als päpstlicher Berichterstatter in Süddeutschland (1546–1559)." *Forschungen zur Geschichte Bayerns* 10: 149–85, 263–93.

Friedrich, Markus. 2004. "Das Buch als Theater: Überlegungen zu Signifikanz und Dimensionen der *Theatrum* Metapher als frühneuzeitlichem Buchtitel." In Theo Stammen and Wolfgang Weber, eds., *Wissenssicherung, Wissensordnung und Wissensverarbeitung: Das europäische Modell der Enzyklopädien*, 205–32. Berlin: Akademie.

Fuchs, Leonhard. 1542. *De historia stirpium commentarii insignes*. Basel: Officina Isingriniana.

Fugger, Hans Jakob, [and Clemens Jäger]. 1545. *Hernach volget das gehaim Eernbuch Mans Stammens und Namens des Eerlichen und altloblichen Fuggerischen Geschlechts. aufgericht A°1545*. Hs. 1668 (Bg. 3731) Fugger, Germanisches Nationalmuseum Nürnberg, Nuremberg.

———. 1555. *Wahrhafftige Beschreibung Zwaier Inn ainem alleredelsten uralten und hochloblichisten Geschlechten der Christenhait des Habspurgischen unnd Osterreichischen geblüets Durch den Wolgebornen herrn Hans Jacob Fugger*. Cgm 895 and 896. Munich: Bayerisches Staatsbibliothek.

Fugger, Markus. 1584. *Von der Gestüterey*. Frankfurt: Feyrabend.

Garber, Klaus, ed. 1998. *Stadt und Literatur im deutschen Sprachraum der Frühen Neuzeit*. 2 vols. Tübingen, Germany: Max Niemeyer.

Gensthaler, Gerhard. 1973. *Das Medizinalwesen der freien Reichsstadt Augsburg bis zum 16. Jahrhundert: Mit Berücksichtigung der ersten Pharmakopöe von 1564 und ihrer weiteren Ausgaben*. Augsburg: Mühlberger.

Gesner, Conrad. 1542. *Catalogus plantarum Latinae, Graecae, Germaniae & Gallice* Zurich: Christoph Froschauer.

———. 1545–55. *Bibliotheca universalis, sive catalogus omnium scriptorum locupletissimus, in tribus linguis, Latina, Graeca, & Hebraica*. Zurich: Christoph Froschauer.

———. 1548. *Pandectarum sive partitionum universalium*. Zurich: Christoph Froschauer.

———. 1551–87. *Historia animalium*. Zurich: Christoph Froschauer.

Goltzius, Hubertus. 1563. *C. Iulius Caesar sive Historiae imperatorum caesarumque Romanorum ex antiquis numismatibus restitutae liber primus*. Bruges: Hubertus Goltzius.

———. 1557. *Vivae omnium fere imperatorum imagines*. Antwerp: Aegidius Copenius.

Gullath, Brigitte, and Bayerische Staatsbibliothek. 2002. *Ottheinrichs deutsche Bibel: Der Beginn einer grossen*

Büchersammlung [1973]. Munich: Bayerische Staatsbibliothek.

Günther, Siegmund. 1882. *Peter und Philipp Apian, zwei deutsche Mathematiker u. Kartographen: Ein Beitrag zur Gelehrten-Geschichte des XVI. Jahrhunderts*. Prague: Verlag der kön. böhmischen Gesellschaft der Wissenschaften.

Häberlein, Mark, and Johannes Burkhardt, eds. 2002. *Die Welser: Neue Forschungen zur Geschichte und Kultur des oberdeutschen Handelshauses*. Berlin: Akademie.

Hajós, Elizabeth M. 1958. "The Concept of an Engravings Collection in the Year 1565: Quiccheberg, *Inscriptiones vel Tituli Theatri Amplissimi*." *The Art Bulletin* 20, no. 2: 151–56.

———. 1963. "References to Giulio Camillo in Samuel Quiccheberg's 'Inscriptiones vel Tituli Theatri Amplissimi." *Bibliothèque d'humanisme et renaissance: Travaux et document* 25: 207–11.

Hartig, Otto. 1917. *Die Gründung der Münchner Hofbibliothek durch Albrecht V und Johann Jakob Fugger*. Munich: n.d.

———. 1933a. "Der Arzt Samuel Quiccheberg, der erste Museologe Deutschlands, am Hofe Albrechts V." *Bayerland* 44: 630–33.

———. 1933b. "Die Kunsttätigkeit in München unter Wilhelm IV. und Albrecht V." *Münchner Jahrbuch der bildenden Kunst* 10, no. 4: 147–225.

Hildebrand, Josephine, and Christian Theuerkauff, eds. 1981. *Die Brandenburgisch-Preussische Kunstkammer: Eine Auswahl aus den alten Beständen*. Berlin: Staatliche Museen Preussischer Kulturbesitz.

Historisch-Biographisches Lexicon der Schweiz. 1921–34. Neuenburg, Germany: Administration des Historisch-Biographischen Lexicons der Schweiz.

Hüllen, Werner. 1990. "Reality, the Museum, and the Catalogue: A Semiotic Interpretation of Early German Texts of Museology." *Semiotica* 80, nos. 3–4: 265–75.

Impey, Oliver, and Arthur MacGregor, eds. 1985. *The Origins of Museums: The Cabinet of Curiosities in Sixteenth- and Seventeenth-Century Europe*. Oxford: Clarendon.

Jansen, Dirk. 1982. "Jacopo Strada (1515–1588): Antiquario della Sacra Cesarea Maestà." *Leids kunsthistorisch jaarboek* 1: 57–69.

———. 1989–90. "Der Mantuaner Antiquarius: Jacopo Strada." In Sylvia Ferino Pagden and Konrad Oberhuber, eds., *Fürstenhofe der Renaissance: Giulio Romano und die klassische Tradition*, 308–22. Exh. cat. Vienna: Kunsthistorisches Museum.

———. 1993. "Samuel Quicchebergs Inscriptiones: de encyclopedische verzameling als hulpmiddel voor de wetenschap." In Ellinoor Bergveld, Debora J. Meijers, and Mieke Rijnders, eds. *Verzamelen: Van rariteitenkabinet tot kunstmuseum,* 57–76. Heerlen: Open Universiteit.

Jante, Peter Rudolf. 1985. *Willibald Imhoff: Kunstfreund und Sammler.* Lüneburg, Germany: Stadtlexikon.

Jenny, Beat Rudolf. 1959. *Graf Froben Christoph von Zimmern: Geschichtsschreiber, Erzähler, Landesherr; Ein Beitrag zur Geschichte des Humanismus in Schwaben.* Lindau, Germany: Thorbecke.

Jöcher, Christian G. 1726–33. *Compendiöses Gelehrten-Lexicon darrinen die Gelehrten aller Stände.* 2 vols. Leipzig: Johann Friedrich Gleditsch und Sohn.

Junius, Hadrianus. 1588. *Batavia.* Leiden: Plantin & Raphelengius.

Karnehm, Christl, Maria Grafin von Preysing, and Paul Munch. 2003. *Die Korrespondenz Hans Fuggers von 1566 bis 1594: Regesten der Kopierbuch aus dem Fuggerarchiv.* 3 vols. Munich: Kommission für bayerische Landesgeschichte bei der Bayerischen Akademie der Wissenschaften.

Katritzky, M. A. 1996. "The Florentine *Entrata* of Joanna of Austria and Other *Entrate* Described in a German Diary." *Journal of the Warburg and Courtauld Institutes* 59: 148–73.

Kaufmann, Thomas DaCosta. 1978. "Remarks on the Collections of Rudolf II: The *Kunstkammer* as a Form of *Representatio.*" *Art Journal* 38, no. 1: 22–28.

Kellenbenz, Hermann. 1980. "Augsburger Sammlungen." In *Welt im Umbruch: Augsburg zwischen Renaissance und Barock.* Vol. 1, 76–88. Exh. cat. Augsburg: Augsburger Druck- und Verlagshaus.

Kelley, Donald R. 1999. "Writing Cultural History in Early Modern Europe: Christophe Milieu and His Project." *Renaissance Quarterly* 52, no. 2: 342–65.

Kenseth, Joy, ed. 1991a. *The Age of the Marvelous.* Hanover, N.H.: Hood Museum of Art.

———. 1991b. "A World of Wonders in One Closet Shut." In Joy Kenseth, ed., *The Age of the Marvelous,* 81–101. Hanover, N.H.: Hood Museum of Art.

Klinger, Linda. 1985. "Portrait Collections and Portrait Books in the Sixteenth Century: The Case of Paolo Giovio and Marco Mantova Benavides." In *Atti del Convegno Paolo Giovio: Il Rinascimento e la memoria,* 181. Como, Italy: Società Storica Comense.

Kluyskens, Hippolyte. 1859. *Des hommes célèbres dans les sciences et les arts, et des*

médailles qui consecrant leur souvenir. Vol. 2. Ghent: Imprimerie et Lithographie de Léonard Hebbelynck.

Kobolt, Anton Maria. 1795. *Anton Maria Kobolts Baierisches Gelehrten-Lexikon.* Landshut: Hagen'sche Buchhandlung.

Kühlmann, Wilhelm, et al., eds. 1997. *Humanistische Lyrik des 16. Jahrhunderts: Lateinisch und Deutsch.* Frankfurt am Main: Deutscher Klassiker.

Künast, Hans-Jorg, and Helmut Zäh. 2004. "Bibliotheca Peutingeriana—zur Rekonstruktion der bedeutendsten deutschen Gelehrtenbibliothek im Zeitalter des Humanismus." *Bibliotheksforum Bayern* 32: 33–54.

Lanzinner, Maximilian. 1980. *Fürst, Räte und Landstände: Die Entstehung der Zentralbehörden in Bayern 1511–1598.* Göttingen: Vandenhoeck & Ruprecht.

Lasso, Orlando di. 1565. *Septem psalmi poeniteniales.* With illuminations by Hans Mielich. Mus. ms. A, I–II, Bayerisches Staatsbibliothek, Munich.

Lehmann, Paul. 1955. "Vorausblicke auf eine Geschichte der alten Függer-Bibliotheken." *Historisches Jahrbuch* 74: 699–702.

———. 1956. *Eine Geschichte der alten Fuggerbibliotheken.* Vol. 1. Tübingen, Germany: Mohr.

———. 1960. *Eine Geschichte der alten Fuggerbibliotheken.* Vol. 2. Tübingen, Germany: Mohr.

Lhotsky, Alphons. 1941–45. *Festschrift des Kunsthistorischen Museums zur Feier des Fünfzigjährigen Bestandes: Die Geschichte der Sammlungen.* Vol. 2, pt. 1, *Von den Anfängen bis zum Tode Kaisers Karls VI.* Vienna: Berger, Horn.

Lieb, Norbert. 1958. *Die Fugger und die Kunst im Zeitalter der hohen Renaissance.* Munich: Schnell & Steiner.

Löcher, Kurt. 2002. *Hans Mielich, 1516–1573: Bildnismaler in München.* Munich: Deutscher Kunstverlag.

Ludovici, Carl G., and Johann Heinrich Zedler. 1732–50. *Grosses vollständiges Universal-Lexicon aller Wissenschaften und Künste.* Q3r, col. 250. Halle: J. H. Zedler.

Lugli, Adalgisa. 1983. *Naturalia et mirabilia: Il collezionismo enciclopedico nelle Wunderkammern d'Europa.* Milan: Gabriele Mazzotta.

———. 1986a. *Arte e scienza: Wunderkammer.* Milan: Electa.

———. 1986b. "Inquiry as Collection: The Athanasius Kircher Museum in Rome." *RES: Anthropology and Aesthetics,* no. 12: 109–24.

Lutze, Eberhard, and Hans Retzlaff. 1949. *Herbarium des Georg Oellinger Anno 1553 zu Nürnberg*. Salzburg. Akademischer Gemeinschaftsverlag.

Lycosthenes, Conrad, and Theodorus Zwinger. 1565. *Theatrum vitae humanae, Omnium fere eorum, quae in hominem cadere possunt, bonorum atque malorum exempla historica, ethicae philosophiae praeceptis accommodata, & in XIX libros digesta, comprehendens: ut non immerito historiae promptuarium, vitaeque humanae speculum nuncupari possit*. Basel: Oporinus.

Maasen, Wilhelm. 1922. *Hans Jakob Fugger (1516–1575): Ein Beitrag zur Geschichte des XVI. Jahrhunderts*. Munich: Datterer.

Marbodeus Gallus. [1539]. *De gemmarum lapidumque pretiosorum formis, naturis atque viribus*. Cologne: Hero Alopecius.

Martin, David. 2011. *Curious Visions of Modernity: Enchantment, Magic, and the Sacred*. Cambridge, Mass.: MIT Press.

Maximilian I. 1517. *Theuerdank*. Nuremberg: Johann Schönsperger.

McCue, George. 1952. "The History of the Use of the Tomato: An Annotated Bibliography." *Annals of the Missouri Botanical Garden* 39, no. 4: 289–348.

Meadow, Mark. 2002. "Merchants and Marvels: Hans Jacob Fugger and the Origins of the Wunderkammer." In Pamela H. Smith and Paula Findlen, eds., *Merchants and Marvels: Commerce, Science, and Art in Early Modern Europe*, 182–200. London: Routledge.

———. 2005. "Quiccheberg and the Copious Object: Wenzel Jamnitzer's Silver Writing Box." In Stephen Melville, ed., *The Lure of the Object*, 39–58. Williamstown, Mass.: Sterling and Francine Clark Art Institute.

———. 2009. "The Aztecs at Ambras: Social Networks and the Transfer of Cultural Knowledge of the New World." In Michael North, ed., *Kultureller Austausch: Bilanz und Perspektiven der Frühneuzeitforschung*, 349–68. Cologne: Böhlau.

———. 2010. "Relocation and Revaluation in University Collections, or, *Rubbish Theory* Revisited." In Sally Macdonald, Nathalie Nyst, and Cornelia Weber, eds., *Putting University Collections to Work in Research and Teaching: Proceedings of the 9th Conference of the International Committee of ICOM for University Museums and Collections (UMAC)*. Special issue, *University Museums and Collections Journal* 3: 3–10.

Menzhausen, Joachim. 1985. "Elector August's *Kunstkammer*: An Analysis of the Inventory of 1587." In Oliver Impey and Arthur MacGregor, eds., *The Origins of Museums: The Cabinet of Curiosities in Sixteenth- and Seventeenth-Century Europe*, 69–75. Oxford: Clarendon.

Meyer, Andreas. 2001. "Die Grosse Ravensburger Handelsgesellschaft in der Region: Von der 'Bodenseehanse' zur Familiengesellschaft der Humpis." In Carl A. Hoffmann and Rolf Kiessling, eds., *Kommunikation und Region*, 249–304. Konstanz, Germany: UVK.

Moller, Daniel Wilhelm. 1704. *Commentatio de Technophysiotameis sive Germanice von Kunst- und Naturalien-Kammern*. Altdorf: n.p.

Mylaeus, Christophorus. 1551. *De scribenda universitatis rerum historia libri quinque*. Basel: Oporinus.

———. 1557. *Theatrum universitatis rerum*. Basel: Oporinus.

NDB [Neue Deutsche Biographie]. 1953–2010. Edited by Historische Kommission bei der Bayerischen Akademie der Wissenschaften. 24 vols. Berlin: Duncker & Humblot.

Occo, Adolph, III. 1564. *Enchiridion sive, ut vulgo vocant, dispensatorium compositorum medicamentorum: pro Reipub. Augstburgensis pharmacopeis*. Augsburg: n.p.

———. 1574. *Pharmacopoeia, seu medicamentarium pro Rep. Augustana*. Augsburg: Georg Willer.

Öllinger, Georg, and Samuel Quiccheberg. 1553. *Magnarum medicinae partium herbariae et zoographicae, imagines quamplurimae excellentes: a praeclaro in hoc studii genere viro, Domino Georgio Oelingero Norimbergensi pharmacopola, mercatore et cive, mira perspicuitate picturae et magnis sumptibus in hunc librum relatae. Norimbergae hic liber multis annis comparatur tandem titulis et commendatio libri a Samuele Quicchelbergs*. Ms. 2362, Erlangen University Library, Erlangen.

Olmi, Giuseppe. 1978. *Ulisse Aldrovandi: Scienza e natura nel secondo cinquecento*. Trento: Libera Univ. degli studi di Trento.

Ong, Walter. 1976. "Commonplace Rhapsody: Ravisius Textor, Zwinger and Shakespeare." In R. R. Bolgar, ed., *Classical Influences on European Culture A.D. 1500–1700*, 91–126. Cambridge: Cambridge University Press.

Overbeeke, Noes M. 1994. "Cardinal Otto Truchsess von Waldburg and His Role as Art Dealer for Albrecht V of Bavaria (1568–73)." *Journal of the History of Collections* 6, no. 2: 173–79.

Owens, Jessie Ann. 1979. "An Illuminated Manuscript of Motets by Cipriano de Rore (München, Bayerische Staatsbibliothek, Mus. Ms. B)." 2 vols. PhD diss., Princeton University.

Pantaleon, Heinrich. 1565–66. *Prosopographiae heroum atque illustrium virorum totius Germaniae in hac personarum descriptio omnium tam armis et authoritate, quam literis & religione totius Germaniae celebrium virorum vitae & res praeclare gestae bona fide referentur.* Basel: Brylinger.

———. 1570. *Der dritte und letste Theil Teutscher Nation Heldenbuch: In diesem werden aller Hochberümpten Teutschen Personen . . . Leben und namhaffte tathen gantz waarhaftig beschriben. . . .* Basel: Brylinger.

Perriere, Guilelme de la. 1539. *Le theatre des bons engins, auquel sont contenus cent emblems moraulx.* Paris: Denis Jacot.

Perry, Claire. 2011. *The Great American Hall of Wonders: Art, Science, and Invention in the Nineteenth Century.* Washington, D.C.: Smithsonian American Art Museum.

Pilaski, Katharina. 2007. "The Munich *Kunstkammer:* Art, Nature, and the Representation of Knowledge in Courtly Contexts." PhD diss., University of California, Santa Barbara.

Pohl, Horst, ed. 1992. *Willibald Imhoff, Enkel und Erbe Willibald Pirckheimers.* Nuremberg: Im Selbstverlag des Stadtrats zu Nürnberg.

Pölnitz, Götz von, ed. 1937. *Die Matrikel der Ludwig-Maximilians-Universität München.* Vol. 1, *1472–1600.* Munich: Lindauer.

———, ed. 1981. *Die Matrikel der Ludwig-Maximilians-Universität Ingolstadt-Landshut-München.* Pt. 1, Ingolstadt. Vol. 4, *Personenregister.* Halbband 1: *A–J.* Halbband 2: *K–Z.* Munich: Lindauer.

Pomian, Krzysztof. 1990. *Collectors and Curiosities: Paris and Venice, 1500–1800.* Translated by Elizabeth Wiles-Portier. Cambridge: Polity.

Purcell, Rosamond. 1997. *Special Cases: Natural Anomalies and Historical Monsters.* San Francisco: Chronicle.

Quiccheberg, Samuel. 1564. *Declaratio picturarum imaginum, acquorumcunque ornamentorum in libro, Motetorum celeberrimi musici Cypriani de Rore. Quae guidem omnia tam cantiones, quam imagines, cum universo libro, auspicio & sumptibus Illustrissimi Principis Alberti Bavariae Ducis &c.* Mus. ms. B, II, Bayerisches Staatsbibliothek, Munich.

———. 1565a. *Declaratio psalmorum poenitentialium et duorum psalmorum Laudate, compositionis excellentissimi musici Orlandi de Lassus. Quantum guidem illi copiosissimis & amoenissimis imaginabus atq. ornamentis illustrantur auspiciis Illustrissimi principis Alberti Com. Pal. Rheni, utriusq. Bavariae ducis monocratoris, a Iohanne Muelichio Monachiensi pictore, eodemq. omnium quae adbibentur, tam biblicarum historiarum, quam aliorum diversissimorum ornamentorum inventore ac delineatore.* Mus. ms. A, I–II, Bayerisches Staatsbibliothek, Munich.

———. 1565b. *Inscriptiones theatri materiarum, imaginumque universitatis seu tituli, promptuarij artificiosarum miraculosarumque rerum ac omnis rari thesauri, vel preciosae suppelectilis aut picturae, ad singularem aliquam prudentiam comparandam utilis, auctore Samuele a Quiccheberg Belga, cum praefatione Leonis a Quiccheberg fratris ad Maximilianum II Rom. Imperatorem. Venetiis in officina.* Fols. 84–125, Vat. lat. 5346, Bibliotheca Apostolica Vaticana, Vatican City.

———. 1565c. *Inscriptiones; vel, tituli theatri amplissimi, complectentis rerum universitati singulas materias et imagines eximias ut idem recte quoq. dici possit: Promptuarium artificiosarum miraculosarumque rerum, ac omnis rari thesauri et pretiosae supelectilis, structurae atq. picturae. Quae hi simul in theatro conquiri consuluntur, ut eorum frequenti inspection tractionecq., singularis aliqua rerum cognitio et prudentia admiranda, citò, facile ac tutò comparari possit.* Munich: Adam Berg.

———. 1571a. *Apophthegmata biblica, tum et responsiones aliae piae, adeoque dialogos etiam eos, qui a' Apophtegmatum non sunt alieni.* Cologne: Arnold Birckmann.

———. 1571b. *Apophthegmata et strategemata biblica.* Cologne: n.p.

———. 1591. *Schema catechisticum sive Doctrinae christianae summam.* Antwerp: n.p.

———. 2000. *Der Anfang der Museumslehre in Deutschland: Das Traktat "Inscriptiones vel Tituli Theatri Amplissimi" von Samuel Quiccheberg.* Edited and translated by Harriet Roth. Berlin: Akademie.

Reinhard, Wolfgang, and Mark Häberlein, eds. 1996. *Augsburger Eliten des 16. Jahrhunderts: Prosopographie wirtschaftlicher und politischer Führungsgruppen 1500–1620.* Berlin: Akademie.

Reinhardstöttner, Karl von. 1890. "Zur Geschichte des Humanismus und der Gelehrsamkeit in München unter Albrecht dem Fünften." *Jahrbuch für Münchner Geschichte* 4: 45–174.

Riezler, Sigmund. 1895. "Zur Würdigung Herzog Albrechts V. von Bayern und seiner inneren Regierung." *Abhandlungen der historischen Classe der königlich Bayerischen Akademie der Wissenschaften, Philosophisch-Historische Klasse,* vol. 21, pt. 1: 65–132.

Roberts, Lisa C. 1997. *From Knowledge to Narrative: Educators and the Changing Museum.* Washington, D.C.: Smithsonian Institution Press.

Robertson, Bruce. 2006. "Curiosity Cabinets, Museums, and Universities." In Colleen J. Sheehy, ed., *Cabinet of Curiosities: Mark Dion and the University as Installation,* 43–50. Minneapolis: University of Minnesota Press.

———. 2010. "Microcosms: An Introduction to an Interdisciplinary Museum Project." In Sally Macdonald, Nathalie Nyst, and Cornelia Weber, eds., *Putting University Collections to Work in Research and Teaching: Proceedings of the 9th Conference of the International Committee of ICOM for University Museums and Collections (UMAC).* Special issue, *University Museums and Collections Journal* 3: 3–10.

Robertson, Bruce, and Mark Meadow. 2000. "Microcosms: Objects of Knowledge." *AI&Society* 14: 223–29.

Rohmann, Gregor. 2004a. *Das Ehrenbuch der Fugger: Darstellung—Transkription—Kommentar.* Augsburg: Wissner-Verlag.

———. 2004b. *Das Ehrenbuch der Fugger: Die Babbenhausener Handschrift.* Augsburg: Wissner-Verlag.

Rore, Cipriano de. 1559. *Motetten.* With illuminations by Hans Mielich. Mus. ms. B, I, Bayerisches Staatsbibliothek, Munich.

[Roth], Harriet Hauger. 1991. "Samuel Quiccheberg: 'Inscriptiones vel tituli Theatri Amplissimi': Über die Entstehung der Museen und das Sammeln." In Winfried Müller, Wolfgang J. Smolka, and Helmut Zedelmaier, eds., *Universität und Bildung: Festschrift Laetitia Boehm zum 60. Geburtstag,* 129–39. Munich: Verlag von PS-Serviceleistungen für Geisteswissenschaft und Medien.

Rudolf, Karl. 1995. "Die Kunstbestrebungen Kaiser Maximilian II. im Spannungsfeld zwischen Madrid und Wien: Untersuchungen zu den Sammlungen der Österreichischen und Spanischen Habsburger im 16. Jahrhundert." *Jahrbuch der kunsthistorischen Sammlungen in Wien* 91: 165–256.

Scheicher, Elizabeth. 1985. "The Collection of Archduke Ferdinand II at Schloss Ambras: Its Purpose, Composition and Evolution." In Oliver Impey and Arthur MacGregor, eds., *The Origins of Museums: The Cabinet of Curiosities in Sixteenth- and Seventeenth-Century Europe,* 29–38. Oxford: Clarendon.

Scheicher, Elizabeth, Ortwin Gamber, Kurt Wegerer, and Alfred Auer, eds. 1977. *Kunsthistorisches Museum, Sammlungen Schloss Ambras: Die Kunstkammer.* Innsbruck: Kunsthistorisches Museum.

Schelenz, Hermann. 1975. *Frauen im Reiche Äskulaps* [1900]. Würzburg: Jal-Reprint.

Schilling, Albert. 1881. *Die Reichsherrschaft Justingen: Ein Beitrag zur Geschichte von Alb und Oberschwaben.* Stuttgart: self-published.

Schlosser, Julius von. 1908. *Die Kunst- und Wunderkammern der Spätrenaissance: Ein Beitrag zur Geschichte des Sammelwesens.* Leipzig: Klinkhardt & Biermann.

Schmidbauer, Richard. 1963. *Die Augsburger Stadtbibliothekare durch vier Jahrhunderte: 1537–1952.* Augsburg: Brigg.

Schramm, Helmar, Ludger Schwarte, and Jan Lazardzig, eds. 2003. *Kunstkammer, Laboratorium, Bühne: Schauplätze des Wissens im 17. Jahrhundert.* Berlin: Walter de Gruyter.

Schulz, Eva. 1990. "Notes on the History of Collecting and of Museums in the Light of Selected Literature of the Sixteenth to the Eighteenth Century." *Journal of the History of Collections* 2, no. 2: 205–18.

Schwarzenberg, Fürst Karl zu. 1963. *Geschichte des reichsständischen Hauses Schwarzenberg.* Neustadt an der Aisch, Germany: Degener.

Seling, Helmut. 1980. *Die Kunst der Augsburger Goldschmiede 1529–1868.* Vol. 3, *Meister-Marke-Waren.* Munich: Beck.

Serrai, Alfredo, Marco Menato, and Maria Cochetti, eds. 1990. *Conrad Gesner.* Rome: Bulzoni.

Sheehy, Colleen J., ed. 2006. *Cabinet of Curiosities: Mark Dion and the University as Installation.* Minneapolis: University of Minnesota Press.

Shelton, Anthony. 1994. "Cabinets of Transgression: Renaissance Collections and the Incorporation of the New World." In John Elsner and Roger Cardinal, eds., *The Cultures of Collecting,* 177–203. London: Reaktion.

Smith, Pamela H., and Paula Findlen, eds. 2002. *Merchants and Marvels: Commerce, Science, and Art in Early Modern Europe.* London: Routledge.

Steuer, Peter. 1988. *Die Außenverflechtung der Augsburger Oligarchie von 1500–1620:*

Studien zur sozialen Verflechtung der politischen Führungsschicht der Reichsstadt Augsburg. Augsburg: AV.

Stockbauer, Jacob. 1874. *Die Kunstbestrebungen am Bayerischen Hofe unter Herzog Albert V. und seinem Nachfolger Wilhelm V.* Vienna: Braumüller.

Sugenheim, Samuel. 1842. *Baierns Kirchen- und Volks-Zustände seit dem Anfange des sechszehnten bis zum Ende des achtzehnten Jahrunderts.* Vol. 1. Giessen: Heyer.

Sweertius, Franciscus. 1628. *Athenae Belgicae sive nomenclator infer. Germaniae scriptorum qvi disciplinis philologicas, philosophicas, theologicas, iuridicas, medicas, et musicas.* Antwerp: Gulielmum a Tungris.

Tebbe, Karin, Ursula Timann, and Thomas Eser, eds. 2007. "Nürnberger Goldschmiedekunst 1541–1868." In idem, *Meister, Werke, Marken.* Vol. 1, pt. 1, 268–69. Nuremberg: Verlag des Germanisches Nationalmuseum.

Textor, Ioannes Ravisius. 1520. *Io. Ravisii Textoris Nivernensis Officina partim historicis partim poeticis referta disciplinis.* Paris: Reginaldus Chauldière.

———. 1524. *Ioannis Ravisii Textoris epitheta: Studiosis omnibus poeticae artis maxime utilia.* Paris: Reginaldus Chauldière.

Thoma, Hans, and Herbert Brunner, eds. 1970. *Schatzkammer der Residenz München: Katalog.* Munich: Bayerische Verwaltung der staatlichen Schlösser, Gärten und Seen.

Thoren, Victor E. 1990. *The Lord of Uraniborg: A Biography of Tycho Brahe.* Cambridge: Cambridge University Press.

Todd, Robert. 1976. "The Four Causes: Aristotle's Exposition and the Ancients." *Journal of the History of Ideas* 37, no. 2: 319–22.

Tremmel, Erich. 1993. "Musikinstrumente im Hause Fugger." In Renate Eichelmann, ed., *Die Fugger und die Musik: Lautenschlagen lernen und ieben; Anton Fugger zum 500. Geburtstag,* 61–70. Augsburg: Hofmann.

Turpin, Adriana. 2006. "The New World Collections of Duke Cosimo I de'Medici and Their Role in the Creation of a *Kunst-* and *Wunderkammer* in the Palazzo Vecchio." In R. J. W. Evans and Alexander Marr, eds., *Curiosity and Wonder from the Renaissance to the Enlightenment,* 63–86. Aldershot, U.K.: Ashgate.

Vehse, Carl. 1851–60. *Geschichte der deutschen Höfe seit der Reformation.* 48 vols. Hamburg: Hoffmann und Campe.

Visser, A. S. Q. 2005. *Joannes Sambucus and the Learned Image: The Use of the Emblem in Late-Renaissance Humanism.* Leiden: Brill.

Vitruvius Pollio, Marcus. [1511]. *De architectura.* Venice: Tacuino.

Volbehr, Theodor. 1909. "Das 'Theatrum Quicchebergicum': Ein Museumstraum der Renaissance." *Museumskunde* 5, no. 4: 201–8.

Wackernagel, Hans Georg. 1956. *Die Matrikel der Universität Basel.* Vol. 2, *1532/33–1600/01.* Basel: Verlag der Universitätsbibliothek.

Warhol, Andy, and Stephen Ostrow. 1969. *Raid the Icebox 1 with Andy Warhol: An Exhibition Selected from the Vaults of the Museum of Art, Rhode Island School of Design.* Exh. cat. Providence: Rhode Island School of Design.

Westenrieder, Lorenz von. 1806. *Beyträge zur vaterländischen Historie, Geographie, Staatistik, etc.* Vol. 7. Munich: Akademische.

Wolf, Gerhard. 1993. "Froben Christoph von Zimmern." In Stephan Füssel, ed., *Deutsche Dichter der frühen Neuzeit (1450–1600): Ihr Leben und Werk,* 512–28. Berlin: Erich Schmidt.

Yates, Frances A. 1966. *The Art of Memory.* Chicago: University of Chicago Press.

Zäh, Helmut. 2002. "Konrad Peutinger und Margarete Welser—Ehe und Familie im Zeichen des Humanismus." In Mark Häberlein and Johannes Burkhardt, eds., *Die Welser: Neue Forschungen zur Geschichte und Kultur des oberdeutschen Handelshauses,* 449–71. Berlin: Akademie.

Zeitelhack, Barbara, and Stadt Neuburg an der Donau, eds. 2002. *Pfalzgraf Ottheinrich: Politik, Kunst und Wissenschaft im 16. Jahrhundert.* Regensburg: Pustet.

Zimmern, Froben Christoph von. 1881–82. *Zimmerische Chronik.* Edited by Karl Barack. Freiburg: Mohr.

BIOGRAPHICAL NOTES ON CONTRIBUTORS

Mark A. Meadow is an associate professor of art history at the University of California, Santa Barbara, specializing in the history and theory of museums and Northern Renaissance art. His publications include *Pieter Bruegel the Elder's Netherlandish Proverbs and the Practice of Rhetoric* (Waanders: Zwolle, 2002), a translation of Symon Andriessoon's *Duytsche Adagia ofte Spreecwoorden* (Verloren: Hilversum, 2003), and numerous articles. Meadow is founding coeditor of the book series Proteus: Studies in Early Modern Identity Formation from Brepols Press in Belgium. He is also a member of the University Museums and Collections International Committee (UMAC) of the International Council of Museums (ICOM).

Bruce Robertson is a professor of art history at the University of California, Santa Barbara, whose areas of specialization include American art and museum studies. The author of numerous books and many essays and articles on museum issues and history, Robertson is on the editorial boards of *Museum and Society* and *Museum History*. He was formerly the associate director of the Los Angeles County Museum of Art and is currently director of the Art, Design and Architecture Museum at the University of California, Santa Barbara.

ILLUSTRATION CREDITS

Every effort has been made to identify and contact the copyright holders of images published in this book. Should you discover what you consider to be a photo by a known photographer, please contact the publisher. Photographs of items in the holdings of the Getty Research Institute are courtesy the Research Library. The following sources have granted additional permission to reproduce illustrations in this book:

Introduction

Fig. 1	© Bayerisches Nationalmuseum München
Fig. 2	Photo: Jacques Quecq d'Henripret. © RMN-Grand Palais/Art Resource, NY
Fig. 3	Kunsthistorisches Museum, Wien

Plates

Pl. 1	Bayerische Staatsbibliothek München, Mus.ms. AI (Erläuterungsbd), f. 131r
Pl. 2	Erich Lessing/Art Resource, NY
Pl. 3	Bayerische Staatsbibliothek München, Cod.icon. 429, f. 1v
Pl. 4	Universität Erlangen-Nürnberg
Pl. 5	Bayerische Staatsbibliothek München, Mapp.XI,25 a
Pls. 6, 7, 14, 17, 19, 20	Kunsthistorisches Museum, Wien
Pl. 8	Photo: Bild1Druck. Germanisches Nationalmuseum, Nürnberg
Pls. 9, 13, 18	The J. Paul Getty Museum, Los Angeles
Pl. 10	Freiherrlich von Berlichingen'sches Archiv, Jagsthausen
Pl. 11	© The British Library Board, C.31.f.10 pl. 20
Pl. 12	© Bayerisches Nationalmuseum München
Pl. 15	Museum für Völkerkunde, Wien
Pl. 16	Courtesy of the Bancroft Library, University of California, Berkeley
Pl. 21	Photo: Yves Siza. © Musée d'art et d'histoire, Ville de Genève
Pl. 22	Photo: Eberhard Lantz. Bayerisches Landesamt fuer Denkmalpflege, München

INDEX

OTHER TRANSLATIONS PUBLISHED IN THE

TEXTS & DOCUMENTS SERIES

Gabriele Paleotti, *Discourse on Sacred and Profane Images* (1592)
Introduction by Paolo Prodi
Translation by William McCuaig
ISBN 978-1-60606-116-9 (paper)

Antoine Quatremère de Quincy, *Letters to Miranda and Canova on the Abduction of Antiquities from Rome and Athens* (1796, 1815)
Introduction by Dominique Poulot
Translation by Chris Miller and David Gilks
ISBN 978-1-60606-099-5 (paper)

Alois Riegl, *The Origins of Baroque Art in Rome* (1908)
Edited by Andrew Hopkins and Arnold Witte
Essays by Alina Payne, Arnold Witte, and Andrew Hopkins
Translation by Andrew Hopkins and Arnold Witte
ISBN 978-1-60606-041-4 (paper)

Le Corbusier, *Toward an Architecture* (1924)
Introduction by Jean-Louis Cohen
Translation by John Goodman
ISBN 978-0-89236-899-0 (hardcover),
ISBN 978-0-89236-822-8 (paper)

Johann Joachim Winckelmann, *History of the Art of Antiquity* (1764)
Introduction by Alex Potts
Translation by Harry Francis Mallgrave
ISBN 978-0-89236-668-2 (paper)

Jacob Burckhardt, *Italian Renaissance Painting according to Genres* (1885–93)
Introduction by Maurizio Ghelardi
Translation by David Britt and Caroline Beamish
ISBN 978-0-89236-736-8 (paper)

Gottfried Semper, *Style in the Technical and Tectonic Arts; or, Practical Aesthetics* (1860–63)
Introduction by Harry Francis Mallgrave
Translation by Michael Robinson and Harry Francis Mallgrave
ISBN 978-0-89236-597-5 (hardcover)

Julien-David Le Roy, *The Ruins of the Most Beautiful Monuments of Greece* (1770)
Introduction by Robin Middleton
Translation by David Britt
ISBN 978-0-89236-669-9 (paper)

Giovanni Battista Piranesi, *Observations on the Letter of Monsieur Mariette; with Opinions on Architecture, and a Preface to a New Treatise on the Introduction and Progress of the Fine Arts in Europe in Ancient Times* (1765)

Introduction by John Wilton-Ely
Translation by David Britt and Caroline Beamish
ISBN 978-0-89236-636-1 (paper)

Carl Gustav Carus, *Nine Letters on Landscape Painting, Written in the Years 1815–1824; with a Letter from Goethe by Way of Introduction* (1831)
Introduction by Oskar Bätschmann
Translation by David Britt
ISBN 978-0-89236-673-4 (paper)

Walter Curt Behrendt, *The Victory of the New Building Style* (1927)
Introduction by Detlef Mertins
Translation by Harry Francis Mallgrave
ISBN 978-0-89236-563-0 (paper)

Aby Warburg, *The Renewal of Pagan Antiquity: Contributions to the Cultural History of the European Renaissance* (1932)
Introduction by Kurt W. Forster
Translation by David Britt
ISBN 978-0-89236-537-1 (hardcover)

Friedrich Gilly: Essays on Architecture, 1796–1799
Introduction by Fritz Neumeyer
Translation by David Britt
ISBN 978-0-89236-280-6 (hardcover),
ISBN 978-0-89236-281-3 (paper)

Nicolas Le Camus de Mézières, *The Genius of Architecture; or, The Analogy of That Art with Our Sensations* (1780)
Introduction by Robin Middleton
Translation by David Britt
ISBN 978-0-89236-234-9 (hardcover),
ISBN 978-0-89236-235-6 (paper)

Claude Perrault, *Ordonnance for the Five Kinds of Columns after the Method of the Ancients* (1683)
Introduction by Alberto Pérez-Gómez
Translation by Indra Kagis McEwen
ISBN 978-0-89236-232-5 (hardcover),
ISBN 978-0-89236-233-2 (paper)

Heinrich Hübsch, Rudolf Wiegmann, Carl Albert Rosenthal, Johann Heinrich Wolff, and Carl Gottlieb Wilhelm Bötticher, *In What Style Should We Build? The German Debate on Architectural Style* (1828–47)
Introduction and translation by Wolfgang Herrmann
ISBN 978-0-89236-198-4 (paper)

Otto Wagner, *Modern Architecture: A Guidebook for His Students to This Field of Art* (1902)
Introduction and translation by Harry Francis Mallgrave
ISBN 978-0-226-86939-1 (paper)